Fair Wilderness

American Paintings in the
Collection of The Adirondack Museum

Catalogue and Checklist by Patricia C. F. Mandel

The Adirondack Museum
Blue Mountain Lake
New York

1990

Editor-in-Chief	Alice Wolf Gilborn
Project Director and Associate Editor	Caroline Mastin Welsh
Checklist Editor	Tracy Nelson Meehan
Editorial Assistant	Kathryn L. Benton
Designer	Jane Mackintosh Storms

The majority of color photographs by Erik Borg.
Remaining by Biff Henrich and others.

Black and white photographs by Erik Borg and Biff Henrich.

Typeset in New Baskerville
Printed by Thorner - Sidney Press, Inc., Buffalo, New York

Publication of *Fair Wilderness: American Paintings in the Collection of The Adirondack Museum* has been funded by the National Endowment for the Arts and the Adirondack Historical Association. Research and photography has been funded by the New York State Council on the Arts and the Adirondack Historical Association.

ISBN 0–910020–40–X

For their pioneer efforts to identify and research
the work of artists in the Adirondacks
this volume is dedicated to
Margaret Goodwin O'Brien and William K. Verner

Contents

Preface

This book completes an assessment of the Adirondack Museum's collection of oil paintings and watercolors having its inception in 1986 when Patricia C.F. Mandel agreed to be consulting curator to the project. Dr. Mandel, who had undertaken similar projects for museums elsewhere, began the first of her many sojourns in Blue Mountain Lake in the winter of 1987. Joining her from the museum were Caroline Welsh, curator of exhibitions and paintings, and Tracy Meehan, registrar, in the Adirondack Museum's first attempt at an overview of its paintings since the opening of the museum in 1957.

The results have been altogether worthwhile: the collection has been documented in word and photograph, it has been examined and conserved, and the fresh insights produced as to its strengths and weaknesses will guide staff and trustees in the future about gaps that need filling and redundancies or poor examples that may be culled. What better way to share the museum's new understanding with the public than to publish Dr. Mandel's catalogue and checklist in book form and display her choice selection of paintings in the exhibition that accompanied this book?

The majority of major American landscapists were drawn to the Adirondack wilds before 1920, so the place of art at an institution of Adirondack history was happily secured from the start and has been sealed by a succession of publications and exhibitions initiated by the museum. It was interesting to learn that the first serious acquisition to the collection took place in November of 1956, when Harold K. Hochschild, the museum's founder, purchased several watercolors by J.W. Hill and his son J.H. Hill. Subsequent gifts by Mr. Hochschild and members of the Hochschild family, who were advised by Rudolph Wunderlich in some notable instances, constitute a

very significant portion of what would become by 1990 the most complete artistic and iconographic record of the Adirondacks to be found anywhere.

The New York State Council on the Arts awarded three grants for research and photography, and the cost of this catalogue has been paid in part from the National Endowment for the Arts, for which the museum is most thankful. Personally, I wish to thank Pat Mandel and Caroline Welsh, who directed the project for four years, as well as Alice Wolf Gilborn, the editor, each of whom is, coincidentally, a graduate of Wellesley College.

In a region that dispenses with formalities, it seems appropriate that *Fair Wilderness* be dedicated to two individuals who approached Adirondack paintings not as art historians, which they were not, but as witnesses of both the reality and spell of the Adirondacks. William K. Verner was formerly curator at the museum, and Margaret Goodwin O'Brien was for years engaged in researching the Adirondack work of artists who came to this region prior to the First World War.

– Craig Gilborn
Director

Acknowledgments

The author would like to express warmest thanks to those who have generously contributed their time and knowledge to the research and organization of this catalogue and exhibition. Special thanks go to the late Peggy O'Brien whose pioneer effort to organize an inventory of artists working in the Adirondacks has provided a useful guide. The curatorial observations and research of the late William K. Verner are the backbone of the catalogue.

Thanks for their courtesy and cooperation are due the staffs of the New York Office, Archives of American Art, Smithsonian Institution, the Prints Division, New York Public Library, Frick Art Reference Library, Museum of the City of New York, National Academy of Design, New-York Historical Society and Pennsylvania Academy of Fine Arts.

Among the individuals to whom she is particularly grateful are Lynn Hochschild Boillot who aided in much of the preliminary research, Warder H. Cadbury, William Diebold, Abigail Booth Gerdts, the late Lloyd Goodrich, Donelson F. Hoopes, Edith Cole Silberstein, David Tatham, Phyllis Wiegand Tilson, Brucia Witthoft, Gloria Gilda-Deák, and museum librarian Jerold Pepper.

The catalogue and exhibition could not have become a reality without the fine mesh of teamwork and team spirit of Tracy Meehan, registrar, and Caroline M. Welsh, curator, who have been active participants in the project since its first day in February 1987.

The author is particularly grateful for the precision, grace and dedication with which editor Alice Wolf Gilborn, assistant Kathryn Benton and designer Jane Mackintosh have transformed the catalogue into a work of art.

Final appreciation must be expressed to director Craig Gilborn for having conceived of the project and overseen its progress.

– Patricia C.F. Mandel

Editors' Notes

Key to abbreviations appearing in the Introduction and Painting Entries:

AMA Adirondack Museum Artists' files
AMC Adirondack Museum Collections
AML Adirondack Museum Library
AMR Adirondack Museum Registrar's files

All dimensions are in inches.

Drawings and etchings that appear in the Entry section of this catalogue are included in the Checklist, but are not numbered.

Key to abbreviations appearing in the Checklist:

AMC Adirondack Museum Collections
AML Adirondack Museum Library
NAD National Academy of Design

The Checklist is arranged alphabetically by artist. Each listing includes the title of the work and the date, followed by medium, dimensions in inches, signature, provenance, and exhibit history, when known. The number at the end of each listing is the Adirondack Museum's accession number; the number in parenthesis is the painting number assigned by the museum; P plus number is the assigned photograph number.

Drawings and etchings that appear in the Checklist have no Checklist number.

Paintings, drawings, and etchings illustrated in the Entry section of this catalogue are indicated with a box next to the title.

The name Ausable is spelled variously throughout this volume according to artist or to map designation. Nineteenth century usage preferred the upper case S; current spelling is generally one word with the s lower case. The town Au Sable Forks appears in the vicinity of the Ausable River on contemporary maps. Since there is little agreement, the editors have used the spelling appropriate to the time a work was painted.

What is Adirondack
in Adirondack Art?

"The cluster of mountains in the neighborhood of the Upper Hudson and Ausable rivers, I propose to call the *Adirondack group*, a name by which a well known tribe of Indians [the Algonquins] who once hunted here may be commemorated," wrote Professor Ebenezer Emmons, geologist and leader of the 1837 natural history survey of the northern wilderness for the State of New York.[1] On the map, the Adirondacks are a range of mountains in northeastern New York dominated by Mount Marcy, with an elevation of 5,344 feet. But for the artists who came to paint the Adirondacks over the next century and a half, 140 of whom are represented in the collection at the Adirondack Museum, the wilderness was more than high peaked mountains. It was six million acres of primordial forest, penetrated by 2,000 lakes of sapphire brilliance; impetuous rivers and irrepressibly tumbling streams; hardwood copses fiery in autumn and shaded glades tender green in spring; broad valleys of farmland and treeless summits of rocky grandeur.

Suffusing this landscape of imagination and fact was the purity of its light, unsullied by suburban haze. This light and its effect on color is responsible for two of the archetypal images in Adirondack paintings: the shrill orange-reds of its sustained sunsets and the dark blue shadows with which the winter sun carves its crusty white snowscapes. These phenomena are especially evident in Sanford Gifford's *A Twilight in the Adirondacks*, 1864 (page no. 58), and Jonas Lie's *Men's Camp and Stables*, painted at Kamp Kill Kare in 1930 (page no. 83). The vastness of the horizon, unencumbered with the visual detritus of civilization, expands the Adirondack artist's usable color range and frees him to explore the absence of color that is white. Whiteness pervades Adirondack painting. Its misty vapors rise from Ausable Lake in Arthur Parton's *In the Adirondacks*, ca. 1866 (page no. 94),

and define the snowy mounds that entrap the sheep in Arthur Fitzwilliam Tait's *Snowed In,* 1877 (checklist no. 295).

The first persons to sketch the Adirondacks, however, were not primarily concerned with the beauties of color or light. Rather, their concerns were graphic. Theirs were the tasks of charting the Adirondack wilderness or designing military fortifications, and their mission was practical, not aesthetic. An early map such as the Englishman Richard William Seale's *A New and Accurate Map of the present War in North America,* 1757, describes the militarily strategic Hudson-Champlain corridor.[2] Other Europeans who made careful drawings in the Adirondacks, long before the region had a name, include the Swedish botanist, Peter Kalm, who visited Lake Champlain in 1749 and whose *Travels in North America,* 1770, was one of the earliest natural history studies of the area.[3]

The story of art in the Adirondacks is that of the convergence of prevailing aesthetic theory, mostly derived from Europe, with the moment of access to a new American wilderness. In 1837, on a survey of landholdings belonging to State Senator and iron ore entrepreneur Archi-bald McIntyre, artist Charles C. Ingham accompanied geologist William C. Redfield to document the Great Adirondack Pass, also known as Indian Pass. The result was Ingham's majestic painting, *The Great Adirondack Pass, Painted on the Spot,* 1837 (page no. 72). The joining of artistic and business forces was not uncommon in the first half of the 1800s. A similar instance occurred in 1839 when Thomas Cole was commissioned by Samuel Ruggles, the Genesee Valley Canal Commissioner, to paint near Portage Falls on the Genesee River.[4] As with portraiture, landscape painting of that time served the function of conveying highly specific information. Although photography had not yet been invented in the 1830s, lithography had been, and it was possible, as in the case of Ingham's painting, to print copies after the original and use them in published reports and surveys.[5]

In 1836, Thomas Cole described the vast northern and eastern tract of the American continent, which included the Catskills, the White Mountains and the Adirondacks, as a land "whose gloom was peopled by savage beasts, and scarcely less savage men...." For the English-born Cole, its most distinctive characteristic

was its wildness.[6] "Distinctive," said Cole, "because in civilized Europe the primitive features of scenery have long since been destroyed or modified – the extensive forests that once over-shadowed a great part of it have been felled – rugged mountains have been smoothed, and impetuous rivers turned from their courses...the once tangled wood is now a grassy lawn...."[7]

Cole may well have viewed Ingham's *The Great Adirondack Pass* at the National Academy of Design of which he was a member. He visited the site of the painting almost ten years later, in 1846, when he made sketches of that "gorge of wonderful sublimity and wilderness."[8] Cole did not live to translate these sketches into

paint, but his *Schroon Lake*, ca. 1846 (page no. 45), completed in his Catskill studio and based on sketches made during an 1837 visit to Schroon Lake, may have revived his enthusiasm for the Adirondacks and inspired him to return. The mood of *Schroon Lake* differs from Cole's description of the "ragged, rocky pinnacles...robed with savage grandeur" he experienced on his trip to Indian Pass. Rather, it reflects his appreciation for light and color presented in the less dramatic, more picturesque manner he had absorbed during his years in Italy in the early 1830s.

Cole's companion on his visit to Schroon Lake in 1837 was Asher B. Durand who, with Cole, was credited with founding the "Hudson River School," an appellation applied long after Cole's death and a catch-all phrase referring to native American landscape painting.[9] In 1855, in a recently established American art journal, *The Crayon*, co-edited by his son John, Durand published his "Letters on Landscape Painting," addressed to the neophyte American landscape painter. Durand encouraged the beginning artist to "Take pencil and paper, not the palette and brushes, and draw with scrupulous fidelity the outline or contour of such objects as you shall select, and, so far as your

Fig. 1. **William James Stillman (1828 - 1901),** *The Philosopher's Camp,* **1858, oil on canvas, 20 x 30. Courtesy collection Concord Free Public Library, Concord, Massachusetts.**

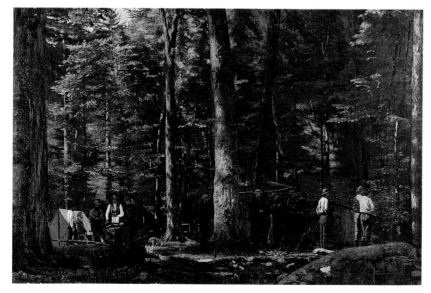

judgment goes, choose the most beautiful or characteristic of its kind."[10] Durand's untitled Boulder and Trees, ca. 1858 (page no. 52), is a parallel in paint to his teachings. His emphasis, like that of the early military map-makers and surveyors, was on line, not color. Like many American artists, Durand's painting career started as that of an engraver, in his case, of banknotes. Line and accuracy were more important than color and personal expression.

The other editor of *The Crayon* was William James Stillman, a landscape painter with a great fondness for the Adirondacks and for the then popular aesthetic theory called Pre-Raphaelitism. Stillman's Adirondack enthusiasm led to the founding in 1857 of the Camp of the Adirondac Club, also known as The Philosopher's Camp, on Follansbee Pond in the Saranac area. The 22,500 acre site was purchased for $600 at Stillman's instigation by several members of Boston's Saturday Club, which included Louis Agassiz, Ralph Waldo Emerson and James Russell Lowell.[11] Stillman painted *The Philosopher's Camp in the Adirondacks,* 1858 (fig.1), showing the participants in action. At the viewer's right, guides are watching target shooting; at the left, Professor

Agassiz stands at a tree stump dissecting a fish before observant campers, and, in the center, philosopher Emerson stands alone and contemplative.

In *The Early Days of the Saturday Club, 1855-1870,* Edward Waldo Emerson quotes Stillman's descriptions of camp life as centering on the scientist Agassiz, "who taught us of the leaves of the pine, and of the vicissitudes of the Laurentian Range, in one of whose hollows we lay...drew new facts from the lake... [dissected] the fish, the deer, the mice (for which he had brought his own traps)...we were his assistants and pupils."[12] Here, scientist and artist collaborate in inventorying the world around them. *The Philosopher's Camp* is a testament to Stillman's embrace of the English theory of Pre-Raphaelitism, whose most eloquent exponent, John Ruskin, was published in *The Crayon.*

Stillman had met Ruskin in London in 1850 and was impressed with his linking of religion and art, "the two being then to me almost identical and to him closely related." Furthermore, the "American tendency toward nature worship [was reinforced by Ruskin's] linking art criticism with the appreciation of nature" and matched Stillman's own delight, for instance, in

the worshipful specificity with which he could describe nature in paint and Agassiz could explain it.[13] Pre-Raphaelitism stressed the importance of "the inexhaustible perfection of nature's details" and of "particular truths over general ones" as well as insisting upon "detail and finish" in painting.[14] Besides Ruskin, its "Brotherhood" included Daniel Gabriel Rossetti, William Holman Hunt, Sir John Everett Millais and William Davis, a close friend of Arthur Fitzwilliam Tait's from their English days.[15] Theirs was a call for a super-realism of the sort they felt existed in the Italian *Quattrocento* before the time of Raphael. They aspired to an art pure in intention and expression with which the monkish term "Brotherhood" could be properly associated.

Although he actively supported *The Crayon,* Asher B. Durand was not a Pre-Raphaelite. He shared the movement's Wordsworthian love of nature, but his teachings, embodied in his "Letters on Landscape Painting," presented American artists with a more pliable, less codified interpretation of it. Among those artists in the museum's collection who were part of the Pre-Raphaelite movement were father and son John William Hill (untitled: The Raccoon, ca. 1842, page

no. 67) and John Henry Hill (*The Island Pines, Lake George,* 1871, page no. 66), and, most dedicated of all, William Trost Richards (*In the Adirondacks,* 1857, page no. 98). One art reviewer who disliked the movement's pompous purism commented acidly in an Albany newspaper, saying that if the Hills "had any consideration for the public they would not exibit [*sic*] such utterly worthless paintings as these."[16] The Hills' bad press reflects a decline of sympathy after 1865 among American art critics for the British inspired Pre-Raphaelites, due in part, perhaps, to British support for the South during the Civil War.[17]

That war involved several Adirondack artists. Jervis McEntee, Roswell Shurtleff, Sanford Gifford and Horace Robbins all served in the Union Army. Most lived in New York City in the Studio Building at 15 West Tenth Street and summered or visited in Keene Valley which became the region's first artists' colony just after the Civil War. Robbins, newly returned from his posting at Harper's Ferry, endowed the valley lying under the protective shoulder of Wolf Jaw Mountain in his 1863 oil (page no. 99) with a special quietude and order. Here was the artist's postwar vision of the

Adirondacks, a safe harbor, a place of peace amidst the chaos of the larger world. The Keene Valley artists' paintings were private, rather than the awesome documentary views of an earlier age, such as Ingham's.

The same desire for the peaceful image manifested itself in the "quietistic paintings we now call 'luminist'," epitomized in the work of John Frederick Kensett.[18] His *Lake George,* 1856 (page no. 78), creates an atmospheric translucence out of the careful observation and integration of earth, air, water and light. This aesthetic is particularly suited to water images and is present in other Lake George paintings in the collection by N.A. Moore (page no. 90) and Alfred T. Bricher (page no. 37). The tranquility evoked by Kensett's image conveys a world in which God and Nature are one. Luminism "transforms atmospheric 'effect' from active painterly bravura into a pure and constant light...[in the luminist painting both artist and viewer are] absorbed in contemplation of a world without movement...a wordless dialogue with nature, which quickly becomes the monologue of transcendental unity...."[19]

Emerson, of the Philosopher's Camp on Follansbee Pond, wrote that "the omnipotent agent is Nature; all human acts are satellites to her orb. Nature is the representative of the universal mind, and the law becomes this, – that Art must be a complement to nature, strictly subsidiary."[20] The Adirondacks became the

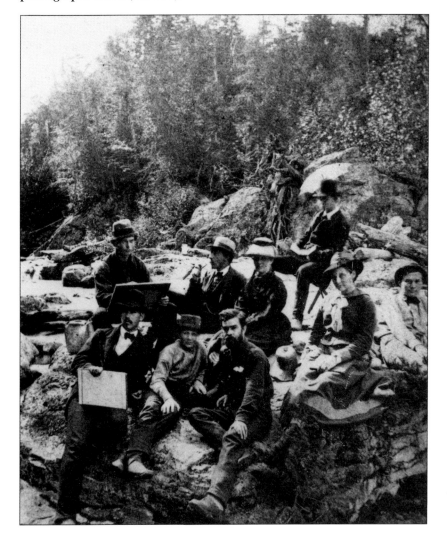

Fig. 2. **Unidentified photographer, artists sketching outdoors, Keene Valley, October 5, 1874, photograph. AMC (P47500).**

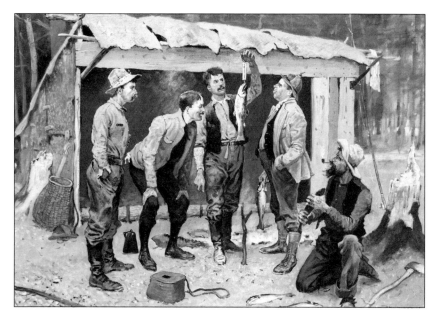

Fig. 3. **Frederic Sackrider Remington (1861-1909),** *Spring Trout Fishing in the Adirondacks - An Odious Comparison of Weights,* **1890, monochrome oil on canvas, 22 x 30. AMC, checklist no. 220.**

theatre in which both artists and philosophers, through their works, exercised their belief that nature could direct mankind in healing its wounds. An 1874 photograph of Keene Valley artists, including Roswell Shurtleff, Kruseman van Elten, Winslow Homer, J. Francis Murphy and Calvin Rae Smith on a sketching excursion (possibly to Hull's Falls) conveys the camaraderie and satisfaction of the effort of transcribing the wonders of nature (fig. 2). Theirs is a world of civility, of gentility (all but one sport hats) and of apparent peace.

Not all post Civil War artists who worked in the Adirondacks were concerned with creating a private, contemplative view of nature. Some, like Frederic Remington, were more interested in the sport the untouched Adirondack wilderness could provide. Remington was born in Canton, New York, and camped, canoed, fished and sketched at Cranberry Lake. His keen knowledge of the realities of a fishing expedition smacks of true-to-life experience in his drawing for an 1890 *Harper's Weekly* illustration, *Spring Trout Fishing in the Adirondacks - An Odious Comparison of Weights* (fig. 3). As a graphic artist, Remington capitalized on a new Adirondack public who came to the mountains and lakes for pleasure, rather than for meditation, an audience responding, in part, to the 1869 publication of the Reverend William H.H. Murray's *Adventures in the Wilderness; or Camp-Life in the Adirondacks.*

Murray's book extolled the health and sporting benefits of time spent in the Adirondacks and led to an "opening up" of the wilderness to the vacationer.[21] These visitors were tourists rather than artists, philosophers or explorers. They were aided in their visit by a practical guidebook, *The Adirondacks: Illustrated,* written by Adirondack artist and photographer, Seneca Ray Stoddard (page no. 112). His book, published annually from

1873 until 1914, inventoried the elaborate hotel resorts that dotted the wilderness during the last decades of the 1800s. One palatial watering spot, the Hotel Champlain, towers in the background above elegant Edwardian couples in W.T. Smedley's preparatory water-color for an 1890 *Harper's Weekly* illustration, *At Bluff Point, Lake Champlain* (page no. 106). Stoddard described the view from the resort as "commanding," overlooking a valley "where the trains of the D.&H. flash like gleaming shuttle through the vari-tinted web of cultivated fields and cross-line country roads."[22] The wilderness was now being enjoyed by those who travelled by railroad and steamboat and who wished to experience it at a comfortable distance. These new visitors had a distinct effect on Adirondack art: they bought and commissioned paintings.

A recipient of many of these commissions was Levi Wells Prentice, born in Harrisburgh, Lewis County, New York, who, in his own personal idiom throughout the 1870s and 1880s, concentrated on such lake scenes as Smith's, Blue Mountain and Raquette (page no. 95). Prentice's works, many of which were executed at the direction of Adirondack enthusiasts in the Syracuse area, were in a sense a response to the new tourists, but all are marked with a personal artistic vision. His interpretation of pictorial reality does not refer to traditional prototypes, and, as a result, he provides fresh Adirondack images.

Another artist who benefited from "Murray's Rush" was Winslow Homer, who had been active in the Keene Valley area from the 1870s, as we know from his monumental oil, *The Two Guides*, ca. 1875 (fig. 4), which depicts "Old Mountain" Phelps and Monroe Holt.[23] Homer, an outdoorsman, joined the North Woods Club in the late 1880s, where he enjoyed hunting, fishing and sketching such watercolors as *Casting, "A Rise"*,

Fig. 4. Winslow Homer (1836 - 1910), *The Two Guides,* ca. 1875, oil on canvas, 24 x 40. Courtesy collection Sterling and Francine Clark Art Institute, Williamstown, Massachusetts.

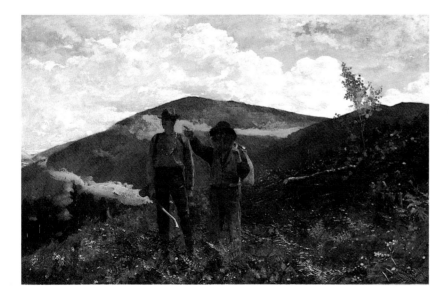

Fig. 5. Arthur Fitzwilliam Tait, *An Anxious Moment*, 1880, oil on canvas, 20 x 30. AMC, checklist no. 294.

1889 (page no. 68). These were commissioned by New York art dealer, Gustave Reichard, for wealthy New Yorkers, such as William T. Evans, who shared Homer's enthusiasm for sports, the Adirondacks and art. The Register of A.F. Tait, the great Adirondack animal and sporting painter, regularly records private commissions, including deer, ducks, kittens and cattle, from the late 1850s until his death in 1905.[24] One of the finest examples in the museum's collection is *An Anxious Moment*, 1880, ordered by a Mr. Chas. R. Flint who exhibited it at the National Academy of Design the next year (fig. 5).

Many tourists at the turn-of-the century fancied themselves amateur artists. Capitalizing on their aspirations was Miles

Tyler Merwin, the proprietor of Merwin's Blue Mountain House, now the site of the Adirondack Museum. Merwin's advertisements for the House – which catered to full-time summer residents – included mention of available instruction in painting, given by Gustave Wiegand, a National Academician who specialized in landscape painting. Wiegand built a studio with skylight on the hotel property and painted and taught at Blue Mountain Lake until 1914, although his first introduction to the Adirondacks had been to Keene Valley at the invitation of Roswell Shurtleff. In a photograph taken around 1913, Wiegand posed with his wife, daughter, easel and palette in front of the studio (fig. 6). The painting on the easel depicts Blue Mountain. It, like the museum's *Blue Mountain*, ca. 1914 (page no. 122), reveals a loose painting style with emphasis on light, color and texture, while remaining objectively true to the subject. Here again, European aesthetic theory (Wiegand was born and studied in Germany) molds the artist's view of the Adirondacks, for we see in this work the painterly brushstrokes of impressionism, yoked to the task of describing the Adirondack winter.

In 1930, the Norwegian artist Jonas Lie painted a series of architectural and scenic views at Kamp Kill Kare on Lake Kora, and chose to execute the task, for which he had been commissioned by the camp's owner, Francis P. Garvan, during the winter whiteness of February (*Men's Camp and Stables*, 1930, page no. 83). Both he and Wiegand studied with the American master, William Merritt Chase, who had himself been trained abroad. Theirs is a painting style in which color, rather than line, prevails. In their awareness of the many hues of whiteness and their analysis of the harsh blue shadows cast by the winter light and its darkening effect on the mountains' ubiquitous evergreens, they signal a latter-day extension of earlier Adirondack artists' exploration of reality.

With the advent of World War I, the Depression and the subsequent world crises that led to World War II, summer visitors and facilities which catered to them declined in the Adirondacks. The route to the wilderness was too expensive to retain. Photography replaced painting as the artistic expression of the visually sensitive visitor, now a day tripper rather than a summer resident. Painters of this era did not go to the Adirondacks – they did not paint nature. Rather, they were mesmerized by the vitality of city life, the sophistication of New York and Paris, by fauvism, cubism, futurism, dadaism, automatism, surrealism.

On the other hand, professional nature photographer Eliot Porter did go. His color photos repeat the earlier nineteenth century painters' absorption in recording with precision the poetic beauty of the Adirondack scene, even unto its minutiae. His work, illustrated in *Forever Wild: The*

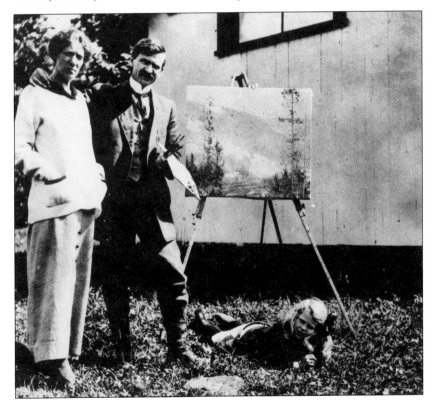

Fig. 6. **Unidentified photographer, Gustave Wiegand with his wife Anna and daughter Phyllis in front of his studio located near Merwin's Blue Mountain House, Blue Mountain Lake, New York. AMC (P23368).**

Adirondacks, is virtually a bible of the earlier Pre-Raphaelite concentration on lichen encrusted rocks, sedgy flowed lands, the forest floor and the winter-white woodlands.[25]

Painters who did come during these years, through the postwar era, were full time residents, like Harold Weston on Upper Ausable Lake, Amy Jones, with her husband at the Trudeau Sanitarium in Saranac Lake, and Rockwell Kent on his farm in Au Sable Forks. All were realists, although the careful drawing of the mountains' outline that lies beneath Weston's high-toned colors and thickly applied paint in *Spring Sunlight–St. Huberts,* 1922 (page no. 119), is shrouded by surface abstraction. Jones' uniqueness lies in her application of social realism to her figural studies such as *St. Regis Reservation,* 1937 (page no. 76), which provides a rare insight into people at work, rather than play, in the Adirondacks. In his landscape *Mountain Road,* 1960 (page no. 80), Kent focuses on his mountain farm with such intensity that his simplification of actual landscape elements transforms the subject into a study of the relationship of abstract planar forms and forces the viewer to focus on the painting itself rather than what it represents. Modernism,

with its emphasis on the picture plane, has determined the way in which nature is depicted. Once again, we see distinctly Adirondack images expressed in the vocabulary of the dominant art movement of the day.

There is little abstract Adirondack art. John Marin's *Adarondack* [sic] *Lake,* 1911 (page no. 85), is one of the few examples in the museum's collection. This delicate watercolor displays an American artist's incorporation of the newly founded European tenets of cubism, which aimed to eliminate the illusion of three dimensional space by reducing objects to their component surface planes which are then arranged by the artist on the canvas. Braque and Picasso were the inventors of the cubistic perception of space that violated all preexisting art theory. They did so in Paris in 1907, and within a few years artists from foreign lands, like Marin, came to partake in their vision. They instinctively turned away from the landscape subjects with which they had begun and moved to the representation of man-made objects, such as wine bottles and musical instruments, arranged in still life compositions. This development suggests the inappropriateness of a painting style that

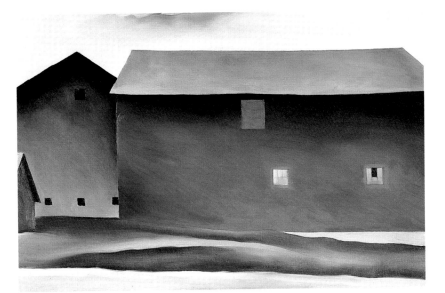

Fig. 7. Georgia O'Keeffe (1887 - 1986), *Lake George Barns,* 1926, oil on canvas, 21 x 32. Courtesy collection Walker Art Center, Minneapolis, Minnesota. Gift of the T.B. Walker Foundation, 1954.

essentially abstracted nature out of recognition for artists whose chief call to the Adirondacks was the celebration and transcription of its majestic natural wilderness.

The small number of abstract paintings in the museum's collection is not solely due to this opposition of style to subject matter. The museum, opened in 1957, was conceived by its founder, Harold K. Hochschild, as a regional museum devoted to the social and material history of the Adirondacks. It is not primarily an art museum. Furthermore, its major art donors, like the majority of the Adirondack artists, have been more receptive to realism than modernism over the years. Though its founding was during the hey-

dey of American abstract expressionism, that movement's forceful personalizing of natural images even beyond recognition did little to inspire the museum to acquire its art.

Georgia O'Keeffe and David Smith are two significant Adirondack artists – associated with modernism – whose work is absent from the museum's collection. O'Keeffe spent time in Lake George in the 1920s before returning to the West where she had been born. She was the second wife of Alfred Stieglitz, the photographer whose "291" New York gallery was the nexus of American modernism. It was there that Marin exhibited the museum's watercolor in 1913 (page no. 85). Although the Lake George property belonged to Stieglitz, the appreciation of it was O'Keeffe's. Stieglitz, like most artists of the day, was preoccupied with the energy of the city – not nature. O'Keeffe's *Lake George Barns,* 1926 (fig. 7), is composed of simple color planes and is based on realistically observed detail, despite its overlay of simplified abstraction. It is kin to the work of Kent and Weston. Its architectural subject matter directs our attention to the scarcity of buildings in Adirondack painting, as indeed in the Adirondack landscape itself. The chief exceptions in the museum's

collection are Jonas Lie's *Men's Camp and Stables,* 1930 (page no. 83), the brilliantly colored Ab [Albert] Thompson's Cabin on Silver Lake, 1884 (untitled, page no. 96), by Frederic Remington, and John W. Ehninger's *Mission of the Good Shepherd, St. Hubert's Island, Raquette Lake,* 1881 (page no. 54), even more unusual because its architectural subject is a religious edifice.

David Smith lived and worked in his studio home in Bolton Landing on Lake George for 24 years. His *Hudson River Landscape,* 1951 (fig. 8), is a free form abstract sculpture stretching across a horizontal plane for just over six feet. It is literally a drawing in steel generated from Smith's off-hand sketching on a train ride down the Hudson; its forms are pictorial, dealing more with line than mass, and are suggestive of natural forms such as mountains, clouds and water intermingled with unnatural ones,

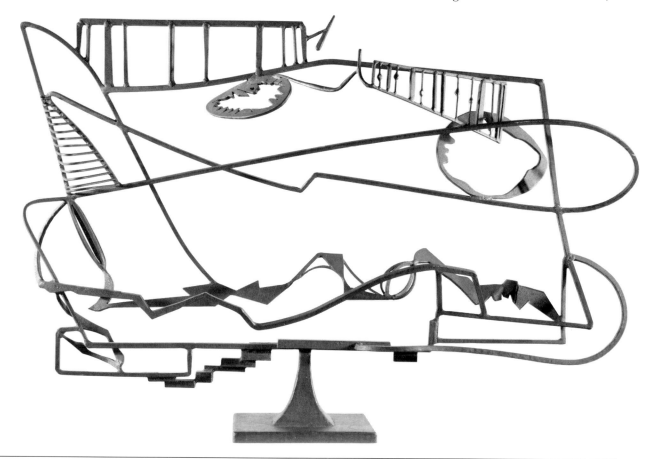

necessary to a river's life, such as bridges. His sculpture is itself an arbitrarily fixed arrangement of the transitory as well as permanent elements of nature.

Since the early 1970s, there has been a renewal of interest in the Adirondacks by such artists as Don Wynn who have made the region their permanent home. Like the majority of earlier Adirondack painters, he is a realist. His *Campfire,* 1975 (page no. 126), introduces a new subject matter into Adirondack art, the figure study. Although his painting, like the earlier camping scenes of Arthur Fitzwilliam Tait, e.g. *A Good Time Coming,* 1862 (checklist no. 296), records a specific event in time, the size and Caravaggiesque lighting of his weary girl camper denote a change in the artist's focus. The figure is more important than the landscape. This marks a real departure in Adirondack art.

Although the human form has been the favorite subject of the artist since pre-classical Greece, it has been noticeably absent in Adirondack art. Also absent, or at least very rare, has been portraiture. An arresting likeness of an Adirondack sitter is Charles C. Ingham's *Portrait of David Henderson,* n.d. (fig. 9). Henderson was Archibald McIntyre's son-

in-law, whose 1826 exploration through Indian Pass and discovery of "the most extraordinary bed of Iron Ore"[26] resulted in McIntyre's acquisition of the 100,000 acre tract in Essex County which produced the geological surveys of 1836 and 1837. Ingham, whose presence on the 1837 survey led to his painting *The Great Adirondack Pass,* was primarily a portrait painter. From his day until Wynn's, with the distinguished exception of Winslow Homer (see *The Two Guides,* 1876, fig. 4), most Adirondack artists have been landscape painters, and the inclusion of figures in their work has been essentially anecdotal.

Wynn's *Casey Mountain,* 1973 (checklist no. 372), makes it clear that his interest in the human figure does not preclude an involvement in landscape. This watercolor reiterates the specificity found in Adirondack art. It is worthy of note that one of the museum's most recent acquisitions of work by a contemporary artist, Allen Blagden, is also a watercolor. Blagden, who has spent much time in the Adirondacks with his family, painted *September Snow – Loon,* ca. 1986 (page no. 32), as part of a series of large watercolors of Adirondack scenes. The precision with which he notes the variation

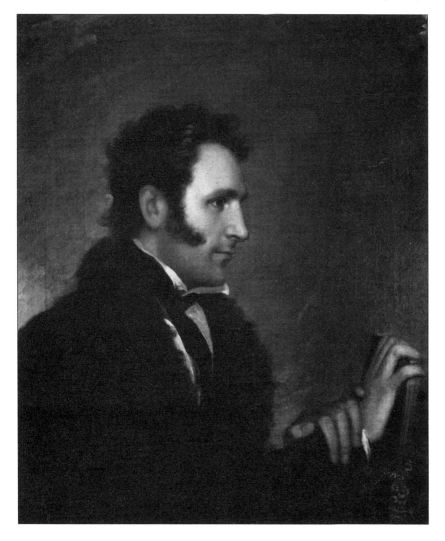

Fig. 9. **Charles Cromwell Ingham (1796 - 1863),** *Portrait of David Henderson,* **n.d., oil on canvas, 30 x 25. Courtesy collection Museum of the City of New York, New York.**

in the loon's black feathers mottled with white and the way it floats, almost motionless, across the dark water, marks him as an Adirondack artist in the Pre-Raphaelite tradition of John William Hill's watercolor of the raccoon. That both these contemporary artists chose the watercolor medium, so sympathetic to recording what is seen with intimacy and immediacy, suggests a return to close-up, true-to-nature Adirondack views, a return to the precise observation of flora, fauna and geology that a 19th century artist like James D. Smillie exhibited in his watercolor, *Top of Giant's Leap, Adirondacks,* 1869 (page no. 109).

The principal distinction between paintings of the Adirondacks, aside from subject (in the Adirondacks, lake scenes and angular peaks; in the White Mountains, serene silhouettes; and in numerous Catskill paintings, the broad Hudson), and other mountain areas of the northeastern United States lies in the timing of their execution. It was not until the mid-1800s that artists, other than Cole and Ingham, arrived in the Adirondacks. By 1850, Thomas Cole, Asher B. Durand, Henry Inman, William James Bennett, John William Hill, Robert Havell, Jasper Francis Cropsey, Frederic Edwin Church, Sanford Robinson Gifford and John Frederick Kensett had all exhibited Catskill paintings at the National Academy of Design. Thomas Cole was in the White Mountains in 1828, and Durand, Alvan Fisher, Russell Smith and Kensett

painted there before mid-century.

The Catskills and the White Mountains were more accessible to the artistic centers of New York, Albany and Boston. The relatively late arrival of artists in the Adirondacks accounts for the different aesthetic in their transcription of this landscape. Earlier visitors to the Catskills and the White Mountains perceived those mountains "in terms of a restricted set of predetermined images," many of them dependent on European neo-classical compositions.[27] By the time they got to the Adirondacks, artists were free of the Claudian pictorial tradition which dominated European landscape painting in the 1700s and early 1800s and retained a firm hold on American painters until the middle of the 19th century.

With this freedom, artists could look at the Adirondacks with a realistic eye and they did. Whether it was according to the strict "truth to nature" code of the Pre-Raphaelites, the more relaxed attitude toward sketching *en plein air* of the native Hudson River School, or the contemporary taste for neo-realism, Adirondack painting rarely turned toward abstraction.

From Ingham to Blagden, each of the 140 artists repre-sented in the museum's collection responded to the Adirondacks in the way that spoke to his or her particular sensibility. The underlying attractions of the region, the shape of the landscape, the grandeur of the vistas, the purity of the light and, above all, the wilderness itself were constant. The artists' sensibilities, and therefore their responses, evolved as life and culture outside the Adirondacks evolved. For 150 years artists have found sustenance for their changing ideas and aesthetic in this magnificent, unchanging landscape.

The initial animus for artistic change was a fascination with the wilderness, to *know* it first in a scientific, explorative way, then, as exploration made the terrain less "savage" and more accessible, to *use* it for spiritual solace and self-expression. Later, as the world outside the wilderness became increasingly unlike it, artists became less preoccupied with wild nature as a spiritual resource and used it in a purely visual sense as an ideal studio, bathed in crisp, clear light and, partially due to that light, kaleidoscopic in color not found beyond the region.

The collection of paintings at the Adirondack Museum is both unique and representative. Of the 73 paintings described in detail in this vol-

ume, many are by well-known artists such as Homer, Tait and Kensett; some are by artists who deserve to be better known, such as Lillian Crittenden, Nancy Bowditch and Robert Decker; still others are by artists who are generally unknown except for the paintings in this collection. As such, it provides us with material nowhere else available. No other museum has such a group of paintings organized for this single purpose; that is, the pictorial documentation in the fine arts of the Adirondack wilderness.

Thomas Cole made his first trip to the Adirondacks in October 1835, three years after his return from Italy and six years after his departure for Europe in 1829. At the time of his trip abroad, Cole's dear friend, William Cullen Bryant, wrote a poem urging the artist not to forget the wonder of the American wilderness once he was immersed in the long-established civilization of Europe. Bryant's last line read: "But keep that earlier, wilder image bright."[28]

On October 7, 1835, just after visiting Schroon Lake, Cole wrote a letter to his patron Luman Reed, who had commissioned the monumental *Voyage of Life* series, that suggested he had taken Bryant's exhortation to heart.

Cole had found "two summits in particular [that] attracted [his] attention: one of a serrated outline, and the other like a lofty pyramid.... They stood in the midst of the wilderness like peaks of sapphire."[29] On his next trip to the lake in June 1837, in Durand's company, Cole sketched the composition that was later to become *Schroon Lake,* ca. 1846 (page no. 45). He also composed these lines:

> An awful privilege it is
> to wear a spirit's form,
> And solitary live for aye on
> this vast mountain peak;
> To watch, afar beneath my feet,
> the darkly-heaving storm,
> And see its cloudy billows o'er
> the craggy ramparts break;[30]

In the 1846 *Schroon Lake,* the peaks of sapphire are somewhat subdued. The years, the artist's maturity, and the prevailing aesthetic have softened his awed and sublime language into a more picturesque rendering. Still, it is clearly a rendering of "that earlier, wilder image," the source of inspiration for all those artists who, each in his own way, transformed the raw and commanding Adirondack landscape into a fair wilderness.

– Patricia C.F. Mandel

1. Ebenezer Emmons, New York State Natural History Survey Report, 1838. Quoted in Frank Graham, Jr., *The Adirondack Park: A Political History* (New York: Alfred A. Knopf, 1978), p. 12.

2. Paul G. Bourcier, *History In The Mapping, Four Centuries of Adirondack Cartography* (Blue Mtn. Lake, N.Y.: The Adirondack Museum, 1985), pp. 6-7, ill.

3. Joseph Kastner, *A Species of Eternity* (New York: Alfred A. Knopf, 1977), pp. 35-39.

4. Patricia C. F. Mandel, *Selection VII: American Paintings from the Museum's Collection, c.1800-1930* (Providence, R.I.: Museum of Art, Rhode Island School of Design, 1977), pp. 26-30.

5. See Bufford's lithograph, "View of the Indian Pass" based on Ingham's oil, New York State Assembly, *Document 200*,1838, relative to the Geological Survey of the State (Albany, 1838).

6. Thomas Cole, "Essay on American Scenery," *The American Monthly Magazine,* New Series, vol. I (January 1836), pp. 1-12. Reprinted by John McCoubrey, ed., *American Art 1700-1960 Sources and Documents* (Englewood Cliffs, N.J.: Prentice-Hall, 1965), pp. 101 ff.

7. McCoubrey, p. 102.

8. Louis L. Noble, *The Life and Works of Thomas Cole,* ed. Elliot Vesell (Cambridge: Harvard University Press, Belknap Press, 1964), p. 280.

9. Anthony F. Janson, "Worthington Whittredge and The Crisis of Hudson River Painting," *Source Notes in the History of Art,* vol. VIII, no. 1 (Fall 1988), p. 32.

10. Asher B. Durand, "Letters on Landscape Painting," *The Crayon,* vol. I (1855), pp. 34-35, 97-98; repr., McCoubrey, p. 110.

11. Barbara Novak, *Nature and Culture: American Landscape and Painting 1825-1875* (New York: Oxford University Press, 1980), p. 65.

12. Edward Waldo Emerson, *The Early Years of the Saturday Club, 1855-1870* (Boston and New York: Houghton Mifflin Co., 1918), pp. 131, 171-72.

13. William J. Stillman, *The Autobiography of a Journalist* (Boston, 1901), vol. I, p. 129. Quoted in Roger Stein, *John Ruskin and Aesthetic Thought in America 1840-1900* (Cambridge: Harvard University Press, 1967), p. 104.

14. John Ruskin, *Modern Painters* (New York: John Wiley & Son, 1868), vol. III, p. 622. Quoted in Allen Staley, *The Pre-Raphaelite Landscape* (London: Oxford University Press, 1973), p. 9.

15. Staley, p. 139.

16. John Henry Hill, Diary at "Artist's Retreat," May 21,1871, AML.

17. William H. Gerdts, "Through a Glass Brightly: The American Pre-Raphaelites and Their Still Life and Nature Studies" in Linda S. Ferber and William H. Gerdts, *The New Path: Ruskin and The American Pre-Raphaelites* (Brooklyn, N.Y.: Brooklyn Museum, 1985), p. 61.

18. Novak, p. 28.

19. Ibid.

20. Ralph Waldo Emerson, "Thoughts on Art," *The Dial,* vol. I, no. 3 (January 1841), pp. 367-378; repr., McCoubrey, pp. 72 ff.

21. William H.H. Murray, *Adventures in the Wilderness; or, Camp Life in the Adirondacks,* preface by William K. Verner with introduction and notes by Warder H. Cadbury (Blue Mtn. Lake, N.Y.: The Adirondack Museum and Syracuse University Press, Syracuse, 1970), Introduction.

22. Seneca Ray Stoddard, *The Adirondacks Illustrated* (Glens Falls, N.Y.: Privately printed, 1894), p. 53.

23. David Tatham, "The Two Guides: Winslow Homer at Keene Valley, Adirondacks," *The American Art Journal,* vol. XX, no. 2 (1988), p. 21.

24. Warder H. Cadbury and Henry F. Marsh, *Arthur Fitzwilliam Tait: Artist in the Adirondacks* (Newark, Del.: The American Art Journal/University of Delaware Press, 1986).

25. Eliot Porter, *Forever Wild: The Adirondacks,* photographs by Eliot Porter, notes and captions by William Chapman White (Blue Mtn. Lake, N.Y.: The Adirondack Museum and Harper and Row, New York, 1966).

26. David Henderson to Archibald McIntyre, Elba, Essex Co., October 14, 1826. Reprinted in Arthur H. Masten, *The Story of Adirondac* with introduction and notes by William K. Verner (Blue Mtn. Lake, N.Y.: The Adirondack Museum and Syracuse University Press, Syracuse, 1968), p. 18.

27. Robert L. McGrath, "The Real and The Ideal: Popular Images of the White Mountains," *The White Mountains: Place and Perceptions* (Hanover, N.H.: University Press of New England, 1980), p. 64.

28. William Cullen Bryant, "To Cole, the Painter, Departing for Europe," 1829; repr., McCoubrey, p. 96. See also James Thomas Flexner, *That Wilder Image: The Painting of America's Native School from Thomas Cole to Winslow Homer* (New York: Bonanza Books, 1957).

29. Noble, p. 152.

30. From "Song of a Spirit" in Noble, p. 179.

William Bliss Baker

(1859 - 1886)

A Pleasant Day at Lake George, ca. 1883

Oil on canvas 20 x 36
Checklist no. 4

A Pleasant Day at Lake George conveys the calm elegance of a summer afternoon. It blends the picturesque beauty of the Lake George hills extending out to water, forming private inlets and a resting place on the rocks at the left where ladies and gentlemen of high fashion gather. The ladies could well have been transposed from Manet's portraits of Paris in the *dernier cri* of the 1880s. Unlike William Smedley's later presentation of well-dressed women enjoying the luxury of a summer resort, Baker's figures are not fashion illustrations. Rather, their grace in dress and movement form a natural continuum with the calm waters and the hazy, dream-like atmosphere of the lake.

Baker's artistic proficiency is evident in the fact that he exhibited this painting at the National Academy of Design in New York City when he was only twenty-four. Unfortunately, the real proof of his talent and popularity came after his death when such great collectors as Benjamin Altman vied to buy his pictures and made notes in their auction catalogues, saying: "a grand picture - a true masterpiece." Baker's tragic death was caused by a fall on the ice while skating. He fractured the lower vertebrae of his spine and suffered excruciating pain.[1]

1. *The Works of William Bliss Baker, Dec'd, Finished Pictures and Studies* (New York: American Art Association, Ortgies and Co., March 11-17, 1887). This catalogue contains quotations from *Harper's Weekly* (December 4, 1886), about the nature of young Baker's death and notations in red ink about *Morning after the Snow* purchased by Altman for the then extremely substantial price of $5,000. No Lake George paintings were included in the sale.

Allen Blagden

(1938 -)

**September Snow - Loon,
ca. 1986**

Watercolor 25 x 40
Checklist no. 6

September Snow - Loon demonstrates Blagden's great skill with two varying aspects of the watercolor medium. On the one hand, his depiction of the loon with its geometric patterning of black and white cross bands is so precise that a glance at *Birds of North America* permits us to identify it as a Common Loon in its summer "dress." On the other, his handling of the early fall snow nestled into gray rock crevices and reflected in the gray-black lake on which the loon rests shows his facility in treating color contrast in a generalized way. The entire surface of the watercolor is covered with nuances of white and black which envelop the viewer as well as the loon.

Blagden summered on Upper Saranac Lake as a boy and spent several more recent years at Kamp Kill Kare, near Raquette Lake, where he may have caught sight of the September snow and loon.[1]

1. *Wilderness Solitude: A Collection of New Paintings by Allen Blagden* (Chicago: Mongerson-Wunderlich Gallery, 1988), cat. no. 9, p. i, ill. The exhibition was also shown at the Adirondack Museum in 1988.

Ralph Albert Blakelock

(1847 - 1919)

Untitled: The Log Cabin, ca. 1890

Oil on board 12 x 10
Checklist no. 7

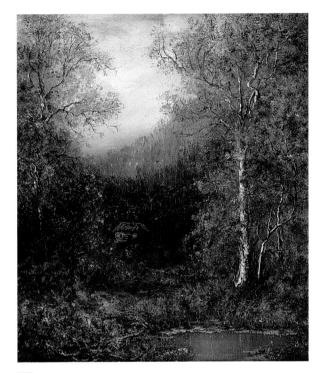

The atmospheric effect of Blakelock's painting of a log cabin produces such a dense overlay of yellow and red foliage that we search to locate the cabin nestled in the center of the painting. It provides a calm focal point in the turmoil of linear excitement created by the wiry tendrils of trees and leaves. Blakelock's "signature" use of scratched lines on the surface of the canvas contributes to the oil's evocation of a spatial enclosure.

Blakelock, who was born in New York City, has been classified as an artist of "poetic landscape" together with Alexander Wyant and Homer Dodge Martin, both represented in the museum's collection.[1] He was particularly fascinated with the American West where he travelled in 1869. His scenes depicted frontier wilderness and Indian life.[2] They are painted with thick overlays of impasto suggesting an emotional intensity that led one author to call him "haunted by the forest" as can readily be seen in the mysterious, ghost-like

forms of the trees hovering over the log cabin in the museum's painting.[3] Blakelock's highly subjective view of nature suggests a disturbed personality which was finally evidenced in his having to be institutionalized in the Middletown State Hospital for the Insane, Middletown, New York, from 1899 until his death.[4] There, he painted small landscapes, the size of paper money, and, at least once, gave three of them to a visitor as money.[5] Sadly, his insanity led to substantial notoriety and his earlier paintings began to bring awards.[6] His has been called "the bitterest known tragedy in the history of American painting."[7]

1. Virgil Barker, *American Painting, History and Interpretation* (New York: Bonanza Books, 1960), chapter 75.
2. Doreen Bolger Burke, *American Paintings in the Metropolitan Museum of Art, A Catalogue of Works by Artists Born Between 1846 and 1864* (New York: The Metropolitan Museum of Art, 1980), vol. III, pp. 34-35.
3. Lloyd Goodrich, *A Century of American Landscape Paintings 1800-1900* (Pittsburgh: Department of Fine Arts, Carnegie Institute, 1939), p. 19.
4. Burke, p. 35.
5. Barker, p. 605.
6. Blakelock received an award at the Universal Exposition in Paris in 1900. Four years later, *The Pipe Dance*, representing an Indian ritual, sold in the Frederick S. Gibbs Collection, American Art Association, New York, Feb. 26, 1904, no. 253 for $3100.
7. Barker, p. 605.

Nancy Douglas Bowditch

(1890 - 1979)

Morning Mist Rising From the Woods, Keene Valley, Adirondacks, N.Y., **1941**

Watercolor 22 x 14
Checklist no. 11

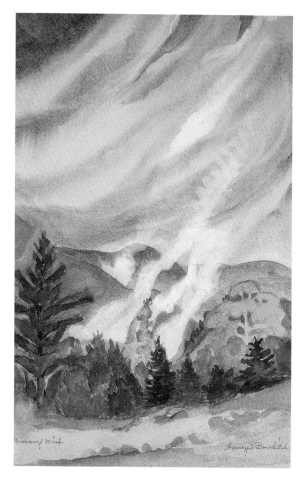

Morning Mist captures the atmospheric wisps that link earth to sky as day breaks. Bowditch has fully realized the effectiveness of the watercolor medium's capacity for fluidity in her smokey strokes of mist. Like her fellow Keene Valley artist, Harold Weston, she has carefully drawn the outline of the mountains in pencil beneath the evanescence she describes.

Nancy Bowditch knew the mountains around Putnam Camp well, and she chose an expressive rather than a representational view.[1] The date of her watercolor may explain her choice. It was drawn in 1941, a year that resounds internationally with the troubles of World War II, but, more personally, it was the year of her father's death. Her father, George de Forest Brush, was one of the most distinguished academic figure painters in nineteenth century America, whose biography she later wrote.

1. Harold Weston, *Freedom in the Wilds, A Saga of the Adirondacks* (St. Hubert's, N.Y.: Adirondack Trail Improvement Society, 1971), p. 57. Weston remarks that September at Putnam Camp was reserved for family: the Putnams, the Bowditches and relatives. "Since 1932, [it] had been run like an unpretentious private club."

Paul Bransom

(1885 - 1979)

**Untitled:
Lake Scene, n.d.**

Watercolor 5 x 8
Checklist no. 19

The lake scene represented is Canada Lake which Bransom first visited in 1908 and where he built his studio in 1917. By the late teens, Bransom was world famous for his animal illustrations such as those for Jack London's *Call of the Wild* and Rudyard Kipling's *Just So Stories,* both of which were published in 1912. With his wife, the actress Grace Bond, he established an artistic colony at Canada Lake which included such writers and artists as James Thurber, John Lowell Russell and Charles Sarka. Together, they "produced" Sunday afternoon "Vespers" parties which "featured alcoholic beverages of their own brewing [and] costumed theatricals."[1] Although Bransom's great fame was as an illustrator, the museum's watercolor demonstrates his ability with a more expressive medium, both in its staining technique and its sensitivity to subtle color, such as the peach tones of the clouds.

1. Edith Evans Asbury, "Paul Bransom, Illustrator, Dies; Called 'Dean of Animal Artists'," *New York Times* (July 22, 1979), p. 34.

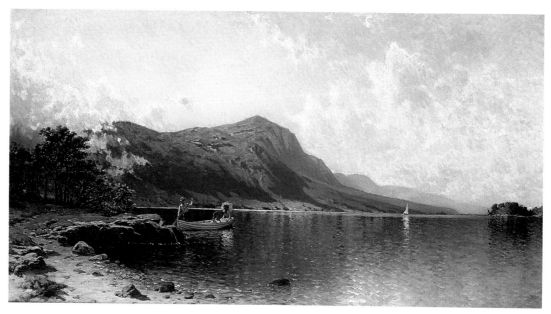

Alfred Thompson Bricher

(1837 - 1908)

**Untitled:
Boating Party on Lake George, ca. 1867**

Oil on canvas 26 x 48
Checklist no. 36

Bricher sketchbooks indicate that he was making drawings on Lake George and, more particularly, the narrows near Bolton in early September 1867.[1] Since these sketchbooks provide the only concrete link between Bricher and Lake George, they may have been preparatory to the boating party painting which depicts a young man pushing his boat off from shore in order to charm his fashionable lady friends who protect themselves from the sun's reflection on the water with parasols. As a modern critic put it: "The paintings of Alfred Bricher undoubtedly made very opulent wedding presents back in the 1880s in New York."[2] His work has a mechanical, almost photographic, quality that would have well suited the vacationing tourist's desire for a souvenir.

1. Sketchbooks of A.T. Bricher, Archives of American Art, Smithsonian Institution, Washington, D.C., reel 911, frames 852-854, dated September 11, 12, 1867.
2. John Duncan Preston, "Alfred Thompson Bricher, 1837-1908," *Art Quarterly*, vol. 25, no.2 (Summer 1962), p.149.

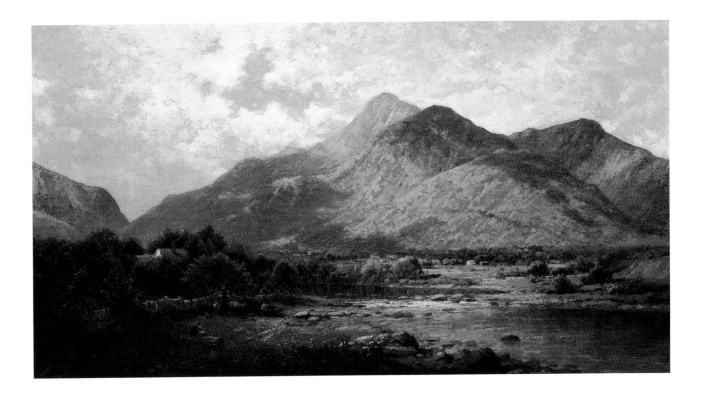

John Bunyan Bristol

(1826 - 1909)

Near Wilmington Pass, Adirondacks, ca. 1881

Oil on canvas 24 x 44
Checklist no. 37

Born in Hillsdale, New York, Bristol painted extensively in the Berkshires, the Adirondacks and Vermont. His earliest paintings in the Adirondack area were of Lake Champlain and Lake George. In the 1880s, he began to exhibit oils of the northern Adirondacks around Whiteface Mountain and Lake Placid. *Near Wilmington Pass, Adirondacks* was shown at the National Academy of Design in 1881. It depicts "The Notch... a chasm cloven boldly through the flank of Whiteface" where "on each side towered the mountains, but at our left, the range rose in still sublimer altitude, with grand precipices like a majestic wall, or a line of palisades climbing sheer from the half-way forests upward... [where] the mountains appeared knitting their stern brows into one threatening frown at our daring intrusion into their stately solitudes."[1]

The museum's painting came to the collection from Vermont and may have been part of a larger group of Bristol's paintings of the area around St. Catherine, Vermont, which he exhibited in the late 1880s. His pictures were described by contemporaries as "placid in spirit, faithful in record, unconventional in composition, and serious in purpose...."[2] His panoramic view of Wilmington Pass captures both the grandeur of the place and the everyday realities. A viewer remarked that the "picture makes me feel as I feel when I go a-fishing."[3] Bristol's painting *The Big Range Seen from the Upper AuSable Lake* shares much of the spirit of *Near Wilmington Pass* with its evocation of vast space. The AuSable painting is a mark of the esteem with which Bristol was held by his contemporaries; it was presented by his fellow members of the Century Club to the Club in 1899.[4]

1. Alfred B. Street, *Woods and Waters, or the Saranac and Racket* (New York: M. Doolady, 1860), pp. 340-341.
2. George W. Sheldon, *American Painters* (New York: D. Appleton and Co., 1879), p. 22.
3. Ibid.
4. A. Hyatt Mayor and Mark Davis, *American Art at the Century* (New York: The Century Association, 1977), p. 36, ill.

James E. Buttersworth
(1818 - 1894)

Fort William Henry Hotel, ca. 1870

Oil on board 7 x 9
Checklist no. 38

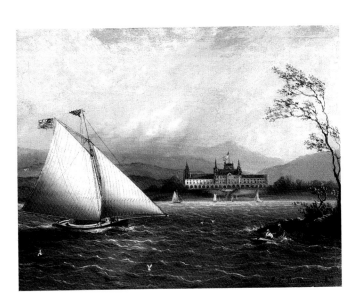

Buttersworth was the best known marine painter in America in the middle and late nineteenth century. He painted many yachting scenes in New York Harbor around 1870. His change of scene to a boater's view of Lake George suggests that he was commissioned to paint a souvenir of the lake with its recently opened Fort William Henry Hotel for the owner of the yet unidentified yacht with full blown sails in the foreground of the painting. The precision with which Buttersworth depicted the hotel in the background provides a visual document of an enterprising era in Lake George history. The Fort William Henry Hotel, no longer standing, was built by T. Roessle and Son in 1868 on the ruins of a pre-revolutionary fort. It boasted "princely accommodations for more than a thousand guests" and a twenty-five foot wide piazza opening onto three hundred and thirty-four feet of lake frontage at the head of Lake George.[1]

Where yachts once raced under the surveillance of the hotel's seven story twin towers, today's cruise ships leave for their seventy-five mile tour of the lake.[2]

1. Benjamin Franklin DeCosta, *Lake George, Its Scenes and Characteristics, With Glimpses of the Olden Times*, 4th edition (New York: Anson, D.F. Randolph and Co., 1868), p. 165.
2. Seneca Ray Stoddard, *Lake George: A Book of To-Day* (Albany, N.Y.: Weed, Parsons and Company, 1873), p. 110. The price per day in 1873 was $5.00.

James Cameron
(1817 - 1882)

Long Lake, ca. 1855

Oil on canvas 26 x 42
Checklist no. 40

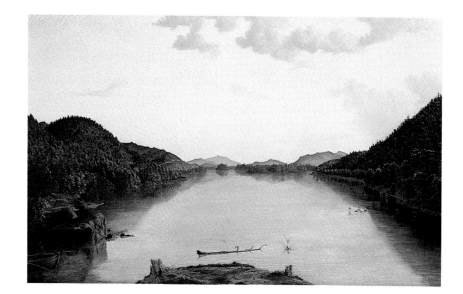

The clarity with which Cameron divides *Long Lake* into balanced sections of sky and water, as well as the minute precision with which he depicts the trees that line the lake and the ducks that land on the water in the right middle ground, suggest that he started his career as a lithographer. His work has a graphic rather than a painterly quality. Its intensified observation provokes an aura of quietude and mystery that is associated with the "luminist" movement in American painting.[1]

The museum's picture was originally owned by Professor Farrand Northrup Benedict who taught mathematics at the University of Vermont in the 1840s and owned land in the central Adirondacks.[2] His will,

dated July 3, 1880, specifically mentions "the Adirondack painting of L. Lake."[3] A Cameron painting of *Long Lake* was announced in the *Burlington Daily Free Press* on January 23, 1855, as being on view at the store of Brinsmaid and Hildreth "for a short time previous to being sent South."[4] Benedict's professional association with Burlington, combined with his predisposition for mathematical clarity and personal association with the Adirondacks, may have led him to "call and see" and subsequently purchase Cameron's landscape.

1. For a discussion of luminism and an illustration of its characteristics in the work of Boston area lithographer and painter Fitz Hugh Lane see:

Patricia C.F. Mandel, *Selection VII: American Paintings from the Museum's Collection, c.1800-1930* (Providence: Museum of Art, Rhode Island School of Design, 1977), cat. no. 69, ill. The only factual connection between Philadelphia-based Cameron and Fitz Hugh Lane is the stencil mark on the back of the museum's painting which reads: "From M.J. Whipple's Artist Supply Store, 35 Cornhill, BOSTON." Whipple was active at that address, according to the American Antiquarian Society, between 1848 and 1867. These are the very years that Lane (1804-1865) was painting in the area.
2. William K. Verner, Adirondack Museum, to Bud H. Bishop, Director, Chattanooga Art Association, September 1, 1978, AMA files.
3. William K. Verner to Mrs. Kenneth Durant, December 6, 1978, AMA files.
4. T.D.S. Bassett, The University Library, University of Vermont, Burlington, to Warder H. Cadbury, July 10, 1964, AMA files.

John William Casilear

(1811 - 1893)

Untitled: Keene Valley, Adirondacks, New York, 1881

Oil on canvas 14 x 20
Checklist no. 41

Like Durand and Cole, Casilear is primarily associated with the Catskill mountains, although it is known that he visited both Keene and Elizabethtown in June and July 1848 with fellow artists Kensett and Durand.[1] Since the date of this painting falls into his later years, we wonder if it may have been based on earlier sketches. Like so many American artists, Casilear trained as an engraver, apparent in the precise way he delineates the trees at the lower right. The lavender tinge in the far mountains is echoed in the mackerel sky above; all merge to create a scene of pastoral tranquility.

1. Asher B. Durand to his son, John, June 22, and July 2, 1848, collection New York Public Library.

George L. Clough
(1824 - 1901)

Untitled: Adirondack Camping Scene, n.d.

Oil on canvas 24 x 36
Checklist no. 43

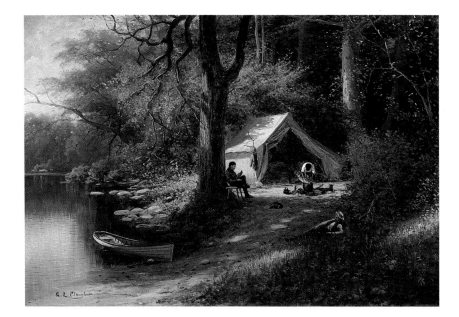

The loose paint strokes and soft coloration of Clough's Adirondack camping scene do not prepare us for the fact that the artist was primarily trained as a portrait painter. He was born in Auburn, New York, where he studied with Charles Loring Elliott, the well-known portrait painter. An oil study for this picture is presently in the collection of the Seward House in Auburn.[1] The camping scene is unusual in that it depicts a black man cooking coffee in front of a tent while the "camper," presumably his patron, dozes comfortably against a tree. Racial distinction is rare and, if observed, unspoken in American sporting paintings of the 1800s. The closest textual parallel we have found to this scene occurs in Jervis McEntee's 1851 diary of his camping at Rackett [sic] Lake where he describes an old Indian, Elijah Benedict, "who is engaged in mending or something of the kind [and] came over to where we were taking care of our sketches and expressed great admiration of our pictures remarking that we 'must get good wages 'else we can't afford to do it.' When we told him that we sold them he asked 'how you know you sell 'em or did you make bargain for 'em 'for you come?'"[2]

1. Professor Brucia Witthoft, Framingham State College, to William K. Verner, October 14, 1978, AMA files. Witthoft mentions that Clough's *Portrait of Theodore Pomeroy*, one-time Speaker of the House of Representatives, hangs in the Capitol, Washington, D.C.
2. Jervis McEntee Diary, Archives of American Art, Smithsonian Institution, Washington, D.C., reel D9, frame 591, July 8, 1851.

Thomas Cole

(1801 - 1848)

Schroon Lake, ca. 1846

Oil on canvas 33 x 32
Checklist no. 45

Thomas Cole's first mention of Schroon Lake occurs in his *Journal*, October 7, 1835, when he writes: "I have just returned from an excursion in search of the picturesque toward the head-waters of the Hudson.... The [Schroon] Lake I found to be a beautiful sheet of water, shadowed by sloping hills clothed with heavy forests. Rowing north for half an hour or so, you will see the lake expanded to the breadth of two or three miles." Cole resolved to "visit this region at a more favourable season."[1]

Cole next visited Schroon Lake on June 24, 1837, in the company of his new wife, Maria Thompson, and his friend, Asher B. Durand.

There, he sketched Schroon Mountain. From these drawings he composed an oil of *Schroon Mountain* which he exhibited at the National Academy the following spring. While working on the painting, Cole wrote Durand on January 4, 1838, of his difficulty in "painting scenes, however beautiful, immediately upon returning from them."[2]

The museum's *Schroon Lake* is not dated, but it, too, is based on drawings Cole made during the 1837 visit. That was his last recorded time in the area.[3] The hewn tree stump in the center foreground of the picture suggests Cole's disturbance at the taming of the wilderness. His *Journal* notes his and Durand's "trampling... beneath some giant denizens of the woods whose companions had all been laid low... [and] a mass of wood on the declivity of the hill [that] enviously hid the anticipated prospect."[4] Cole also remarked upon their passing "a log house or two whose inhabitants seemed aghast at the apparition of two strangers sweeping across their domains without stopping to ask a question, or say 'good day'."[5] The log house in the center middle ground of the painting has been identified as that of Joseph Richards who owned the sawmill shown at the far right. The mill, built in 1798, was located above Paradox Lake Outfall, and Richards had a shop for the sale of lumber attached to his home. The cemetery in the clearing above the mill is

Severance Cemetery. There is a schoolhouse near the lake.[6]

The frame-within-a-frame format of *Schroon Lake* is also found in *The Cross in the Wilderness* of 1846, part of Cole's last and unfinished spiritual series of *The Cross and the World*. *Schroon Lake*, which may have been executed at the same time, is characteristic of Cole's later paintings in its preoccupation with the sky, its luminosity and spiritual suggestiveness. The museum's picture is far more concerned with the effect of the sky than with a depiction of the lake. Cole wrote a poem in his *Journal* of January 1, 1846, after a discussion of his intended series. The first stanza reads:

> Hark! I hear the tread of time,
> Marching o'er the fields sublime,
> Through the portals of the past,
> When the stars by God were cast
> On the deep, boundless vast.[7]

Schroon Lake's "tondo" form creates a portal which distances the viewer from the minutia of the scene and evokes Cole's less explicitly religious sentiments when he visited the area in 1837. "Here," he wrote, "we felt the sublimity of untamed wildness, and the majesty of the eternal mountains."[8]

1. Louis L. Noble, *The Course of Empire, Voyage of Life and Other Pictures of Thomas Cole N.A. with Selections from His Letters and Miscellaneous Writings* (New York: Cornish, Lamport & Co., 1853), p. 206.
2. Howard S. Merritt, *Thomas Cole* (Rochester: Memorial Art Gallery of the University of Rochester, 1969), cat. no. 35, ill. 53. The painting is now

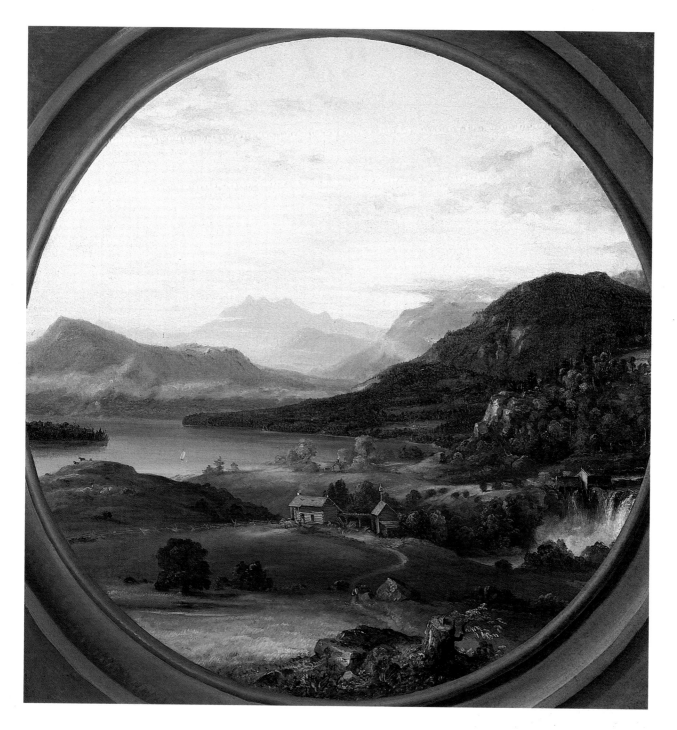

in the collection of the Cleveland Museum of Art.

3. Noble, pp. 373-375. Cole's last visit to the Adirondacks was in September 1846. He visited Long Lake (that "Lago Maggiore," of the woods, as Cole himself called it), the ironworks at Mt. McIntyre and returned home via Lake Champlain.

4. Noble, pp. 240-241.

5. Ibid., p. 240.

6. Tracy Meehan, registrar, Adirondack Museum to William K. Verner, October 1, 1980, AMA files. Ms. Meehan's information was provided by William L. Richards of Glens Falls, a descendant of Joseph Richards. Richards reported that Joseph's son, Orson, was called the "Lumber King" and was the first to float logs down the Hudson and that the property was sold in 1847.

7. Elliot S. Vesell, ed., *The Life and Works of Thomas Cole by Louis LeGrand Noble* (Cambridge: Harvard University Press, Belknap Press, 1964), pp. 274-275.

8. Noble, p. 241.

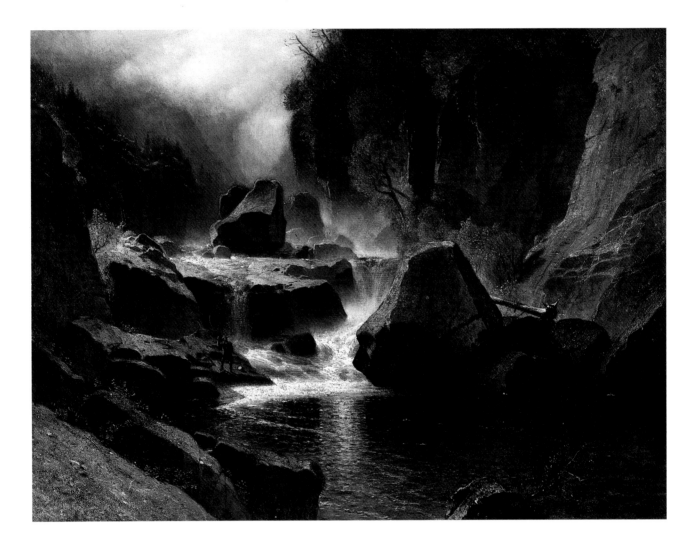

Samuel Colman

(1832 - 1920)

Untitled: AuSable River, ca. 1869

Oil on canvas 30 x 40
Checklist no. 48

Colman accompanied James D. Smillie on his forays to the top of Giant's Leap on September 4th and 6th, 1869, and because Colman's time on those days was spent fishing "up the stream," it is possible that the museum's oil depicting a fisherman swirling his line into the spiralling waters of the boulder strewn river may have been executed at the same time.[1] Colman's composition places far greater emphasis on the rough hewn rocks and spume from the waterfall than on the angler. In the precision of his delineation of immense rocks which close in on the scene on all sides, Colman displays his own interest in graphic accuracy. In the late 1860s, he, like Smillie, was experimenting in the very exacting art of watercolor. Indeed, Colman was the first president of the American Society of Painters in Water-Colors founded in 1866.[2] Although this picture is executed in oil paint, it may well have been based on an on the spot watercolor sketch as is suggested by its immediacy of detail in the striations of the rocks and the surface patterns of the intensely highlighted rushing water.

1. James D. Smillie Diaries, Archives of American Art, Smithsonian Institution, Washington D.C., reel 2849, frames 844-845.
2. George W. Sheldon, *American Painters* (New York: D. Appleton and Co., 1879), p. 74.

Lillian Haines Crittenden

(1858 - 1919)

Partley [sic] *Cloudy,*
ca. 1908-1917

Pastel on
academy board 8 x 16
Checklist no. 55

Lillian Crittenden lived with her husband, Walter, in one of the Ausable Club cottages for the summers of 1908-1917.[1] In 1892, she studied at the Shinnecock Art School with William Merritt Chase and later sketched in Holland, Switzerland and Norway. "Pastel was her favorite medium, its clear, rapid technique lending itself most admirably to the seizing of the quick changing colors and atmospheric effects on mountains, river and shore...."[2] The small, dark board on which she drew facilitated the speed with which she was able to capture the fleeting moment; she worked on the spot and was attuned to weather changes as the label reading "Partley [sic] Cloudy" on the back of the painting suggests.

1. Pauline Goldmark, "Keene Valley Artists," typescript, 1940, Keene Valley Library, Keene Valley, N.Y., p. 17.
2. Gertrude Young, "Pastel Paintings by Lillian Haines Crittenden," *The Brooklyn Museum Quarterly*, vol. VII, no. 4 (October 1920), p. 209.

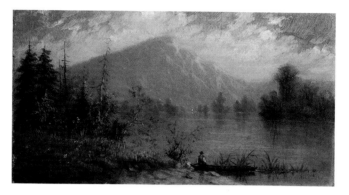

Jasper Francis Cropsey

(1823 - 1900)

Untitled: Adirondack Landscape, n.d.

Oil on canvas 6 x 11
Checklist no. 56

The small size of this Adirondack landscape is typical of Cropsey's work as evidenced in a recent catalogue covering his work from ca. 1841 to 1890. Of the fifty paintings included, at least ten were close in measurements to the 6 x 11 dimensions of the museum's oil.[1] Despite its given dimensions, it conveys a monumentality that we associate with Cropsey's majestic *Indian Summer Morning in the White Mountains*, 1857, that measures 34 x 61.[2] It is possible that Cropsey's ability to project a panoramic image from a small oil sketch reflects his training as an architect. He was particularly well known as the designer of the fourteen fire-resistant galvanized stations of the Gilbert Elevated Railroad Company along Sixth and Second Avenues in New York City, built in 1878.[3]

Cropsey's Adirondack landscape is probably of Lake George, the subject of several of his National Academy entries from the later 1850s through 1880s. Despite its evocation of monumentality, the oil demonstrates great delicacy in the thin strokes of green-blue in the sky and the carefully depicted wild flowers on the shore at the lower left. The viewer identifies with the single man whose boat is pulled ashore and looks with him across the calm waters to the great mountain beyond.

1. Ella N. Foshay, Barbara Finney and Mishoe Brennecke, *Jasper F. Cropsey, Artist and Architect* (New York: The New-York Historical Society, 1987), cat. nos. 1, 2, 3, 12, 14, 30, 36, 41, 44 and 49.
2. Peter Bermingham, *Jasper F. Cropsey 1823-1900 A Retrospective View of America's Painter of Autumn* (College Park, Md.: University of Maryland Art Gallery, 1969), cat. no. 10. Collection Currier Gallery of Art.
3. Barbara Finney, "Jasper F. Cropsey: Architect" in Foshay, Finney and Brennecke, pp. 144-147, figs. 8, 9.

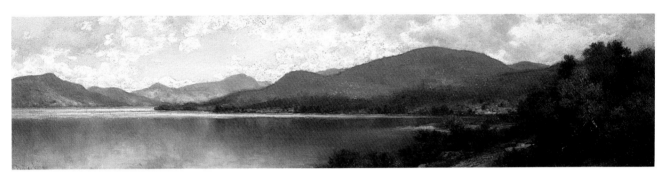

Robert M. Decker

(1847 - 1921)

From the Rising House, Looking South at Hague, Lake George, n.d.

Oil on canvas 10 x 40
Checklist no. 67

Such a long, panoramic vista suggests by its very shape that it was especially designed to be placed over a fireplace mantel. It is possible that Decker, who summered for much of his life at Hague, wished to enjoy this memento of Lake George during his winter months in Brooklyn, New York. The light gray tone of the scene could blend with the interior environment. The *Lake George Mirror* quoted Decker in August 1901: "I have known and loved Lake George for forty-five years, since my earliest childhood in fact, and it was roaming its woods and

fields and studying its lovely skies that first made me long to be a painter...."[1] If we take Decker's statement seriously, he must have come to Lake George as a boy of about ten from his native Troy, New York, not far from the lake.[2]

Although Decker was brought up in the Albany-Troy area, his mentor was R. Swain Gifford of New Bedford, Massachusetts. They both lived in the New York City area in the 1880s and shared a fondness for "lovely skies" near water. Decker never achieved Gifford's fame, and he admitted in a letter to the New York City art dealer, William Macbeth, in April 1893: "While I am not entirely unknown in New York and have sold a number of things there...I am in the 'vast minority' as I doubt if you ever even heard of my name before."[3] However, twenty-eight years later, at Decker's death, the renowned connoisseur Hamilton

Easter Field acknowledged Decker's genius, saying "I have just heard of the death of Robert M. Decker, whom I have considered Brooklyn's most distinguished artist ever since I saw his work at the exhibition of the Brooklyn Society of Artists in 1919.... Here was a man who knew his technique as none of the younger artists do, whose work was drawn with the skill and knowledge which none but the masters have."[4]

1. "Robert M. Decker," *Lake George Mirror* (August 10, 1901).
2. Howard I. Becker, art dealer, Rexford, New York to Adirondack Museum, July 1962, notes Decker's parents' motivation for visiting Lake George was "an attempt to cure his mother's lung condition." AMA files.
3. New York City, Macbeth Gallery Papers, Archives of American Art, Smithsonian Institution, Washington, D.C., reel no. N Mc6, frames 819-20.
4. Hamilton Easter Field, *Brooklyn Eagle* (October 30, 1921).

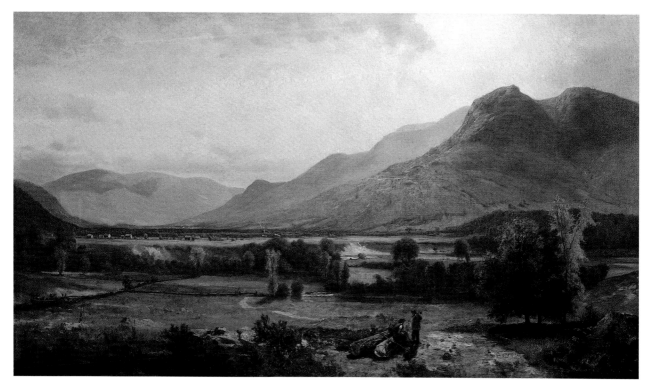

John Henry Dolph

(1835 - 1903)

The Adirondack Mountains, Near Elizabethtown, Essex Co., N.Y., 1866

Oil on canvas 27 x 48
Checklist no. 69

The name J.H. Dolph is traditionally associated with paintings of cats, although none appear as subject matter in his National Academy of Design painting entries until 1887. His early oils, like the museum's, are landscape views. *The Adirondack Mountains, near Elizabethtown, Essex Co., N.Y.* which depicts Keene Valley, a gathering place for artists in the late 1860s, is his earliest Adirondack painting. It is also one of the earliest views of the Valley, for it predates the visits of John Fitch and Roswell Shurtleff to the area. Dolph, unlike these Hartford based artists, was a native of upper New York State. He was born in Fort Ann, just southeast of Lake George. The specificity of his title for the painting suggests his awareness that the scene was one that would appeal to tourists in the area. Its idyllic setting of an open valley backed with high mountains and a path of golden sunlight indicates Dolph's experience as an artist of popular ornamental cards and scene designs.[1]

1. Peggy O'Brien, notes on John H. Dolph, AML, n.d., unpaged.

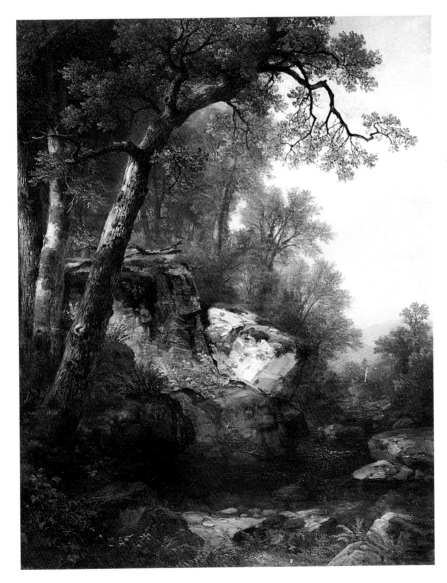

Asher Brown Durand (attributed)

(1796 - 1886)

Untitled: Boulder and Trees, ca. 1858

Oil on canvas 25 x 20
Checklist no. 72

Asher Brown Durand is probably the single, most important artist in American nineteenth century art in his role as a teacher. Among the artists in the museum's collection, John W. Casilear and Samuel Colman apprenticed in Durand's New York City studio. In 1855 his influence was extended beyond his studio with the publication of "Letters on Landscape Painting" in the American periodical, *The Crayon*. In the article, a series of letters to a beginning landscape painter, Durand, who had been trained as an engraver, cautioned the neophyte painter to "Practice drawing with the pencil till you are sure of your hand."[1] As is evidenced in the museum's oil of a carefully delineated boulder overshadowed by a towering tree on the left, Durand stressed fidelity to nature in both his paintings and his writing: "If your subject be a tree, observe particularly wherein it differs: in the first place, the termination of its foliage, best seen when relieved by the sky, whether pointed or rounded, drooping or springing upward...mark the character of its trunk and branches...."[2] Durand's "Letters" were widely read by many artists of the mid-1850s who were principally self-taught.

Durand's distinguished position as a founder and President of the National Academy of Design from 1845 until 1861 further enhanced the attention with which beginning painters read his words of advice.

Durand's interest in Adirondack forest scenery can be dated to 1848 when he wrote his son, John, from Elizabethtown: "The mountain scenery is beautiful, superior to any I have met with in this country, but I have not done much at it, having commenced on...a study of rocks [in an effort to begin] with easier subjects first in order to get my hand in...."[3] The painting of boulder and trees in the museum's collection, undated and unsigned, may date from Durand's first Adirondack forays, but its close stylistic resemblance to *A Sycamore Tree, Plaaterkill Clove*, ca. 1858, in the Yale University Art Gallery, suggests that it is a later date.[4] Durand's depiction of greenery growing out of the huge boulder prompted the criticism that his pictures were "too green." Durand defended his preoccupation with green tones by noting that "in our American landscapes green predominates: our mountains are covered with trees, while in Europe the peaks and crests are often all rock."[5]

The museum's painting of boulder and trees was a gift from the daughter of Professor Allan Marquand of Princeton University whose father Henry Gurdon Marquand (1819-1902) was a noted collector of paintings and whose presence at a "Sketch Club" meeting, attended by Durand just before he left for his first visit to the Adirondacks, is noted in the Club's "Name and Roster List."[6] Since the artist and collector were acquainted, it is possible that the museum's picture was acquired directly from the artist.

1. Asher B. Durand, "Letters on Landscape Painting," *The Crayon*, (1855). Letter II reprinted in John W. McCoubrey, *American Art, 1700-1960 Sources and Documents* (Englewood Cliffs, N.J.: Prentice-Hall, 1965), p. 111.
2. Ibid., p. 110.
3. David B. Lawall, *A.B. Durand 1796-1886* (Montclair, N.J.: Montclair Art Museum, 1971), p. 59. Original letter in Durand Papers, New York Public Library.
4. Ibid., cat. no. 76, ill. p. 106.
5. George W. Sheldon, *American Painters* (New York: D. Appleton and Company, 1879), p. 130.
6. James T. Callow, author of *Kindred Spirits, Knickerbocker Writers and American Artists, 1807-1855* (Chapel Hill, N.C.: The University of North Carolina Press, 1967) to Warder H. Cadbury, November 10, 1975, AMA files.

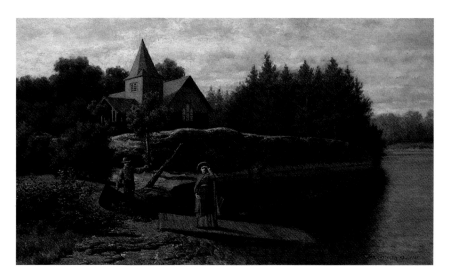

John Whetten Ehninger

(1827 - 1889)

Mission of the Good Shepherd, St. Hubert's Island, Raquette Lake, 1881

Oil on canvas 25 x 44
Checklist no. 75

Architectural subjects are rare in paintings concerned with the Adirondack wilderness. *The Mission of the Good Shepherd* is particularly unique since it represents a religious edifice. Most of the visitors to the Adirondacks came in search of sport or a spiritual union with nature that did not necessarily involve a codified institution, such as the Episcopal Church. The land for the church and its accompanying rectory was donated by Dr. Thomas Clark Durant and his son, William West Durant. In 1877, William West Durant supervised "the construction of the rustic cabins known as Camp Pine Knot [which] became famous as the first stylish camp in the Adirondacks...." The church, known euphemistically as "The Mission," as if it were established in a foreign country, was consecrated in 1880. Its construction "probably had less to do with piety than with attracting prosperous families to Raquette Lake."[1]

On Sunday, September 26, 1880, the Saratoga Springs artist John Ehninger stayed with his wife and daughter, Tatty, at the Forked Lake House, near the outlet of Raquette Lake.[2] His visit may have been connected with the dedication of the Mission. There is no evidence of the Durants having commissioned Ehninger's painting, but its highly stylized figure treatment suggests that it may have been based on photographs of the Mission by Seneca Ray Stoddard whom the Durants had hired to memorialize the camp and adjoining buildings.[3] The cloaked lady in the foreground, who has just arrived on the island with her guide and canoe, searches anxiously for friends to accompany her to church services.

1. Craig Gilborn, *Durant: The Fortunes and Woodland Camps of a Family in the Adirondacks* (Blue Mtn. Lake, N.Y.: The Adirondack Museum, 1981), p. 41, fig. 27.
2. William K. Verner, notes in AMA files, June 4, l975.
3. Unsigned, undated notes in AMR files. Gilborn, pp. 19-20, mentions Stoddard's involvement with Camp Pine Knot as early as 1877 and Stoddard's inclusion of it as "unquestionably the most picturesque and *recherché* affair of its kind in the wilderness" in his 1881 edition of *The Adirondacks, Illustrated.*

Hugh Antoine Fisher

(1867 - 1916)

Rapids of the Au Sable, n.d.

Watercolor and gouache
40 x 30
Checklist no. 80

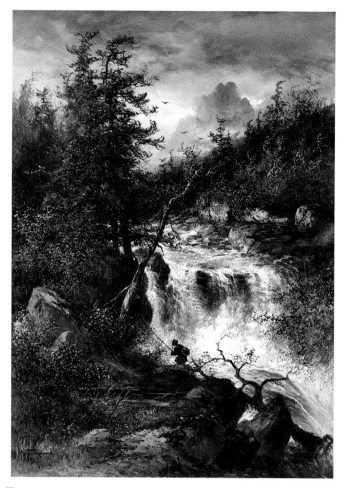

Little is known about this painting besides what we see. It is evident that Fisher was fully aware of the seventeenth century tradition of romantic landscape painting, such as the works of Salvator Rosa (1615-1673), whose sensibility to man's struggle with nature infiltrated much of eighteenth and early nineteenth century European painting. We can gather by his name that Fisher was a French or Swiss artist for whom the exuberant waters of the Ausable and a fisherman's fight with its spume provided a worthy subject of gigantic proportions.

John Lee Fitch

(1836 - 1895)

Eagle Lake, 1881

Oil on canvas 15 x 36
Checklist no. 81

Fitch and his wife stayed at the Prospect House on Blue Mountain Lake along with their two babies and a nurse in August 1881.[1] It is unusual to find Fitch painting in the area around Blue Mountain Lake, for he is associated with Keene Valley where he lived during the summers from the middle of the 1860s through the middle of the 1870s.[2] In the winter of 1882, he exhibited *Eagle Lake* at the Century Club, New York City, where he was an active member of the Exhibition Committee and where he met with his long-time friends, Winslow Homer and Homer D. Martin.[3]

Fitch's depiction of Eagle Lake is at once concerned with topographical accuracy and the effect of light upon water and sky. His image is one of peace, held still for a moment; in this sense, it is not unlike the Lake George paintings of John F. Kensett whose most famous representation of that lake still hangs in the Century Club.

1. Peggy O'Brien, Fitch notes, AML, p. 5 and Prospect House Register, AML.
2. Pauline Goldmark, "Keene Valley Artists," typescript, 1940, Keene Valley Library, Keene Valley, N.Y., pp. 1-2.
3. Ibid., p. 2. As visual evidence of their close friendship see: Lloyd Goodrich, *Winslow Homer* (New York: The Whitney Museum of American Art and the MacMillan Co., 1944), p. 25. Mr. Goodrich learned the identity of the painters represented in Winslow Homer's *Artists Sketching in the White Mountains,* 1868, former collection, Mr. and Mrs. Charles S. Payson, in conversation with Miss Fitch, the daughter of John Fitch. The artists are John Fitch and Homer Martin. The painting is illustrated in Albert Ten Eyck Gardner's *Winslow Homer, American Artist: His World and His Work* (New York: Bramhall House, 1961), p. 104.

Arthur Burdett Frost

(1851 - 1928)

Breaking Up Camp/ The Racquette [sic] River at the End of Sweeny Carry, 1881

Gouache 8 x 14
Checklist no. 83

Although best known for his creation of Br'er Rabbit and Uncle Remus with writer Joel Chandler Harris, Frost was also a popular sporting illustrator. The museum's gouache was the basis for the engraving, *A Carry-The End*, which appeared in *Harper's New Monthly Magazine*, October 1881.[1] The unsigned article, titled "Adirondack Days," tells of a canoe trip up the Saranac River where the "quiet bays and 'slews' are filled with many-colored aquatic plants [and] the broad dark leaves and coarse yellow flowers of splatterdock mingle with the lighter and more delicate leaves and shining white blossoms of the pond-lily...."[2] The illustration shows the campers, whose boats had been "tossed like cockle-shells by the white capped waves" of Upper Saranac Lake, at the end of Sweeny Carry, a three mile road connecting the waters of Upper Saranac with those of the Raquette River.[3] The campers were disappointed upon viewing the muddy waters of the Raquette after their exertion on the lake. One of them, named Howard, "stood silent for a moment on the muddy bank, and then uttered in German, 'Donnerwetter noch einmal! What a hole!'"[4]

Frost's illustration conveys the frustration expressed by the campers. Each performs a specific function; none has a facial expression, and the pile of camping equipment occupies center stage. In both the engraving and the drawing, "The most beautiful of wild rivers" is a little more than a planar space.[5]

1. "Adirondack Days," *Harper's New Monthly Magazine* (October 1881), p. 685.
2. Ibid., p. 684.
3. Ibid., p. 685.
4. Ibid.
5. Ibid.

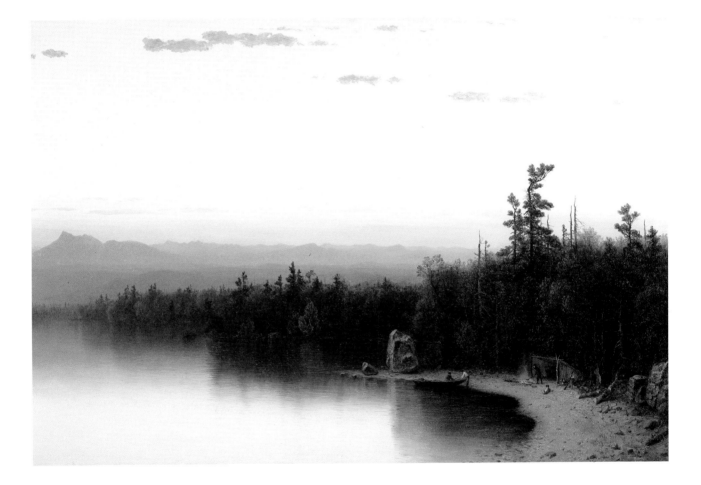

Sanford Robinson Gifford

(1823 - 1880)

A Twilight in the Adirondacks, 1864

Oil on canvas 24 x 26
Checklist no. 85

A Twilight in the Adirondacks was on Gifford's list of his "chief pictures" and was one of those he chose to exhibit in the United States Centennial Exhibition in 1876.[1] Slightly more than a century later, it was chosen to be shown at the Vatican Museum as a representative of "American Art in Religion."[2] Its "religion" is basically that of nature, meticulously observed at the hour when "an irregular horizontal band...marginally legible as pines and deciduous trees [appears] against the field of pinkish-orange and yellow light of sky and water."[3] Ila Weiss has related Gifford's imagery to Longfellow's poem, "The Golden Sunset":

The golden sea with its mirror spreads
 Beneath the golden skies,
And but a narrow strip between
 Of land and shadow lies.
The sea is but another sky.
 The sky a sea as well.
And which is earth, and which
 the heavens
 The eye can scarcely tell.[4]

The poem was published in *The Crayon* six years before Gifford's scene was painted. It reflected the then popular Emersonian transcendental

philosophy which asserted the transcendence and the ultimate reality of the spiritual over the material.

For almost a hundred years, *Twilight* "hung in the dark panelled dining room of my grandfather's house - 276 Madison Avenue....No one knew exactly where it was but I would guess it might have been Gifford's special idea of DeBar or perhaps Sable Mountain from Meecham Lake, or it might have been St. Regis Mountain from Spitfire near Paul Smiths."[5] So writes C.T. Ludington whose grandfather, C.D., lent the picture to the National Academy of Design the year it was painted and who, therefore, may well have commissioned the scene.

1. Ila Weiss, *Sanford Robinson Gifford (1823-1880)* (New York, London: Garland Publishing Inc., 1977), p. 240.
2. John I.H. Baur, Curator, New York, Friends of American Art in Religion, Inc., *A Mirror of Creation*, Exhibit, Vatican Museum, Rome, Italy, October - November, 1980.
3. Weiss, p. 240.
4. Ibid., p. 241.
5. C.T. Ludington, Old Lyme, Ct. to Mrs. Harold K. Hochschild, August 22, 1963, AMA files.

Regis Francois Gignoux
(1816 - 1882)

Log Road in Hamilton County, 1844

Oil on canvas 27 x 34
Checklist no. 89

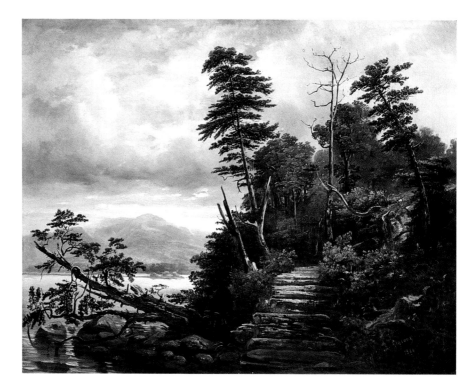

Regis Gignoux, distinguished as the teacher of American landscape painter George Inness, was an early visitor to the Adirondacks. In 1843 he exhibited *Indian Pass in the Adirondacks* at the Apollo Association and a painting of the same title at the National Academy in 1848. It is possible that *Log Road* was sketched while Gignoux was at work on his 1843 Apollo landscape, *Indian Pass. Log Road* is noteworthy for its inclusion of an Adirondack corduroy bridge (see Sonntag, checklist no. 276) as the thematic focus of the painting. Note the large snake slithering up the log road. We can appreciate Gignoux's sense of drama in his handling of light outlining the trees along the way.

Philip R. Goodwin

(1881 - 1935)

The Little Shack by the Lake, Adirondacks, Cranford Camp, n.d.

Oil on canvas 12 x 16
Checklist no. 91

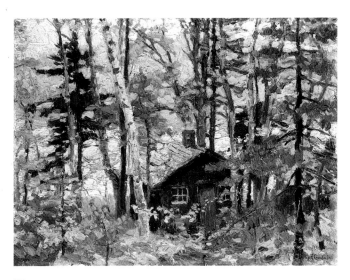

Philip Goodwin's oil of *The Little Shack by the Lake, Adirondacks, Cranford Camp* depicts one of the best documented family camps in the Adirondacks, the Cranford Camp, located on Osgood Pond near Paul Smiths.[1] Goodwin, an illustrator, was a frequent visitor to the camp. His loose, impressionistic style reproduces a shack at the camp in shades of green and yellow. His friend, Ralph Noyes Cranford, an architect, designed the camp for Goodwin's father in the summer of 1889 and frequently joined Goodwin on painting trips there.

1. See Logbooks, Cranford Camp, ca. 1889-1891, AML, MF 5.2.

Samuel W. Griggs

(1827 - 1898)

Scroon [sic]*Lake, N.Y.,* ca. 1871

Oil on canvas 14 x 24
Checklist no. 101

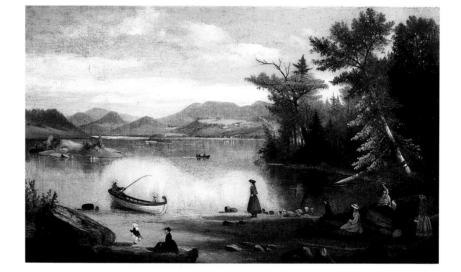

Griggs' scene of placid waters, sleeping mountains and lovely ladies reflects an idyllic summer-time. The ladies have been identified as the "Clark Girls," daughters of General Bayard Clark of New York City.[1] The Clarks summered on Isola Bella, the only island on Schroon Lake.[2] The steamer in the distance, the *Effingham,* ran regular trips across the lake, and the fishermen near shore are trolling.[3]

A Boston based artist, Griggs stayed at the long established Ondawa House on Schroon Lake. According to family tradition, the granddaughter of the owner claims that Griggs paid for his board with a painting identical to the museum's.[4] The Ondawa painting, which is still owned by the family, is dated 1871 while the museum's is not dated.

The existence of the two paintings of this scene attests to Griggs' ability to spot a popular image. In it, he has captured what a contemporary guidebook said the Ondawa provided: "glimpses of the lake and busy scenes at the wharf where the little steamers take on loads and the company gather to comment on new arrivals."[5]

1. William K. Verner, notes, AMA files, December 30, 1968.
2. Benjamin Franklin De Costa, *Lake George, Its Scenes and Characteristics with Glimpses of the Olden Times*, 4th edition (New York: Anson, D.F. Randolph and Co., 1868), p. 168.
3. Seneca Ray Stoddard, *Lake George; A Book of To-Day* (Albany, N.Y.: Weed, Parsons and Company, 1874), p. 168.
4. Verner, December 30, 1968.
5. Stoddard, p. 167.

James McDougal Hart

(1828 - 1901)

Untitled: View on Loon Lake, 1862

Oil on canvas 19 x 32
Checklist no. 109

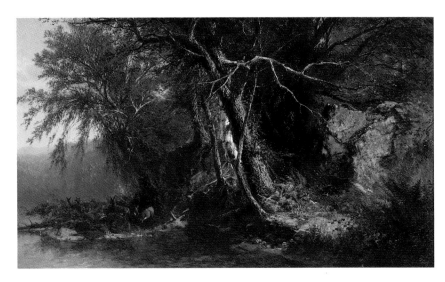

The way in which James Hart organizes landscape elements of trees and rock to emphasize the herd of deer as they proceed out of the woods toward the lake marks him as a worthy collaborator of Arthur Fitzwilliam Tait. The two began working together on a single canvas in the late 1850s and continued to do so for the next twenty years.[1] Hart provided the landscape portion while Tait depicted the deer. In this particular painting, solely by Hart, it is clear that he has learned much of Tait's sensitivity to the grouping of deer and to their distinctive behavioral trait: ears alert to possible peril.[2] Of special charm is the way in which Hart echoes the movement of the deer with that of a single gray squirrel, tail erect, on the dead bough of the foreground tree that overhangs the water. The mist over the lake serves to isolate the animals in a moment of acute intensity when all sense the possibility that their privacy may be temporary. The detail with which Hart treats the gray-green of the rock at the right and the delicate pink flowers nearby further identifies him as a keen observer of nature.

1. *At the Spring* exhibited as the joint work of James Hart and A.F. Tait, N.A., National Academy of Design, 1859, cat. no. 413.
2. Hart's early mastery of this animal motif is apparent in the museum's *A Bit of Lake Placid*, 1860, checklist no. 108.

William M. Hart
(1823 - 1894)

Untitled: Night Scene, Keene Valley, 1861

Oil on canvas 8 x 16
Checklist no. 111

Two things make Hart's small oil unique: its date and the fact that it is a night scene. The painting is dated 1861 which is very early for a painting whose size makes it clear that it was done for pleasure, not on commission or to illustrate a geological survey. In 1870, an unidentified writer described the Adirondacks of the 1850s "almost as unknown as the interior of Africa. There were few huts or houses there, and a very few visitors. But of late the number of sportsmen and tourists has greatly increased, and taverns have been established in some of the wildest spots."[1] Hart's work predates the "rush" to the wilderness of the 1870s and the visits of such Keene Valley artists as John Fitch, Roswell Shurtleff and James D. Smillie. He probably travelled to the area with his brother, James, whose painting of *Lake Placid* in the museum's collection (checklist no. 108) is dated 1860. The Hart brothers came from Albany, New York, which traditionally had ties to Keene Valley.[2]

Night scenes are rare in American landscape painting of the mid-1800s, a period of great respect for "truth in nature" and little concern for the romantic embellishments of moonlight. Hart clearly depicts the silhouettes of the mountain peaks and, at the same time, explores the dramatic effects of the moon on the water. His inclusion of the illuminated cottage at the lower right further enhances the sense of privacy and mystery that the painting evokes.

1. "Adirondack Scenery," *Appletons' Journal of Popular Literature, Science and Art*, vol. IV, no. 78 (September 24, 1870), pp. 364-365.
2. Pauline Goldmark, "Keene Valley Artists," typescript, 1940, Keene Valley Library, Keene Valley, N.Y., p. 14.

John Henry Hill

(1839 - 1922)

The Island Pines, Lake George, 1871

Watercolor 7 x 10
Checklist no. 116

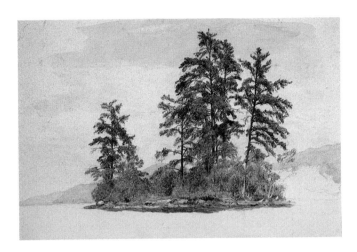

John Henry Hill had a cabin called "Artist's Retreat" on the shore of Lake George from Christmas 1870 through the spring of 1874. His diary for October 18, 1871, reads: "Finished etching subject *Island Pines....*" Less than a week later, on the 27th, he "printed a few impressions of the island pines which came out nicely" and noted "a lovely moonlight night not a cloud in the sky and very mild air."[1] The etching of *The Island Pines*, dated 1871, includes the precise image represented in the museum's watercolor in its right middle ground; the reverse image, together with a half moon, appears in an etched vignette, dated 1871, framing *The Narrows, Lake George* as surveyed by his brother, George W. Hill, and etched by John Henry.[2]

The islands in the Narrows of Lake George occupy much of John Henry Hill's diary, and judging from George W. Hill's survey map, we can identify the tiny island as either Gravelly or Watch. The sketch was probably drawn from a rowboat, as during much of the fall of 1871, John Henry Hill was preoccupied with getting his old boat fixed and making diagrams of the proper shape for a boat's "ribs."[3] *The Island Pines* has a solitary presence and carries with it a "quiet" and "perfect stillness."[4] His technical skill in combining the precisely drawn pines and the broad watercolor strokes which outline the hills beyond captures his own sentiment about his work, "a reminiscing of nature's inevitable beauty, appreciation and delight in that beauty [which] is certainly desirable because elevating...."[5]

1. John Henry Hill, Diary at "Artist's Retreat," October 21, 27, 1871, AML.
2. Hill's *Lake George* etchings are numbers 11 and 9 in the Avery Collection, Print Room, New York Public Library. About the matter of his reversing his drawings in order to prepare his etchings, Hill remarks (about another print), "forgot to reverse it, but it is of little consequence as few would notice the difference." J.H. Hill, Diary, October 19, 1871.
3. Ibid., September 2, 1871.
4. Ibid., September 3, 1871.
5. Ibid., September 2, 1871.

John William Hill

(1812 - 1879)

Untitled: The Raccoon, ca. 1842

Watercolor 4 x 7
Checklist no. 122

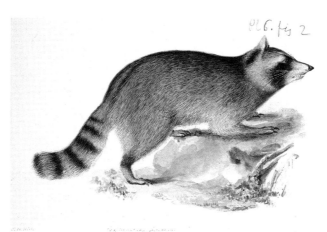

In 1838, John William Hill exhibited an oil of *Otsego Hall, The Residence of J. Fenimore Cooper, Esq.* at the National Academy of Design. The topographical painting was lent by Dr. J.E. DeKay who later included an engraving based on the museum's water-color of a raccoon in the zoology section of *Natural History of New York, 1842.*[1] Hill and DeKay may have become acquainted through Dr. Ebenezer Emmons with whom Hill travelled when Emmons made his third geological expedition to the Adirondacks in 1840. The specificity with which Hill depicts the raccoon suggests that he worked from a museum specimen, such as the one in the State Collection DeKay described in his text.[2] Hill's precise drawing and attention to detail serve to place him, like his son, John Henry, within the "truth to nature" movement in American art associated with Pre-Raphaelitism.

1. James E. DeKay, *Natural History of New York* (Albany, N.Y.: W. & A. White & J. Visscher, 1842), Part I, p. 6, fig. 2.
2. Ibid., p. 26.

Winslow Homer

(1836 - 1910)

Casting, "A Rise", 1889

Watercolor 9 x 20
Checklist no. 123

Homer's watercolor *Casting, "A Rise"* was sketched on Mink Pond at the North Woods Club.[1] In the same year, Homer made an etching of the same subject titled *Fly Fishing, Saranac Lake.* When Homer authority Lloyd Goodrich first saw *Casting, "A Rise"* on December 9, 1939, he commented that it was "effective as illustration, as an expression of mood, of the spirit of the place."[2] Thus far, no original commission for the work to be used as an illustration has been unearthed, but many reproductions have been made of it, particularly in books devoted to the art of fishing.[3] The painting is dark; deep shades of green suggest night-time which is relieved by a linear swirl of white depicting the fishing line in a sweeping "S" motion. Other spots of light define the water's surface and the lily pads in the near foreground.

Although he first visited the Keene Valley area of the Adirondacks where his friends John Fitch and Roswell Shurtleff resided, Homer made later trips, often with his brother, Charles, looking for "the wilder nature that he had come to prefer both as a sportsman and as an artist." Both men were charter members of the North Woods Club which they visited regularly

throughout the 1880s.[4] *Casting, "A Rise"* is part of a series of Adirondack fishing subjects that Homer executed in 1889 whose "linear beauty... handsomeness of pattern [and] resonant color harmonies remind one of the great Japanese printmakers."[5]

1. Norman R. Sturgis, Adirondack Store, to Holman J. Swinney, Director, Adirondack Museum, February 18, 1967.
2. Lloyd Goodrich, "Record of the work of Winslow Homer," New York, City University of New York/Goodrich/Whitney Museum of American Art, December 9, 1939.
3. Such as Lee Eisenberg and DeCourcy Taylor, *The Ultimate Fishing Book* (Boston: Houghton Mifflin, 1981), pp. 38-39.
4. David Tatham, "The Two Guides: Winslow Homer at Keene Valley, Adirondacks," *The American Journal*, vol. XX, no. 2 (1988), p.33. Lloyd Goodrich, *Winslow Homer in the Adirondacks, An Exhibition of Paintings* (Blue Mtn. Lake, N.Y.: The Adirondack Museum, 1959), p.8. David Tatham, "Homer at the North Woods Club" in Nicolai Cikovsky, Jr., ed., *Winslow Homer: Symposium Papers* (Washington, D.C.: National Gallery of Art, forthcoming).
5. Lloyd Goodrich, *Winslow Homer* (New York: George Braziller, Inc.), 1959, p. 28. Two of the related watercolors are fig. 56, *Casting in the Falls*, 1889, collection Mrs. Charles R. Henschel, and fig. 57, *Leaping Trout*, 1889, collection Museum of Fine Arts, Boston.

Charles Dow Hunt

(1840 - 1914)

On the Asauble [sic], 1873

Oil on canvas 15 x 24
Checklist no. 125

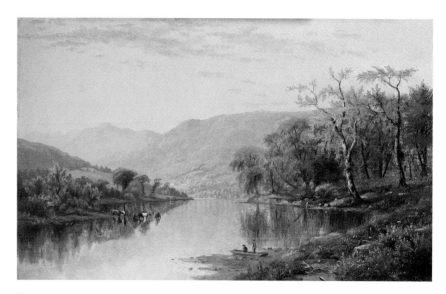

Born in Detroit, C. D. Hunt settled in Brooklyn, New York, and exhibited paintings of the Adirondacks at the Brooklyn Art Academy from the middle 1860s through the late 1890s. This particular view depicts Sand Point on the Ausable Ponds with a view of Sawtooth Mountain in the background.[1] Its primary concern is with light and the reflections of cows and trees in the water; the yellow-oranges of autumn diffuse with a coral sky to create a veiled atmosphere that disperses form and evokes reverie.

1. Peggy O'Brien, *Adirondack Paintings* (Plattsburgh, N.Y.: Myers Fine Art Gallery, State University College, 1972), cat. no. 32, unpaged.

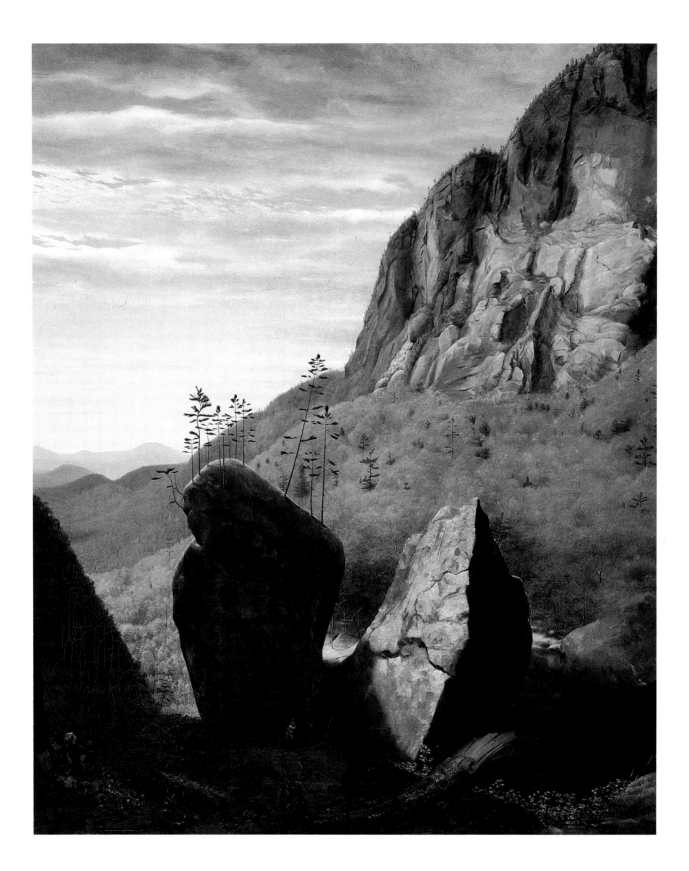

Charles Cromwell Ingham

(1796 - 1863)

The Great Adirondack Pass, Painted on the Spot, 1837

Oil on canvas 48 x 40
Checklist no. 127

In June 1837, Thomas Cole asked Charles Ingham to join him at Schroon Lake in the Adirondacks. Ingham replied, "I hope to be able to join a party that is going to Mc-Intyre's settlement to spend a month. I am told it is much more savage country than the one you were in, that there is no land capable of cultivation at all. A good deal of time we will camp out, as there is but one house on the place. I will show you my sketches; they will not be as numerous as yours or Durand's."[1] In August 1837, Ingham did indeed join Archibald McIntyre, owner of the 100,000 acre tract in Essex County which would be incorporated as the Adirondack Iron & Steel Co. McIntyre had made the trip a year earlier with his son-in-law, David Henderson, and Mr. James Hall, assistant State Geologist for the Northern District, among others.[2]

The 1837 journey included Dr. Ebenezer Emmons, then a professor of geology at Williams College and State Geologist of New York, as well as Ingham.[3] The fruit of Emmons' participation was his *Report on the Second Geological District* published by the New York State Legislature in 1842. Ingham's role was precisely stated in the title he gave this painting when it was exhibited at the National Academy of Design in 1839, to paint what was known as Indian Pass "on the spot." The motivation for pictorial accuracy was linked to the critically important geological survey which contained an "exhaustive description of the ore deposits of the entire Adirondack region."[4] A lithograph by John H. Bufford based on Ingham's painting appeared in the preliminary version of the *Report* published in 1838.[5]

In the fall of 1837, Charles Fenno Hoffman had visited the Pass, finding "a sloping platform amidst the rocks, where the finest view of the whole scene is to be obtained, and from which, during the last summer, Mr. Ingham, the artist, took a view of the Indian Pass." Hoffman predicted that "a few years hence, and I doubt not that the Indian Pass will become as favorite a place of resort as Lake George, Trenton Falls or Niagara."[6] Later, Jervis McEntee verified Ingham's "on the spot" triumph stating that: "We climbed the ledge and after walking perhaps fifty rods came to the place where Ingham took his sketch...the view is toward the West instead of the East as I had supposed and was the most magnificent picture I had ever gazed upon."[7] Still later, in *The Indian Pass*, Alfred Billings Street stated: "I wish to bear testimony to the graphic accuracy of the engraving of the loftiest point of the Indian Pass...it is a perfect photograph of the magnificent sight."[8] The painting entered the museum by way of McIntyre descendants. A year after Ingham had exhibited it at the National Academy, he wrote David Henderson, saying: "Having exhibited *The Adirondack Pass* as much as I desire, I wish to send it as a present to Mrs. McIntyre as a small token of the many obligations I feel myself under to Mr. McIntyre."[9]

1. Charles C. Ingham to Thomas Cole, July 10, 1837, Manuscript Room, New York State Library, Albany, N.Y.
2. Arthur H. Masten, *The Story of Adirondac*, with introduction and notes by William K. Verner (Blue Mtn. Lake, N.Y.: The Adirondack Museum and Syracuse University Press, Syracuse, 1968), p. xxxvii and p. 74.
3. Ibid., pp. 76, 82.
4. Ibid., p. 82.
5. New York State Assembly, *Document 200*, 1838, relative to the Geological Survey of the State (Albany, 1838), pl. 2 as "View of the Indian Pass."
6. C.F.H. [Hoffman], "Scenes at the Sources of the Hudson," *New York Mirror* (October 7, 1837), p. 119.
7. Jervis McEntee, Diary, August 2, 1851, AML, MS 67-19, p. 81.
8. Alfred B. Street, *The Indian Pass*, (1869; repr., Harrison, N.Y.: Harbor Hill Books, 1975), p. 63.
9. Gratz Collection, Philadelphia Historical Society of Pennsylvania, Archives of American Art, Smithsonian Institution, Washington, D.C., reel P22, frame 246, March 21, 1840.

Henry Inman (attributed)

(1801 - 1846)

Untitled: Portrait of Henry Eckford (1775-1832), n.d.

Oil on wood panel 9 x 9
Checklist no. 130

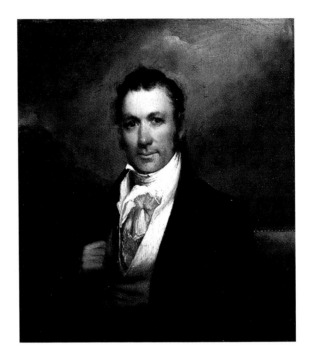

On June 20th, 1833, William Dunlap noted in his *Diary* that Thomas Sully, the distinguished Philadelphia portrait painter, had spoken of Inman, saying that on "going around your Exhibition room at N.Y. [National Academy of Design]," he had come upon "the finest Miniature I ever saw - it was a Lady in Black. Who is the Miniature painter?" he asked. "Inman" was the reply.[1] Inman's Portrait of Henry Eckford cannot be classed as a miniature, and was not exhibited in this National Academy exhibition. However, it does demonstrate "the rapidity, diversity and excellence" with which Sully characterized Inman's large portraits.[2] The museum's picture, although unsigned, very much resembles Inman's signed painting of *John Watts, Jr.* in the Museum of the City of New York.

Inman probably painted Eckford's portrait sometime before 1825 when Eckford's fortune as a ship builder was lost due to the opening of the Erie Canal and the ensuing collapse in freight rates. Prior to that date, Eckford's portrait had been painted by Inman's colleague at the National Academy of Design, Robert Fulton.[3] Fulton's association with Eckford was marked by their mutual interest in surveying connected lakes in the central Adirondacks, later known as the Eckford Chain and the Fulton Chain of Lakes. In addition to the portrait, Eckford's link with Fulton is documented by his having built a private ocean-going steam vessel named after Fulton in 1819.[4]

1. William Dunlap, *Diary of William Dunlap, 1766-1839* (New York: New-York Historical Society, 1930), vol. III, p. 693.
2. Ibid.
3. Harold K. Hochschild, *Township 34, A History with Digressions of An Adirondack Township in Hamilton County in the State of New York* (Privately printed, 1952), p. 51, ill. The Fulton portrait of Eckford is in the National Gallery of Art, Washington, D.C.
4. Ibid., pp. 49-52.

David Johnson

(1827 - 1908)

Lake George, Looking North, from Tongue Mountain Shore, 1874

Oil on canvas 14 x 22
Checklist no. 131

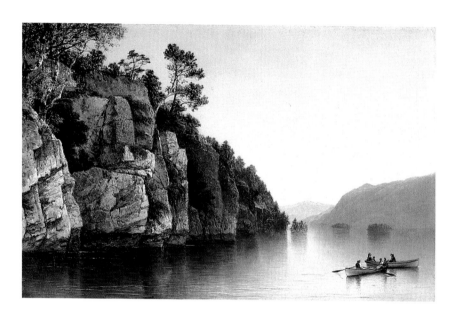

David Johnson and his wife visited John Henry Hill at the "Artist's Retreat" on Lake George in 1870.[1] In 1872, Johnson did a careful pencil study of a rock configuration on the lake from the top of which sprout new trees.[2] A very similar grouping of rocks appears to the left in the museum's painting *Lake George, Looking North, from Tongue Mountain Shore.* To the right of the picture, Johnson depicts two Lake George rowboats, one with a mother and child and the other with two ladies enjoying an afternoon's row on the lake. Massive rock fissures dominate the painting on the left contrasting with the smooth, even waters of the lake on the right. Johnson's paintings "record the mid-century Lake George, not an inaccessible wilderness but a serene vacation spot, rich with natural beauty."[3]

Although Johnson's association with the Adirondacks is principally related to his paintings of the Lake George area in the 1870s, namely Buck Mountain, Cat Mountain and Roger's Slide, a recent catalogue *raisonné* records paintings based on views further north in Essex County as early as 1859.[4] It is possible that his later concentration on the Lake George area stemmed from his life-long friendship with John Frederick Kensett.[5]

1. John Henry Hill, Diary at "Artist's Retreat," September 12, 1870, AML.
2. Gwendolyn Owens, *Nature Transcribed: The Landscapes and Still Lifes of David Johnson (1827-1908)* (Ithaca, N.Y.: Herbert F. Johnson Museum of Art, 1988), cat. no. 46, ill.
3. Ibid., pp. 36-37.
4. Ibid., "A Working List of Paintings by David Johnson," pp. 69-84.
5. Ibid., cat. no. 1, p. 16 illustrates Johnson's "First Study from Nature - made in company with J.F. Kensett and J.W. Casilear." It is dated 1849 and depicts *Haines Fall, Kauterskill Clove.*

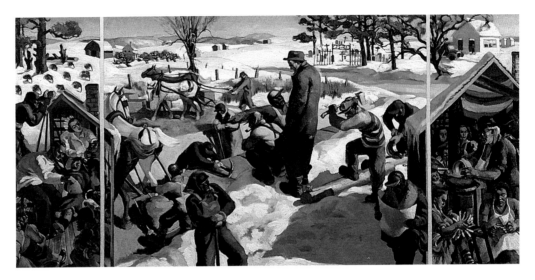

Amy Wisher Jones
(1899 -)

St. Regis Reservation, 1937

Oil on masonite 28 x 53
Checklist no. 133

Jones' triptych describes daily activities on the St. Regis Indian reservation during the 1930s. It was submitted in competition for mural commissions given by the United States Department of Interior as part of the Works Progress Administration projects of the Roosevelt era. The St. Regis mural was never actualized, but it led to Jones' assignment in 1938 to execute a mural for the Winsted, Connecticut, Post Office.[1]

Amy Jones became familiar with the Iroquois Indians at St. Regis while her husband was recovering from tuberculosis at the Trudeau Sanitarium in Saranac Lake. She sketched the panels from life; on the left, a doctor and nurse examine a child's chest for tuberculosis, and on the right, the central figure dyes splints encircled by women and children making baskets. The center panel revolves around a non-Indian supervisor overseeing the arrival of logs and their being cut into splints for use in basketry. The spatial organization of this central picture reveals Jones' academic training and familiarity with old master paintings. She has placed the supervisor, like Raphael's *St. Paul at Athens*, on a level above the work-a-day scenes of horses carting logs and the snowbound Catholic cemetery in the far right. He is at once the pivot of activity and a stranger.

Amy Jones chose reservation life at St. Regis because the subject related, she felt, to the national awareness of family health and the dignity of labor. It is the first art owned by the museum from the WPA era, and with its emphasis on public health, manual labor and the crafts livelihood of the basket makers, it has strong social and political references. It is a valid representation of Indians in northern New York by an artist who spent nearly 15 years in Saranac Lake.

1. Karal Ann Marling, *Wall-to-Wall America, A cultural history of post-office murals in the great depression* (Minneapolis: University of Minnesota Press, 1982), pp. 204-205, ill. The subject of the mural was *Lincoln's Arbiter Settles the Winsted Post Office Controversy.*

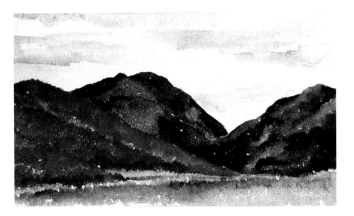

Herbert S. Kates
(1894 - 1947)

Avalanche Pass, 1924

Watercolor 4 x 7
Checklist no. 143

In the early 1920s and 1930s "when few people were on the mountains," Herbert Kates and his brother, Jerome, climbed forty-four of the Adirondack high peaks, using Robert Marshall's, *The High Peaks of the Adirondacks,* 1922, as their guide.[1] Born in New York City, Herbert studied at the Art Students League and the Pratt Institute. Later, he studied medical art at Johns Hopkins University, and when World War I broke out in 1917, he became the first medical artist in the United States Army. His meticulous

Adirondack drawings are memorialized in Russell Carson's *Peaks and People in the Adirondacks.* Carson noted that: "I have never heard of any other artist who carried a bottle of ink on his back for five weeks without spilling it."[2]

Kates' proficiency with watercolor, as well as ink, can be noted in the museum's collection of thirty watercolors, given by Jerome Kates. *Avalanche Pass* is one of the smallest of Kates' watercolor drawings; its 1924 date suggests that its inception may be substantiated by Jerome's logbook of the brothers' climbs that August. On these sojourns, each brother had a specific role: Jerome was "pathfinder and trail leader" as well as moving picture photographer; Herbert, in addition to being artist and still photographer, was the cook and builder

of balsam beds.[3] The latter activity is described with care by Jerome on their way to Panther Peak. "By chopping six young balsams and trimming their branches," he writes, "we made a floor of poles upon which we laid the springy branches. On top of this we shingled a huge pile of balsam tips and we had a real comfortable woods bed."[4]

1. Peggy O'Brien, "The Kates Brothers: A Creative Team, Part II," *Adirondac,* vol. XLIX, no. 10 (December 1985), p. 18.
2. Jerome S. Kates, "Herbert S. Kates 1894-1947 A Remembrance," *Adirondac,* vol. XLVIII, no. 1 (January 1984), p. 14.
3. Peggy O'Brien, "The Kates Brothers: A Creative Team, Part I," *Adirondac,* vol. XLIX, no. 9 (October/November 1985), p. 8.
4. Ibid., from the 1924 Logbook of Jerome Kates: "We Climb Panther and Santanoni," p. 11.

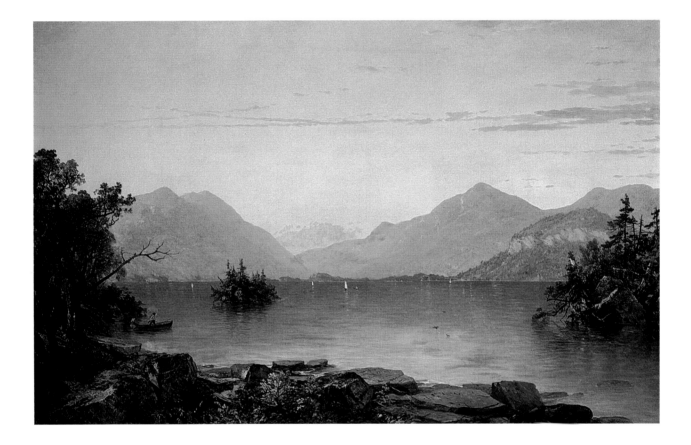

John Frederick Kensett

(1816 - 1872)

Lake George, 1856

Oil on canvas 26 x 42
Checklist no. 165

Kensett first visited Lake George in 1853. The lake became his signature as a subject, culminating in *Lake George*, 1869, which now hangs in the Metropolitan Museum of Art.[1] The museum's version more closely resembles that of 1853 in the Williams College Museum of Art.[2] Both depict the lake encircled with juttings of rocky coastland, tree strewn islands and mountain vistas which leave little pictorial space for Kensett's later preoccupation with water and its absorption of light. Hints at his ability as a colorist can, however, be marked in the deftness with which the pinkish tones of the mountain reflect the horizontal clouds above and are mirrored in the calm lake below forming an atmospheric unity of color tone that won Kensett "the honor of being called the lyrical poet of American landscape art" by his contemporaries.[3]

By the time he first visited Lake George, Kensett was one of the best known and most successful landscape painters in America. The engraved version of his 1851 *Mount Washington* was circulated across the country to subscribers to the American Art-Union lottery.[4] The precision with which Kensett depicts the foreground detail of rocks and shrubs in *Lake George* reveals his own early training as an engraver.

1. John K. Howat, *John Frederick Kensett 1816-1872* (New York: The American Federation of Arts, 1968), chronology, unpaged, cat. no. 40, ill.
2. Ibid., cat. no. 18, ill.
3. Henry T. Tuckerman, *Book of the Artists* (New York: 1867; repr., New York: James F. Carr, 1967), p. 512.
4. Maybelle Mann, *The American Art-Union* (Otisville, N.Y.: ALM Associates, Inc., 1977) p. 74, ill. The engraving was executed by James Smillie.

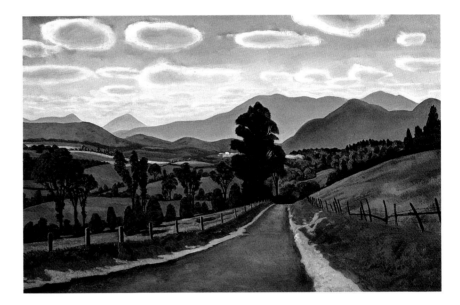

Rockwell Kent

(1882 - 1971)

Mountain Road, ca. 1960

Oil on canvas 28 x 44
Checklist no. 168

*M*ountain Road depicts Kent's view of the Adirondacks near his dairy farm in Au Sable Forks. The farm, built in 1928 and destroyed by fire in 1969, was called Asgaard, meaning Farm of the Gods. On its five hundred acres, Kent kept forty Jersey cows. Kent's land overlooked the east branch of the Ausable River and had as a backdrop the high peaks with Whiteface Mountain to the west. In his book, *This Is My Own*, written twenty years before the museum's picture was painted, Kent wrote: "Mount Whiteface dominates the Adirondack mountain region. It stands alone, commanding thousands of serene and beautiful, unscarred, unbuilt upon square miles...,

it does command - not by its height alone or by the grandeur of its form, but by that portion of the unchanged wilderness that it holds up for us to see and contemplate: a symbol of immutablilty."[1]

The crisp clarity with which Kent describes *Mountain Road* reveals his years as both an architect and illustrator. His forms are simple and straightforward, and his vibrant colors remain flat on the surface of the canvas. His pictorial creation is symbolic, rather than illusionary. Fences define both sides of the road; the one on the left is regular and rectangular in its posts and their positioning, while the one on the right is haphazard in its shape and angle

and is strung together with strands of barbed wire. These differences preview those of the mountains ahead - with sharp peaks on the left and rounded clusters on the right. Geometrically shaped clouds enclose the scene from above, creating a scenario of natural order which bespeaks Kent's personal dedication to world peace.[2]

1. Rockwell Kent, *This Is My Own* (New York: Duell, Sloan and Pearce, 1940), p. 229.
2. Kent was presented the Lenin Peace Prize in 1967 and subsequently donated $10,000 of the award to the Viet Cong women and children, despite a U.S. prohibition on gifts to Vietnamese Communists. See *Albany Times Union* (July 18, 1967).

Charles Lanman

(1819 - 1895)

Untitled:
Temporary Camp, n.d.

Oil on canvas 18 x 24
Checklist no. 171

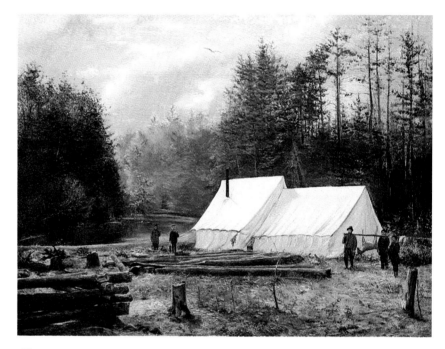

Charles Lanman was an inveterate traveller and an amateur artist. His career centered in Washington, D.C., where he catalogued the private art collection of William Wilson Corcoran in 1857 and published the *Dictionary of the United States Congress* in 1859.[1] He executed at least 1,000 oil studies, all made on the spot during his summer tours across America.[2] This painting of a temporary camp shows his gift for narrative detail. He describes with architectural precision two adjoining white canvas tents situated near a river bank. The roof of the tent closest to the water is pierced with a stove pipe which suggests it may be the cooking area. The campers, outside the tents, display their conquests: fish near the river bed and deer from the woods at the right. The real work lies in the foreground of the painting where a log cabin is being constructed. The painting has a documentary air, depicting an inventory of the chores and pleasures of outdoor life in backwoods America of the 1800s.

1. Harry Frederick Orchard, *Charles Lanman Landscapes and Nature Studies* (Morristown, N.J.: Morris Museum of Arts and Sciences, 1983), p. 14.
2. Ibid., E. Maurice Bloch, Foreword, p. i.

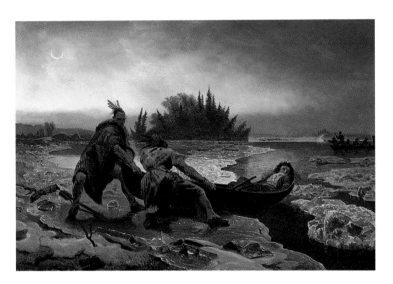

Emanuel Gottlieb Leutze

(1816 - 1868)

Indians and American Captive, ca. 1862

Oil on canvas 17 x 25
Checklist no. 173

German-born Emanuel Leutze is best known for his painting of *Washington Crossing the Delaware,* ca. 1851, which he executed in Dusseldorf with Worthington Whittredge, due to his height, serving as a model for Washington. Following the *Washington* picture, Leutze entered into lengthy negotiations with M.C. Meigs, the architect of the United States Capitol, with regard to his designing a mural for the building's interior. The mural, painted in stereochromy, or mineral painting, a modern process initiated in Germany in the 1840s, was entitled *Westward the Course of Empire*

Takes Its Way.[1] *Indians and American Captive* dates from the same period as the Capitol mural and has been related to the Indian scenes of Charles Wimar whom Leutze had known in Dusseldorf.[2] Although Leutze did travel to the western territories of the United States in preparation for the mural, it is unlikely that the museum's painting, also known as *The Pioneer's Daughter,* was based on direct observation. Rather, it is a studio stage setting, not unlike *Washington Crossing the Delaware,* in the woodenness of its figures and the artificiality of its ice floe. Like the *Washington* picture, *Indians and American Captive* may well have German political overtones, for Leutze was an activist in the German Revolution of 1848 for which the American Revolution served as a prototype and symbol.[3]

As with the *Washington* painting, whose original was destroyed by fire in the studio, the museum's picture is a replica of one owned by the

Thomas Gilcrease Institute of American History and Art in Tulsa, Oklahoma. Its provenance is made certain by its having come to the museum via Dusseldorf where Leutze returned after having completed his mural in 1863.[4] Its visual and dramatic strength rivet the viewer's attention, but its purported association with Lake George is tenuous.[5]

1. Barbara S. Groseclose, *Emanuel Leutze, 1816-1868: Freedom is the Only King* (National Collection of Fine Arts, Smithsonian Institution, Washington, D.C., 1975), pp. 96-97.
2. Ibid., nos. 102, 106, ill., pp. 97-98.
3. Ibid., pp. 36-38.
4. Ibid., p. 68. William K.Verner, in notes dated November 15, 1968, AMA files, states that prior to World War I the painting was in the collection of Wilhelm Mugs, Bank Director, Dusseldorf.
5. Harold K. Hochschild to R.B. Inverarity, Director, Adirondack Museum, June 23, 1965, AMA files refers to the dealer's suggestion in a letter of June 18, 1965, that the scene of the painting is located at Lake George.

Jonas Lie
(1880 - 1940)

Men's Camp and Stables, 1930

Oil on canvas 30 x 45
Checklist no. 176

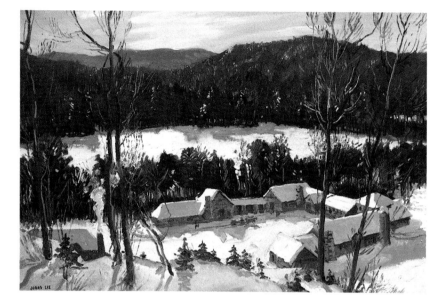

Jonas Lie spent February 1930 painting at Kamp Kill Kare on Lake Kora about four miles south of Raquette Lake. He did so at the request of the camp's owners, Mr. and Mrs. Francis P. Garvan, with whom he had become acquainted while staying in the Adirondacks in the 1920s. The commission dated from 1928, but the time of execution was entirely of Lie's choosing.[1] Lie, a Norwegian by birth, was partial to winter, and February 1930 was a notably mild one.[2]

Lie is known to have painted in the Adirondacks as early as 1921.[3] He lived in the Saranac Lake region full time in 1923 and 1924 while his second wife, the Norwegian dancer Inga Soutum, was being treated for tuberculosis at the Trudeau Sanitarium in Saranac Lake.[4]

Lie painted ten oils, all of good size, at Kill Kare.[5] Represented were architectural subjects such as the camp and stables, the boathouse, chapel and main camp, as well as landscapes of trees, the lake and the home pond outlet. A 1931 review of these pictures pointed out Lie's "silver birch composition - a subject which one has come to inevitably

83

associate with his name."[6] *Men's Camp and Stables* is painted from a high perspective, permitting an overview of the organization of the compound and its relationship to the land. Rather than overwhelming the onlooker with minute architectural details, Lie presents a mood of comfort, showing buildings nestled in surrounding mountains. The vitality of his paint treatment - with its thick, broad strokes and intense colors - is so arresting that it is several moments before we realize the area depicted, designed for human and animal activity, is devoid of either. The painting leaves an impression of stillness and snow, and we are reminded of Lie's lineage to his uncle, the Norwegian poet and novelist after whom he was named.

1. Anthony N. B. Garvan, *Adirondack Winter - 1930: Paintings by Jonas Lie* (Blue Mtn. Lake, N.Y.: The Adirondack Museum, 1971), p. 6.
2. Ibid., pp. 6-7.
3. Peggy O'Brien, notes on Jonas Lie, AML, p. 1 refers to Lie's having painted *Ice Harvest* in 1921 which depicts the cutting of ice on Lake Placid.
4. Garvan, p. 3.
5. Ibid. All are illustrated.
6. Helen Appleton Read Papers, Archives of American Art, Smithsonian Institution,Washington, D.C., reel N736, frame 296.

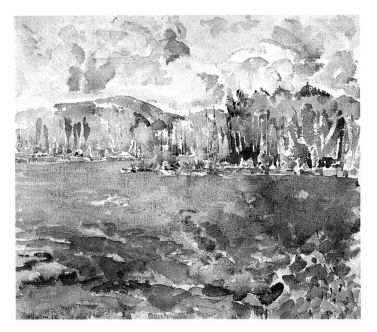

John Marin
(1870 - 1953)

Adarondack [sic] *Lake,*
1911

Watercolor 14 x 16
Checklist no. 178

The period just before the First World War is usually associated with Marin's cubist interpretations of the Manhattan skyline and the romance of modernity and the city. However, in tandem with his spatial explorations of architectural subjects, Marin was working on landscapes of the Berkshires and the Adirondacks. *Adarondack* [sic] *Lake* is an arrangement of color planes loosely washed on; turquoise water is shadowed by fuchsia colored tree trunks whose upper boughs are brightened with chartreuse leaves. The museum's watercolor conveys Marin's personal exuberance at this time when he was engaged to Marie Jane Hughes who travelled with him to the Adirondacks and "went along on the painting trips daily, just as she was to do...for the rest of her life."[1]

1. MacKinley Helm, *John Marin* (Boston: Pellegrini and Cudahy, 1948), p. 27.

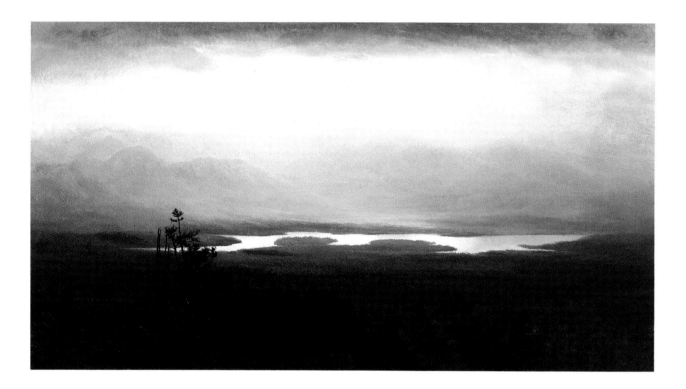

Homer Dodge Martin

(1836 - 1897)

Mountain View on the Saranac, 1868

Oil on canvas 30 x 56
Checklist no. 183

Homer Martin made his first trip to the Adirondacks in 1864 and continued to visit the mountains regularly for more than a decade. He went first to Keene Valley where his teacher and fellow Albanian, James Hart, had summered since 1860. Martin enjoyed the out-of-doors and the rustic solitary life of camping. He wrote his friend William C. Brownell in August 1875 from Jackson's, Indian Lake: "How are you for a couple of weeks vacation and why won't you think well of the green and silent woods?"[1] Love of the wilds beckoned Martin to the more remote western region of the Adirondacks represented in this vista. *Mountain View on the Saranac* had practical as well as pleasurable motives. Martin was commissioned by the periodical *Every Saturday* to illustrate an article promoting William H.H. Murray's recently published *Adventures in the Wilderness* which generated a tourist boom in the Adirondacks of the 1870s. The choice of Martin for illustrator may have been suggested by Martin's good friend, Winslow Homer. Homer had been associated with magazine illustration, most notably for his depictions of the Civil War, and knew of Martin's standing interest in the Adirondacks. Homer himself made his first trip to that area in 1870, the year Martin's wood engraving appeared.

The engraving, *Mountain View on the Saranac*, has long been revered both for its classical bird's eye panorama and its association with "Murray's Rush." On the other hand, this Adirondack Museum publication marks the first time that the oil on which the print is based has been illustrated. For nearly a hundred years, the painting hung unrecognized in a part of the United States that has nothing to do with either the Adirondacks or Martin, namely Dillon, Nevada. The town was the hub of the gold and silver rush in the late nineteenth and early twentieth centuries, and *Mountain View on the Saranac* graced the walls of Dillon's Eagle Hotel. The only thread of connection with Martin might be Martin's eldest son, Ralph, who was involved in mining. It is possible that Ralph visited Dillon and was able to barter this good-sized canvas for room and board.

Mountain View mingles the suggestion of air and atmosphere with a geographically correct topographical view. The Saranac Valley in the middle ground rivets the eye, while its waters provide the lightest point in the painting. The soft lavenders and grays of the river are echoed in the lavender and rose of the sky; both stand in dynamic pictorial contrast to the dark green trees of the foreground mountain peak. Martin was particularly noted for his use of color, especially in his treatment of the sky.

1. Martin to Brownell, August 18, 1875, Princeton, N.J., Princeton University Library, Rare Book Collection.

Jervis McEntee
(1828 - 1891)

Wood's Cabin on Rackett [sic] Lake, 1851

Pencil drawing 11 x 13

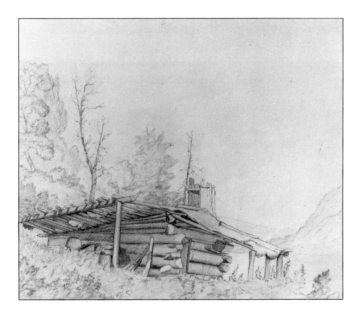

Jervis McEntee was primarily an artist of his native Catskill mountains. He first visited the Adirondacks as a youth of twenty-three and recorded his impressions in both diary and newspaper reports.[1] McEntee saw Wood's cabin on Raquette Lake on July 6th, 1851. He described it as "comfortable" with "unmistakable traces of industry" and "built of logs with a bark covered porch in front. It stands on a gentle elevation about fifty yards from the lake [and Wood] has a very good garden, entirely free from weeds and quite a field of rye and potatoes growing." It was after McEntee had seen the cabin that Wood appeared and McEntee writes: "I wondered when I saw him that a man like him should be able to live in so wild a region. He was an unfortunate cripple - both feet having been frozen so as to render amputations of the legs necessary as he was compelled to walk on his knees... yet travels over this wild country for miles in all directions."[2]

When McEntee went to "sketch with pencil...Wood's house" twelve days after his first visit, Wood was absent, "having gone by the inlet after a moose. It was a beautiful day, the lake was at times still and placid then ruffled by a gentle breeze [and] the raspberries were beginning to ripen...and [we] had nearly as many as we could eat."[3]

1. J.M., "Rambles in the Adirondacks," *Rondout Courier* (July 18, 1851), p. 1. Cited in *Selection of Drawings by Jervis McEntee* (New York: Hirschl and Adler Galleries, 1976), footnotes, unpaged.
2. Jervis McEntee Diary and Sketchbook, Archives of American Art, Smithsonian Institution, Washington, D.C., reel D9, frame 589.
3. Ibid., frame 594.

Andrew W. Melrose

(1836 - 1901)

Lake George, n.d.

Oil on canvas 22 x 36
Checklist no. 186

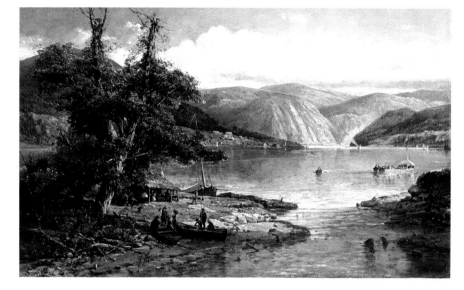

Melrose's view of *Lake George* is distinguished by its emphasis on the activities taking place on the lake, rather than its evocation of quietude. Rowboats and day cruisers with canopied roofs are depicted along with sailboats, fishermen and a hut that services all these varieties of water recreation. The popularity of this workaday scene is evidenced by its having been chromolithographed for the amusement of a more general public.

Nelson Augustus Moore

(1824 - 1902)

Untitled:
Lake George, 1872

Oil on canvas 14 x 24
Checklist no. 187

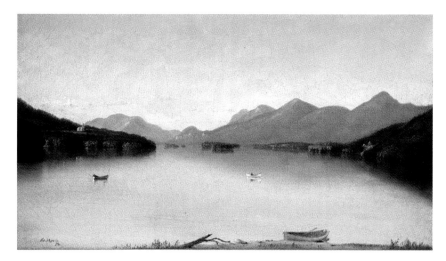

Moore's earliest dated painting of Lake George was executed in 1866.[1] He summered there for the next twenty-five years.[2] His arrival at the lake coincided with his decision to give up a successful daguerreotype studio in New Britain, Connecticut, and become a painter, first of portraits and then, of landscapes.[3] His panoramic view of Lake George is organized from a high perspective as if shot from a camera. His emphasis is on the lake itself with its reflections of the hills beyond. Three boats are depicted but only as spatial demarcations; Moore's painting is of the lake, not the people who enjoyed its waters. It is a souvenir, post-card view, cool and objective in tone.

1. *Nelson Augustus Moore (1824-1902)* (New Britain, Conn.: New Britain Museum of American Art, 1981), unpaged.
2. *Mid Nineteenth Century Landscapes by N.A. Moore, 1824-1902* (Boston: Vose Galleries, 1971), unpaged.
3. *Nelson Augustus Moore (1824-1902)*. Information is based on Ethelbert Allen Moore (N.A. Moore's son), *Tenth Generation* (Privately printed, 1950), p. 17.

William Ongley

(1836 - 1890)

Untitled: Hunters in Canoe, ca. 1886

Oil on canvas 18 x 30
Checklist no. 198

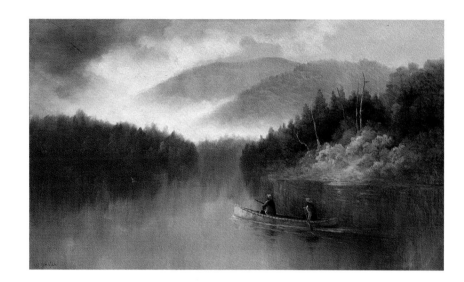

Little is known about William Ongley except that he was born in England, was a resident of Utica, New York, and "was found dead in his bed at Oil City, Pennsylvania" on November 20th, 1890. He died while travelling on tour to sell his pictures.[1] The misty view of hunters in a canoe chasing an antlered deer swimming a distance in front of their boat closely resembles another painting by Ongley whose title, *The Chase*, is inscribed on its stretcher.[2] Both scenes are extremely generalized, focusing on the hunters, one with rifle aimed from the bow of the canoe and the other paddling stern. The dramatically lit mountain scenery is more suggestive of a stage setting than that of a specific Adirondack site. The painting, with the exception of the figures, is executed in a loose, slap-dash fashion suggesting Ongley's possible training as a set designer. According to his obituary, his "productions" - a word with distinct theatrical overtones - "usually found a ready sale."[3] We attribute the painting to ca. 1886 on the basis of its stretcher brace, patented December 21, 1886.

1. *Utica Daily Observer* (November 21, 1890), p. 5. Courtesy of Rosemarie Romani, Librarian, Everson Museum of Art, Syracuse, New York, and Diane Mathews, Secretary, Oneida County Historical Society, Utica, New York. Letter dated August 19, 1987, AMA files.
2. Painting in the collection of George Friend, Hamilton, New York. Slide dated August 1980 in AMA files.
3. *Utica Daily Observer* (November 21, 1890), p. 5.

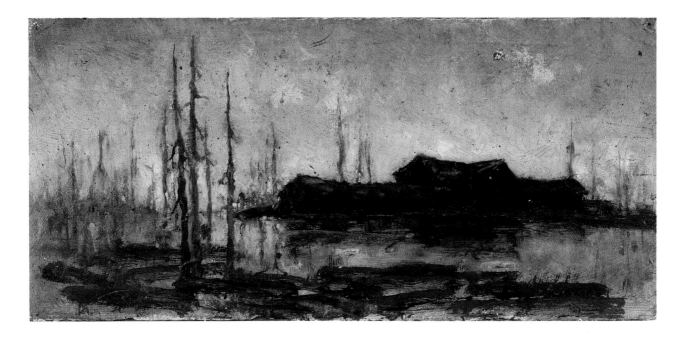

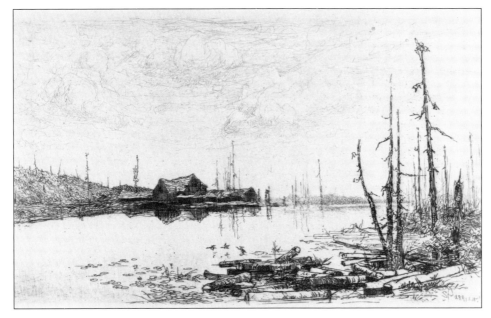

Stephen Parrish

(1846 - 1938)

Flooded Lands, Adirondacks, 1880

Oil on cardboard 4 x 9
Etching - image 4 x 7
Checklist no. 202

Stephen Parrish, father of the better known Maxfield Parrish, visited the area around Schroon Lake shortly after he had become a painter and an etcher. The museum is fortunate in owning both his oil sketch for *Flooded Lands, Adirondacks,* and the etching after it. They are approximately the same size and provide an opportunity to compare the painting and printmaking techniques of America's most distinguished painter-etcher, with the exception of expatriate, James Abbott McNeill Whistler (1834-1903). Parrish's distinction lay not only in his subject matter, which ranged from *Fishermens Houses Cape Ann,* 1881, to *A Florida Swamp,* 1887, but in his subtle use of technique. Parrish's etched line creates dense areas of shadow which are set off in dramatic contrast to passages of total whiteness interrupted by only the merest suggestion of line, such as the tiny dog paw prints which mark the snowy landscape in *A Winter's Day - Windsor, N.S.,* 1887.[1]

While the monochromatic painting *Flooded Lands* displays a broadness in brush stroke and a primary interest in dramatic effect, playing darkness against light, and the horizontal mass of the buildings on the right against the spindly, water-soaked trees at the left, the etching achieves the same results with greater acuity. Parrish was particularly ambivalent about his work in both mediums at this time in his career and wrote the critic S.R. Koehler July 13, 1880, regarding a different image: "...and the painting is far superior to the etching."[2] Later in the summer, he wrote, "I shall now turn my attention ...more to painting, putting aside the needle for a time. I find the two play well into each other's hand and each acts as a relaxation to the other."[3] By the following July, a year after both forms of *Flooded Lands* had been executed, he wrote: "...and just now the needle seems handier to hold than the brush."[4]

1. See Thomas P. Bruhn, "Stephen Parrish (1846-1938)," *American Etching: The 1880s* (Storrs, Conn.: The William Benton Museum of Art, University of Connecticut, 1985), cat. nos. 81, 92, 91.
2. Sylvester Rosa Koehler Papers, Archives of American Art, Smithsonian Institution, Washington, D.C., reel D189, frame 0192 - 0193.
3. Ibid., frame 0181 - 0182, September 5, 1880.
4. Ibid., frame 0237, July 24, 1881.

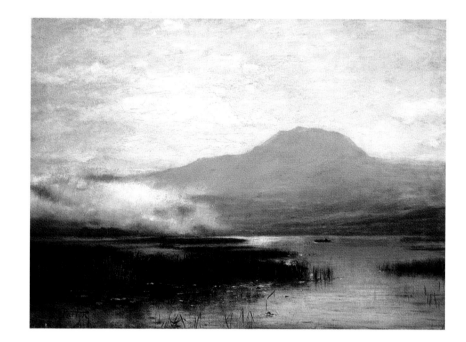

Arthur Parton
(1842 - 1914)

In the Adirondacks,
ca. 1866

Oil on canvas 21 x 29
Checklist no. 204

In the Adirondacks blends the gray rising mist with deep green spikes of grass in the marshy foreground. Parton interweaves colors to produce atmospheric effect. The whitish tone of the mist is echoed in the thick impasto of the sky and the white accents of water lilies floating amidst the grasses in the near foreground. The museum's oil marks the first of Parton's forays in the Adirondacks where he continued to visit for the next decade, concentrating on the area around Keene Valley and the Ausable Lakes.[1]

Parton was an experienced fisherman, noted for being "the best fishing fellow you could wish to meet...and how he can paint!"[2] We can imagine him as the solitary fisherman in this dream-like scene, full of calm and the mystery of nature. As a student of William Trost Richards in the early 1860s, Arthur wrote his brother Ernest in 1863 not to bother to come to Philadelphia or in fact to have lessons at all. Rather, he wrote: "What little advances I have made within a few years is not to instructions from any master but to labor out of doors...."[3] *In the Adirondacks* evokes Parton's intimacy with nature.

1. Georgette Turner, "Mystical Paintings by Arthur Parton,"

The Chatham Courier, Section B (November 1, 1973), ill., shows Parton's *Rapids on the Ausable* engraved by R.C. Morrand in *Aldine Magazine,* vol. VII, no. 10 (October 1874). Peggy O'Brien, notes on Arthur Parton, AML, n.d., pp. 1,5 cites Register of Mansion House, Elizabethtown, N.Y., for Parton's visit in July 1874.
2. George Gould to his father, Jay, from Catskill Country in "Bye the Bye on Wall Street," *Wall Street Evening Edition* (May 23, 1923) in Archives, National Academy of Design, New York.
3. Charles W. Parton, grandson of Arthur, to Abigail Booth Gerdts, Associate Director, National Academy of Design, n.d. in Archives, National Academy of Design, New York.

Levi Wells Prentice

(1851 - 1935)

White Birches of the Racquette [sic], ca. 1878

Oil on canvas 30 x 25
Checklist no. 211

Prentice shared with his contemporaries a keen interest in the observation of the natural phenomena inherent in *White Birches of the Racquette* [sic]. He recorded these elements, however, with a freshness that comes with freedom from artistic preconceptions. Like so many others, he was self-taught; more importantly, Prentice was self-reliant in his artistic notations. In *White Birches*, the energy with which sheaves of birch bark fall from the tall erect trunks at the left of the painting suggests a primordial era when trees were thought to have personae of their own. The animation with which Prentice draws the spiralling of loose bark connotes the rhythms of mythic goddesses unveiling themselves before

a retinue of stoic, regularly-placed druidic pines depicted at the right.[1] Prentice's vision anticipates the early 1900s primitivism of Henri Rousseau (called le Douanier) in France who, in turn, inspired the cult of artistic surrealism of the 1920s associated with the paintings of Max Ernst and Salvador Dali. Levi Wells Prentice is at once the most primitive and the most modern of Adirondack painters.

Prentice's adherence to his particular natural and artistic order is further underlined in his habit of constructing his own frames of birch and pine indigenous to the real Adirondack woods he was recreating on canvas (see checklist no. 215).[2] A self-framed Prentice painting is a hermetic entity.[3]

1. The near-sculptural, almost goldsmith quality to Prentice's treatment of birch bark had a practical source: his father, and brother Albert, were confectioners. Ribbon candy shapes come to mind. See William K. Verner, "Nature and Art, The Adirondacks and the Paintings of L.W. Prentice," unpublished manuscript, late 1960s, p. 5 and letter from Alberta De Mere Prentice Poppe, daughter of Albert Prentice, to William K. Verner, May 19, 1978, p. 10. Both documents are in AMA files.
2. William K. Verner notes, from a conversation with Mrs. Franklin Kent Prentice, Jr., wife of Levi Wells Prentice's nephew and donor of the painting: "The frame is said to have been built, as were most of his frames, by the artist himself."
3. Ibid., p. 6. Prentice's penchant for placing his paintings in self-made "shadow boxes" serves to verify this opinion.

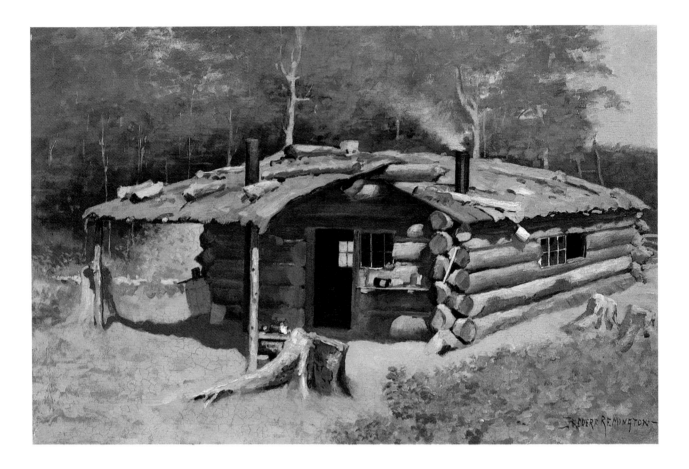

Frederic Sackrider Remington

(1861 - 1909)

Untitled: Ab [Albert] Thompson's Cabin on Silver Lake, ca. 1890

Oil on panel 18 x 28
Checklist no. 219

Frederic Remington first camped at Cranberry Lake in the western Adirondacks in his teens and continued to visit there every summer until 1899.[1] Albert Thompson, the owner of the log cabin depicted in Remington's oil, was reported to be Cranberry Lake's earliest settler. He hailed from Cooperstown and settled in the village of Harewood, now Cranberry Lake, in 1884. He built a one room log cabin on the shore of nearby Silver Lake that year. The cabin was a year-round residence for Thompson, his wife and six children until 1898 when he built a two story clapboard house on an adjoining lot.[2]

The painting is an architectural analysis of the cabin; one could reconstruct its like from this sketch as if it were a blueprint. Remington explicitly demarcates the interweaving of large logs at its corners, its skinned hide roof and amenities of stove pipes and glass windows. The entire painting is preoccupied with the structure, whose presence is dramatized by the color play between the strong chartreuse trees at the left and the orangish glow of light from within. It is possible that the painting's analytical tone may result from Remington's having used a photograph of the scene as a model.[3]

Remington is generally associated with action scenes of the west, such as his illustration of "Western Types" published by *Scribner's Magazine* in 1902, or oil paintings such as *The Cowboy,* 1902, in the Amon Carter Museum in Fort Worth, Texas.[4] Most famous are his bronzes of cowboys in action, shooting guns in the air and riding on horses galloping so fast not a foot touches the ground. An example is *Coming Through the Rye.*[5] Yet, Remington was born in Canton, New York, and lived most of his life in the east. An early photograph shows him as a boy of eleven posing with the St. Lawrence Hose Company No. 1 for whom he became the official mascot.[6] His careful depiction of Thompson's cabin provides insight into the graphic precision that lies behind his images of spontaneous action. The same explicitness of detail we see in Remington's close-up view of Thompson's cabin appears earlier in his drawing of another of his favorite North Country architectural constructions, the *Rushton American Traveling Canoe,* which he, an admirer of Rushton and his craft, sent to Rushton for use in his catalogues.[7]

1. Peggy O'Brien, "Frederic Remington (1861-1909)," *Adirondac,* vol. XLIX, no. 6 (July 1985), p. 4.
2. George Bowditch, Curator, Adirondack Museum to Albert Fowler, Rosemont, Pennsylvania, November 15, 1967, and Paul Jamieson, Canton, New York, to William K. Verner, April 17, 1967, AMR files.
3. Bowditch letter November 15, 1967. This photograph is in the collection of the Adirondack Museum, no. P11782.
4. Peter Hassrick, *Frederic Remington, Paintings, Drawings and Sculpture in the Amon Carter Museum and the Sid W. Richardson Foundation Collections* (New York: Harry N. Abrams, Inc., 1974), cat. no. 39, ill.
5. Ibid., cat. no. 58, ill.
6. Atwood Manley, "Frederic Remington in the Land of His Youth: Some of Frederic Remington's North Country Associations," 1961, reprinted in William Crowley, ed., *The North Country Art of Frederic Remington Artist in Residence* (Blue Mtn. Lake, N.Y.: The Adirondack Museum, 1985), pp. 15-16, fig. 10.
7. Ibid., p. 17, checklist no. 24, ill. p. 63.

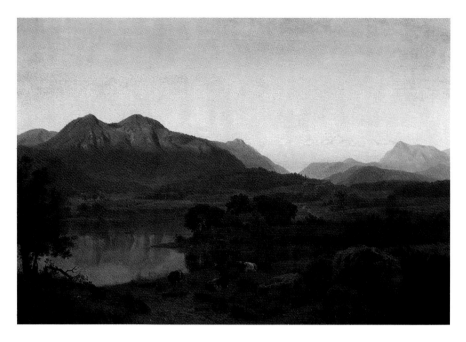

William Trost Richards
(1833 - 1905)

In the Adirondacks, 1857

Oil on canvas 29 x 44
Checklist no. 224

Philadelphia-born William Trost Richards first started visiting the Adirondacks, particularly the area around Elizabethtown, in 1855.[1] *In the Adirondacks,* dated 1857, was sketched in the summer of that year and depicts Mount McIntyre in the background protecting the cows' lazing near the water's edge.[2] Richards used Elizabethtown as a center for his Adirondack sojourns into the 1870s. He painted at least two other versions of the same site, one of which, also dated 1857, was exhibited at the Pennsylvania Academy of Fine Arts in 1858.[3]

Of the three, the museum's painting is the most idealized, suggesting Richards' innate predisposition toward "landscape as a medium of noble and powerful expression," earlier evidenced in his 1854 *Landscape Vignette Illustrating a Passage from John Greenleaf Whittier's "Pictures,"* and his recent European exposure to the 17th century Arcadian landscapes of Claude Lorrain.[4]

Richards' appreciation for precise natural detail is evident in the museum's idyllic landscape. As with the Whittier illustration, languorous bovines inhabit the American landscape. They recline near the foreground, hemmed in by large boulders and farm buildings drawn with a lucidity that clarifies not only their individual forms but the air that surrounds them.

Richards' earliest training was as an ornamental copyist, specifically of gas fixtures, chandeliers and lamps.[5] The exactitude required in delineating ornamental metalwork has here been transferred to the natural realm. This interest in precise detail contributed to his later becoming one of the greatest adherents to the American Pre-Raphaelite movement. Richards received plaudits for his "leaves, grasses, grain-stalks, weeds, stones and flowers," so carefully finished "that we seem not to be looking at a distant prospect, but lying on the ground with herbage and blossom directly under our eyes."[6]

1. Linda S. Ferber, *William Trost Richards American Landscape and Marine Painter, 1833-1905* (Brooklyn, N.Y.: The Brooklyn Museum, 1973), Chronology, unpaged.
2. Ibid., cat. no. 20, ill.
3. Ibid., cat. nos. 19, 20, 21, ill.
4. Ibid., pp. 15, 17, 18, cat. no. 5, ill.
5. Ibid., p. 14, fig. 1.
6. Henry T. Tuckerman, *Book of the Artists* (New York: 1867; repr., New York: James F. Carr, 1967), p. 524.

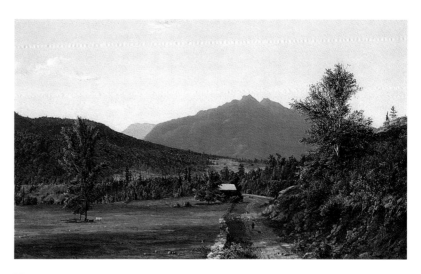

Horace Wolcott Robbins, Jr.

(1842 - 1904)

Untitled: Wolf Jaw Mountain, 1863

Oil on canvas 13 x 22
Checklist no. 226

Robbins first came to Keene Valley through the influence of his teacher, James M. Hart, in whose New York City studio he studied in 1863 after he, a southerner by birth, had been discharged from service in the Civil War where he served with New York's twenty-second Regiment at Harper's Ferry.[1] The museum's painting silhouettes Wolf Jaw against a luminous sky and shows an extended view of the valley itself with cleared fields, grazing sheep, orderly stone walls, and a man walking with his dog. The impression is one of quietude, most welcome to viewers after the tumult of war.

Robbins did not return to Keene Valley until the late 1870s when he purchased "Robbins Knoll" on the west side of the valley.[2] Thereafter, many of his entries in the National Academy of Design depict that area, such as *Sunny Banks of the Ausable, Morning*, 1878, which was illustrated in George Sheldon's *American Painters*, 1879. At that time, Robbins spoke to Sheldon of his strong belief in the "close study of facts and details... careful drawing and local coloring" which aid the artist in his role as "the interpreter of Nature."[3]

1. Peggy O'Brien, notes on Horace W. Robbins, Jr., AML, n.d., p.1.
2. Ibid., p. 2.
3. George W. Sheldon, *American Painters* (New York: D. Appleton and Co., 1879), p. 134, ill. opp. p. 131.

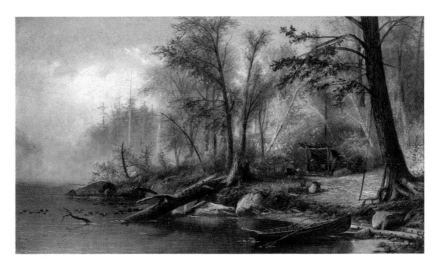

Augustus Rockwell
(1822 - 1882)

4th Lake Camp,
John Brown Tract,
Herkimer Co., 1874

Oil on canvas 10 x 17
Checklist no. 232

The *Syracuse Standard* of July 27, 1859, reported that the "accomplished Artist" Augustus Rockwell of Buffalo "left yesterday afternoon for the fishing grounds of the Walton Club" in Brown's Tract.[1] Rockwell's party was led by H.H. Thompson of Whitestown who subsequently wrote of later camping trips with Rockwell as his canoe partner. Thompson made no claim for Rockwell's talent as a hunter or fisherman but reported his quick wit when the bottom of their canoe struck a snag on a sunken log. "The water rushed in through a hole an inch in diameter, close to Rockwell's right side. He had a coat over the breach in the twinkling of an eye, and in about seven twinklings more the boat had been beached, unloaded and upturned." Rockwell patched the hole with a cut out from the campers' tin butter pail and some white lead from his artist's box.[2]

His experience as a camper is recorded in *4th Lake Camp*. The boat is pulled up to shore, the lean-to and cooking pots are set out and firewood is waiting to be lit. Rockwell's minute attention to detail won him distinction in the field of portraiture.[3] This same gift brings a sense of immediacy to the camping scene with its careful notation of lily pads bobbing on the blue waters and exhausted campers nodding.

1. "Hot for Brown's Tract," *Syracuse Standard* (July 27, 1859). This news article was quoted from the *Utica Herald* (July 26, 1859).
2. H.H. Thompson, "Camping Twenty Years Ago," *The American Angler, A Weekly Journal of Fish and Fishing*, vol. V, no. 15 (April 12, 1884), pp. 225-230. The article relates Thompson's trip with Rockwell on the Raquette River in July 1862.
3. H.P. Smith, "Augustus Rockwell," *History of Buffalo and Erie County* (Syracuse, N.Y.: Mason, 1884), vol. II, p. 89.

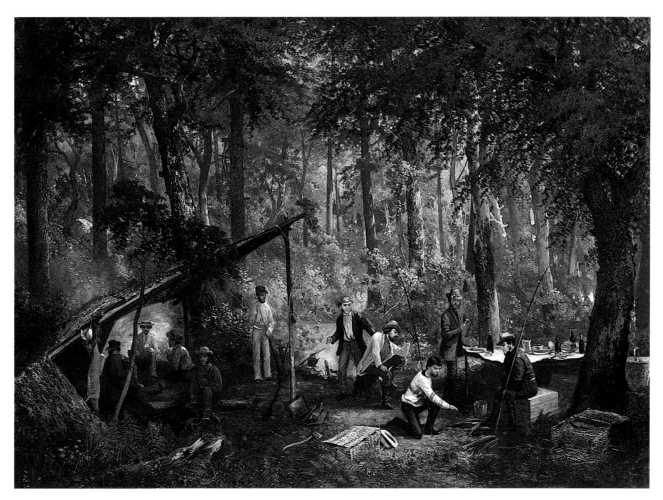

Frederic Rondel

(1826 - 1892)

A Hunting Party in the Woods./ In the Adirondac [sic], N.Y. State, 1856

Oil on canvas 22 x 30
Checklist no. 234

A Hunting Party in the Woods is the first painting that Paris-born Rondel exhibited at the National Academy of Design (1857). It shows a camping scene in the Adirondacks, although its precise location is yet unknown. The campers are depicted with photographic accuracy under a leafy canopy of tall trees. They are clearly preparing for a mid-day feast with table, wine bottles and mugs set at the far right. Five names are faintly scratched in pencil on the back of the painting stretcher: J.J.(?) Whiting, R.F. Stevins, S.H. Pearce, John Bradbury and J. Foster Folson. Such a figure

key was traditional in the mid-nineteenth century, and a parallel exists for W.J. Stillman's *The Philosopher's Camp in the Adirondacks,* 1858.[1] Unfortunately, none of the names identified in the two pictures are the same, although both camps had Boston connections.

Rondel, who was at the time working in Boston, signed the painting at the lower right. His name reappears on the back, spelled "Rondell" which suggests that the campers' chart was scratched in by one of the members, rather than by the artist himself. Probably the artist is represented just

to the right of center seated on a stump, for he is the only member of the group not actively involved in the preparation of the meal. The remaining four men must be guides hired for the outing. As in the Stillman picture, guides and gentlemen alike wear hats. Only one young man who kneels before the fire to the right of the center, in front of the artist, is hatless. His hat is casually tossed to his right and rests against a wicker picnic baskct that is inscribed with the word "Batkins" on its top and the initials "C.W.W." on its side. "Batkins Club" is listed with the key of names on the back of the stretcher, but so far its identity is unknown, except for the playful suggestion that it may refer to "little bats" who treat a camping trip as a caper.[2] It is impossible to decipher Mr. Whiting's first two initials as "C.W.," so the identity of the initials on the basket also remains a mystery. The name "Mr. Whiting" is the only one that appears twice on the back of the picture and is joined by the address: 69 Washington [?] Square. An examination of city directories for the period may provide the clue: John W. Whiting is listed as a lawyer at 69 Wall in the New York City directories of 1863 and 1864. Rondel's skill in painting outdoor gatherings on commission is verified by his having painted an undated scene of *The Picnic* for Henry S. Frost, now in the collection of the Butler Institute of American Art, Youngstown, Ohio.

1. See key to William J. Stillman painting given by E. Rockwood Hoar, one of those represented, to the Concord Free Library, Concord, Massachusetts. Photograph in AMA files.
2. William Morris, ed., *American Heritage Dictionary of the English Language* (New York: American Heritage Publishing Co., Inc., 1969), p.112 lists as slang definition for "bat": "to go from place to place aimlessly; wander."

Charles Nicolas Sarka

(1879 - 1960)

Garbage Dump, ca. 1910

Watercolor 16 x 21
Checklist no. 257

Charles and Grace Sarka, like their long-time friends and neighbors, Paul and Grace Bransom, summered for many years in Canada Lake. They built a cottage there in 1910, the year of this amusing watercolor. It is doubtful that Sarka knew, eighty years ago, how vital the subject of *Garbage Dump* would become. To him, according to his drawing, it is a natural event full of bright colors, interesting forms and serendipity. Like Bransom, Sarka was primarily an illustrator, contributing regularly to such magazines as *Collier's, Scribner's* and *Harper's*. He sketched exotic places from Egypt to Tahiti, but it was to Canada Lake that he returned before his death.[1]

1. *Adirondack Paintings by Charles Sarka, 1879-1960* (Caroga, N.Y.: Caroga Historical Museum, n.d.).

Roswell Morse Shurtleff

(1838 - 1915)

The Road to the AuSable, ca. 1893

Oil on canvas 40 x 30
Checklist no. 262

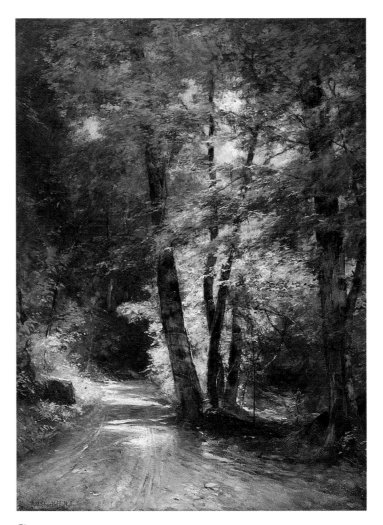

Shurtleff was introduced to the Keene Valley area while he was teaching at the Hartford Seminary during the year 1867-68 by fellow artist, John Fitch, who had spent the previous summer there.[1] From that date until his death, he was the dean of Keene Valley artists; at one time, he reported in 1910, he counted 40 umbrellas near his studio "with artists, canvas and paints beneath each one."[2] Artists who visited Shurtleff in-cluded Winslow Homer, Homer Martin, Alexander Wyant and Kruseman van Elten.[3]

During his early years in Keene Valley, Shurtleff and his bride, Claire Eugenia Halliday of Hartford, stayed at Crawford's near the center of the village. In 1882, he purchased 160 acres "on a little height on the west side of the valley near Washbond's Flume, about a half mile back from the main road."[4] There, he built a house

with a large studio in the center, two stories high.

Proof of Shurtleff's "advanced" taste for his time can be found in his fondness for orientalia - paralleling the interests of better known artists such as William Merritt Chase. Among the many Japanese objects in his studio, the outstanding one was a "Japanese umbrella, sixteen foot in diameter, one of the largest, it is said, ever imported to this country."[5] Despite his taste for the exotic, such as wearing a sombrero while riding a pony sporting a Mexican saddle to scenes he wished to paint, Shurtleff was primarily a landscape artist who painted out of doors, seldom far from the house. "I work quickly," he said in an interview, "seldom longer than two hours on any one subject, for by that time the lights and shadows have changed...."[6]

Shurtleff was very much a painter of "lights and shadows." He used a limited repertoire of colors. "Ordinarily, my palette is set about like this: white, yellow ochre, gold ochre, the two cadmiums, vermillion, burnt sienna, two mixed greens, a light and a dark, Italian pink and black."[7] Henrietta Gibson Ledden, the donor of *The Road to the AuSable*, and her family were Shurtleff's nearest neighbors. She remembers his always being in mountain clothes, with a full beard, mustache and chewing tobacco.[8] She had seen the painting many times in Shurtleff's studio and her father bought it from the artist's widow just after his death. "We know just where on AuSable Lake Road Mr. Shurtleff painted it."[9]

1. Pauline Goldmark, "Keene Valley Artists," typescript, 1940, Keene Valley Library, Keene Valley, N.Y., p. 2.
2. *American Art News*, vol. IX, no. 3 (October 29, 1910), p. 4.
3. A photograph in the museum's collection (P47500) shows Winslow Homer, John Fitch, J. Francis Murphy, Calvin Rae Smith and Kruseman van Elten seated on the rocks of the Ausable River with their sketching equipment.
4. Goldmark, p. 3.
5. Ibid., pp. 3, 4.
6. Ibid., p. 2. *The Art Amateur*, vol. 32, no. 4 (March 1895).
7. Ibid.
8. Peggy O'Brien, notes on Shurtleff, AML, unpaged.
9. Mrs. Ledden to the Adirondack Museum, November 7, 1973, AMR files.

William Thomas Smedley

(1858 - 1920)

At Bluff Point, Lake Champlain, 1890

Watercolor and
gouache on paper 17 x 13
Checklist no. 267

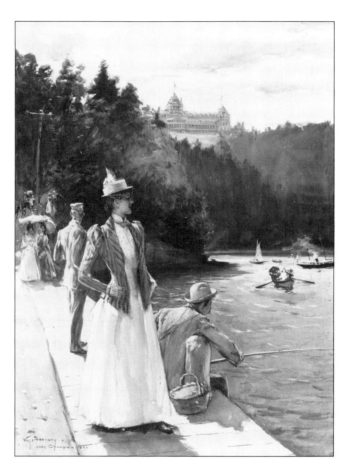

Smedley prepared illustrations such as *At Bluff Point, Lake Champlain* regularly for *Harper's Weekly* magazine. He specialized in scenes involving ladies of fashion on holiday, such as at the Madison Square Garden or the Plaza Hotel.[1] His ladies, like the one on the dock in front of the Hotel Champlain, provide the quintessential image of the Gibson girl: "The American girl of the 1890s as idealized in sketches by Charles Dana Gibson and typically dressed in a tailored shirtwaist with leg-of-mutton sleeves, and a long skirt." Smedley devoted his art to

the contemporary scene, believing it to be "the real historic painting."[2] A newspaper article from 1892 described him as the "Harper's artist,"[3] a role which he retained throughout the 1890s and for which he was so well paid that in 1899 he was able to build a grand Tudor style house and studio in Lawrence Park, Bronxville.[4]

1. Alan M. Pensler, *William Thomas Smedley (1858-1920)* (Chadds Ford, Pa: Brandywine River Museum of the Brandywine Conservancy, 1981), nos. 29, 36, 3, 13, and 11.
2. P.G.H., Jr., "Book Illustrators. II. William T. Smedley," *The Book Buyer,* vol. II, (1894 ?), p. 75, AMA files.
3. Pensler, p. 14 based on "A Dinner to W.T. Smedley," unpaged, November 23, 1892, Smedley Papers, Archives of American Art, Smithsonian Institution, Washington, D.C., reel no. 1255, frame 82.
4. Ibid., p. 20, p. 24, ill. p. 26. Pensler notes that in 1891 Harper and Brothers paid Smedley $100 for full page illustrations and $50 for half-page works. Information based on Letters, W.T. Smedley to Harper and Brothers Publishers, December 1891, Harper Autograph Letter Collection, Archives of American Art, Smithsonian Institution, Washington, D.C., reel no. N711, frame 707.

George Henry Smillie

(1840 - 1921)

**Untitled:
A Lake in the
Woods, 1872**

Oil on canvas
36 x 60
Checklist no. 268

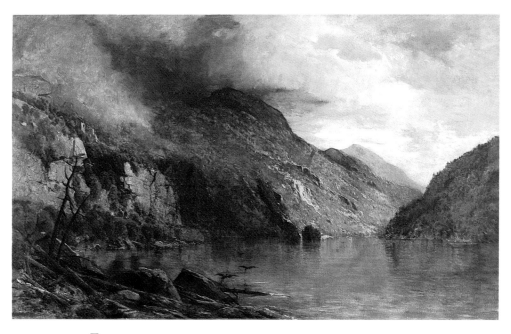

Like his brother James D., George Smillie was a noted engraver and etcher as well as painter. The museum's painting of a lake in the woods is signed 1872, and due to the size and finish was undoubtedly the picture that George Smillie exhibited at the National Academy of Design that year.[1] It was sketched, together with his *Morning on the AuSable*, the summer before, during the trip described by an unidentified writer in the magazine *Aldine*, February 1872:

"...We are ushered into the wild beauties of the Lower Lake. The mountains rise from the water precipitously, here in abrupt abutment walls, six or eight hundred feet in height, there in vast slide-ways, where huge masses of detached rocks have slidden down, and lie along the water's edge. Streams trickle from dizzy heights, bearing along the marks of many a wild flood and gnarled and uprooted

trees are swept down by wind and tempest."[2] The museum's painting, like the engraving after *Morning on the AuSable* which appeared in the *Aldine* article, conveys the threat of a coming storm.[3] Dark clouds veil the mountain tops in the upper left of the canvas and provide Smillie with an excellent opportunity to display his flair for applying color with dramatic effect.

Smillie's aptitude for creating a precise pictorial representation of the scene is well documented in his 1868 painting *AuSable Lake, Adirondack Mts.* (checklist no. 269) in the museum's collection. His visits to the Keene Valley area were encouraged by his brother whose *Top of Giant's Leap, Adirondacks* (checklist no. 271) was executed in 1869 and who "owned the land at the upper end of the Valley, a hilltop under towering pines which [we] always called 'Smillie's hill'."[4]

1. It was Smillie's usual procedure to sign and title his paintings on the back of the canvas. This canvas was relined before it was acquired by the museum and no records were kept of the original lining.
2. "Morning on the AuSable, N.Y.," *Aldine*, vol. V, no. 2 (February 1872), p. 40.
3. The painting, *Morning on the AuSable*, has yet to be located.
4. Pauline Goldmark, "Keene Valley Artists," typescript, 1940, Keene Valley Library, Keene Valley, N.Y., p. 15.

James David Smillie

(1833 - 1909)

Top of Giant's Leap, Adirondacks, 1869

Watercolor 20 x 13
Checklist no. 271

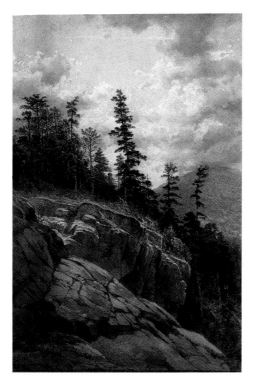

James Smillie's meticulous record keeping enables us to reconstruct the circumstances of the creation of this watercolor on October 1st, 1869. Not only did Smillie date the painting, but he also kept a diary of that date and the days leading up to the production of this work of art. Of the final day itself, a Friday, Smillie wrote: "Yet another superb day – like a weather breeder...got to the top of Giant's Leap a little before 9 o'clock and worked at once on watercolor study, finishing it at 12:30 when I cooked my lunch."[1] A full month earlier, Smillie had been to Giant's Leap with Samuel Colman and was at work on an oil painting. He wrote of commencing "a study of the first fall back of the 'Leap'" and noted that "the rock masses, fractures and colors please me."[2] These are just the qualities that "hold" the viewer to his watercolor. Smillie's depiction of rock is analytical, geological and precise in both drawing and color. It is no surprise that he, the son of America's greatest steel-engraver, would himself become one of the country's foremost painter-etchers. On August 21st, Smillie wrote of starting an "outline" for a watercolor study measuring 15 x 22 which is close in size to the museum's. At that time, he cited the "trees and rock" that interested him as being "at the immediate top of the fall looking from the north side to the south."[3] That particular day he was turned back by heavy rain, but again on September 6th and 11th he records being at work on "my watercolor study at the head of the falls."[4] Learning the genesis of this painting makes viewing it palpably real. A hundred years after it was painted, we can look at Smillie's watercolor with the same intensity with which he created it and sense the chance rain storm in the offing and "the woods [that] seemed to be so desolate."[5]

1. James D. Smillie Diaries, Archives of American Art, Smithsonian Institution, Washington, D.C., reel 2849, frame 858.
2. Ibid., frame 844.
3. Ibid., frame 837.
4. Ibid., frame 848.
5. Ibid., frame 858.

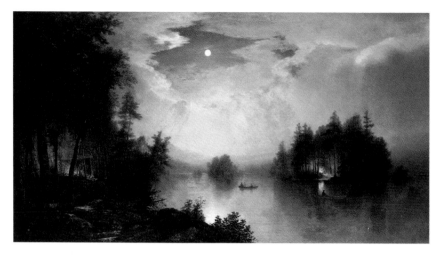

Thomas Lochlan Smith

(1835 - 1884)

Untitled: Night in the North Woods, n.d.

Oil on canvas 27 x 48
Checklist no. 275

Moonlight scenes were frequent in T.L. Smith's entries in the National Academy exhibitions, but those recorded were associated with winter scenes. Such is clearly not the case with the museum's painting, executed while Smith was summering at his family farm in Tully, New York, near Syracuse.[1] The picture was purchased about 1895 by Seymour Van Santvoord of Troy, New York. Family tradition locates the painting at the headwaters of the Beaver River on Smith's Lake, a site later depicted by Levi Wells Prentice. The lean-to and campfire at the left of the picture could be Van Santvoord's who "camped, hunted and fished the Beaver River area [of the Adirondacks] from 1878."[2] The painting remained in the Van Santvoord family until it entered the museum's collection.[3]

1. William K. Verner to George Van Santvoord, donor of the painting, February 16, 1968, AMR files. Verner reports, "...since receiving the painting we have run across a newspaper piece on Thomas Lochlan Smith at the Onondaga Historical Association which indicated that although he had most of his career in New York, he nonetheless spent many summers at his family farm, near Syracuse. My guess is that he ventured into the Adirondacks from there."
2. Van Santvoord to Verner, November 22, 1967, AMR files.
3. Ibid.

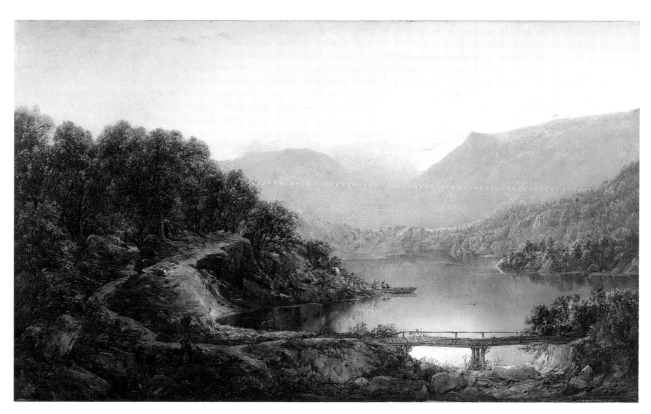

William Louis Sonntag, Sr.

(1822 - 1910)

View Near Cascade Bridge–Valley of the Susquehanna, 1863

Oil on canvas 33 x 55
Checklist no. 277

View Near Cascade Bridge embodies Sonntag's preference for panoramic mountain views in which the near distance shows carefully defined trees and rocks. What distinguishes this painting is Sonntag's rendition of the corduroy bridge constructed of wooden logs laid together transversely in the foreground. Although the picture's title suggests that the scene is located outside of the Adirondacks, such road-bridges are not uncommon there.

Sonntag's painting technique is characterized by his fondness for thickly applied paint and for highlighting bands of trees with dramatic touches of white. In *View Near Cascade Bridge,* the strong color contrasts in the sky create a dramatic sense of atmospheric light which picks up the myriad of impasto highlights Sonntag has dotted throughout his dense foliated tree scenery.

Seneca Ray Stoddard

(1843 - 1917)

In the Drowned Lands of the Raquette River, ca. 1888

Monochrome oil
on academy board 6 x 8
Checklist no. 281

*In the Drowned Lands.
of the Raquette River*

The extraordinary feature of *In the Drowned Lands* is the way that the barren tree at the left of the painting extends beyond the picture frame at both top and bottom. Such an invasion of conventional realistic representation recalls the way in which medieval illuminators treated the first letter in their text as a work of art in itself, as well as the commencement of a Biblical text. Stoddard's monochrome painting relates in both its lack of coloration and its composition to his albumen printed photograph of the same subject.[1]

In addition to being a distinguished landscape photographer who "wanders around all over the lake, taking views and money" and specializing in the "fringes" of the Adirondacks such as Lake George, Fort Ticonderoga and Lake Champlain, Stoddard was a writer.[2] In 1873, he published the first edition of his guidebook, *The Adirondacks: Illustrated*, which he revised annually until 1914 or 1915.[3] Moreover, he wrote manuscripts of a more literary nature; among these were his unpublished "The Hudson from the Mountains to the Sea," ca. 1870,[4] and "The Story of Atlantis," 1890.[5] The compositional format of *In the Drowned Lands* reinforces the lonely imagery of Stoddard's written words. This desolate scene with gnarled roots and desiccated trees evokes a world of gothic imagination which has yet to be linked to a specific Stoddard script.

1. William Crowley, *Seneca Ray Stoddard: Adirondack Illustrator* (Blue Mtn. Lake, N.Y.: The Adirondack Museum, 1982), cat. no. 15, plate 30.
2. Ibid., p. 4.
3. Ibid., p. 9.
4. MS 75-2, AML.
5. Crowley, cat. no. 148.

L.L.S.

(fl. 1876)

Adirondacks / Memory / Sketches / Depiction of Camp, **1876**

Watercolor 7 x 9
Checklist no. 237

Many visitors to the Adirondacks during the period of "Murray's Rush" in the 1870s were amateur artists, enjoying the chance to bring home their special experiences of wilderness. The identity of L.L.S., an amateur watercolorist, has yet to be established. We can confine the artist's time period to the summers of 1875 and 1876 and the locale to Whiteface Mountain and Upper Saranac Lake on the basis of notations which appear on the sketches.[1] *Depiction of Camp* is one of four watercolors on a single sheet whose location is not identified. The way the straight, vertical tree trunks enclose the camp area, which, like the trees, is highlighted in white, makes it clear that the artist was focusing on a single aspect of the mountain trip; the other sketches on the page are lake views with sloping mountains in the background. The artist's handling of color and form is competent and well suited to the small images represented.

1. The closest identification we have located is Louise E. Strickler who signed the Register at Blue Mountain House in 1877.

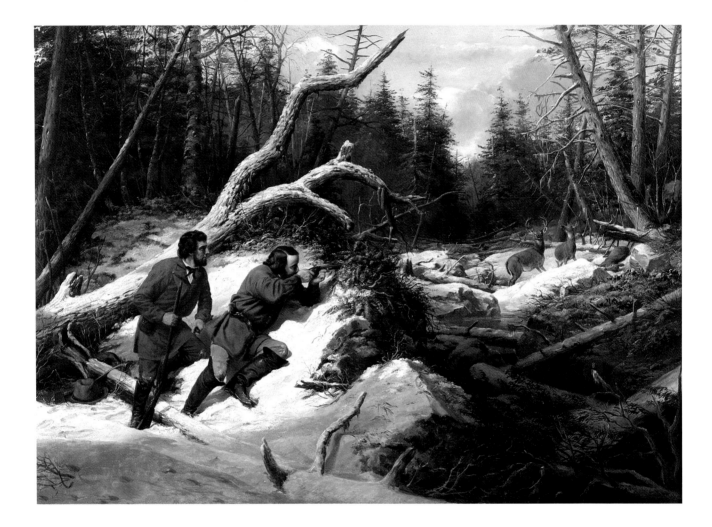

Arthur Fitzwilliam Tait

(1819 - 1905)

Still Hunting on the First Snow: A Second Shot, 1855

Oil on canvas 54 x 76
Checklist no. 301

Arthur Fitzwilliam Tait arrived in New York City from his native Liverpool, England, in the fall of 1850. He came to this country as a mature artist with an established reputation in England as a lithographer of animals. His well-known lithograph, *Portrait of Sir Thomas Fairfax*, a celebrated bull, executed in 1842, was based on an oil by English artist Richard Andsell.[1] After his arrival in America, Tait himself began to paint oils, such as *Duck Shooting, Some of the Right Sort*, commissioned in 1851 by James Clark of Brooklyn.[2] Tait's *Duck Shooting*, which represented a boat ashore on marshy land filled with wild ducks and two hunters in the company of a dog bringing yet more fowl back to the boat, was exhibited at the National Academy of Design in 1854 and published as a lithograph in 1859 by Nathaniel Currier, called *Wild Duck Shooting, A Good Day's Sport*.

Within a year of his arrival in the States, Tait visited the Adirondacks, spending time in the Chateaugay country, not far from where his brother Augustus and wife had settled. The wilderness scenery and the good hunting and fishing appealed to the artist who quickly established himself as one of the "finest painters" of this genre.[3]

*Still Hunting on the First Snow: A Second Shot,*1855, measures 54 x 76 inches and is one of Tait's largest pictures. It was clearly intended as an Academy painting which would encourage critics who viewed Tait as "A plebeian Cockney... of no more consequence than any of the 'animals' with which [he is] associated" to take him seriously as an academic painter who could convincingly portray human figures in a dramatic scene.[4]

In his effort to lay claim to his seriousness as an artist, Tait, with near photographic accuracy, depicted two hunters nestled beneath a snow covered, dead tree trunk at the left of his picture. Tait's connection with photography is strengthened by the identification, according to family tradition, of the hunter at the extreme left as Matthew Brady, soon to become famous for his photographs of the Civil War and portrait of President Abraham Lincoln.[5] Although undocumented, it is possible that Tait relied on photographs to accurately portray both Brady and himself, the other hunter in this monumental painting. Tait was accustomed to working with models: "his spoils of deer-antler heads and legs" and "birds carefully preserved and cunningly grouped as they

were caught in covey."[6] He could have considered photography as a sort of preserved specimen to better enhance the veracity of the hunting drama he wished to enact in *A Second Shot.*

Tait has created a scenario in paint, pitting the eager hunters, who are in close view, against another, more distant, twosome of deer. The deer hit by the hunter's first shot lies to the extreme right middle ground, its red blood contrasting with the whiteness of the snow. The fully antlered deer nearest the hunters turns defiantly toward Tait who is firing the second shot. The buck's gesture recalls Tait's earlier English experience and his familiarity with such grand deer images as Sir Edwin Landseer's *Monarch of the Glen,* 1848.[7] The exactitude with which Tait composed this major, early picture is evident in the way the large rack of the soon-to-be shot buck mirrors the dead, snow covered branches of the fallen tree under which the hunters secure their position. Tait's precision of detail in *A Second Shot* contributes to the tension portrayed and to its dramatic effect.

In his biography of Tait, Warder Cadbury suggests that the large size of this "most ambitious of Tait's paintings at this time" indicates "that Tait did not think it would be copied directly onto stone," and yet, a year after it was executed and exhibited at the National Academy of Design in 1855, it was published in lithographic form as *Deer Shooting "On the Shattegee"* by Nathaniel Currier.[8] Harry T. Peters, who published the first definitive account of Currier and Ives in the early 1930s, called *A Second Shot* "Tait's masterpiece."[9]

1. Patricia C. F. Mandel, "English Influences on the Work of A.F. Tait," *A.F. Tait: Artist in the Adirondacks* (Blue Mtn. Lake, N.Y.: The Adirondack Museum, 1974), p. 16.
2. Warder H. Cadbury and Henry F. Marsh, *Arthur Fitzwilliam Tait: Artist in the Adirondacks* (Newark, Del.: The American Art Journal/University of Delaware Press, 1986), no. 51.12, ill.
3. Ibid., pp. 40-41. Quotation is from the *New York Mirror* (February 1, 1853), p. 1.
4. Excelsior, "Art Correspondence. National Academy of Design-Reply to Mr. Tait," *Daily News* (May 17, 1858), pp. 4, 5. Cadbury and Marsh, p. 45.
6. "Arthur F. Tait," *Cosmopolitan Art Journal 2* (1858), pp. 103-104.
7. Mandel, pp. 16-17. Patricia C.F. Mandel, "The Animal Kingdom of Arthur Fitzwilliam Tait," *The Magazine Antiques* (October 1975), p. 752, fig. 15.
8. Cadbury and Marsh, p. 46.
9. E.J. Rousuck, Wildenstein & Co., New York City, to Walter Hochschild, the donor of the painting, January 22, 1965, AMA files.

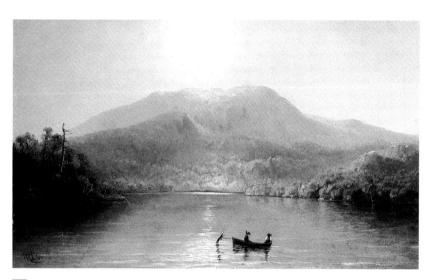

William
Richardson Tyler

(1825 - 1896)

West Mountain, Raquette Lake, ca. 1875

Oil on canvas 12 x 20
Checklist no. 322

Tyler moved from his hometown of Nunda in Livingston County, New York, to Troy in the early 1840s and painted decorative panels for the interiors of coaches manufactured by Eaton and Gilbert.[1] The romance associated with travel may have influenced his mildly saccharine interpretation of scenes such as *West Mountain, Raquette Lake.*[2] The painting with its central placement of a single boat with fishermen on calm, luminous waters directly in front of West Mountain is synonymous with other Tyler views, such as that of *Lake George* in a private collection.[3] His pictures are at once competent, intimate and pleasing. Many of them describe Adirondack locations, ranging from a *View Near Elizabethtown,* which he exhibited at the National Academy of Design in 1865, to Whiteface

Mountain and Schroon Lake.[4] These placid scenes evoked a certain nostalgia for wealthy Troy patrons committed to post-war industrialization but who cherished the tranquility embodied in Tyler's landscapes. Many of Tyler's views were sold by the local jeweler, Sim & Co., and remain in public and private collections in the Troy area.[5] His work does much to exemplify popular American taste after the Civil War.

1. Jannea R. Harriman, *The Art of William Richardson Tyler 1825-1896* (Troy, N.Y.: Rensselaer County Historical Society, 1971), p. 4.
2. The original stretcher was inscribed with this title. It has since been relined. AMR files.
3. A photograph of this painting was sent to the museum in 1987. AMA files.
4. Harriman, cat. nos. 14 and 15, ill.
5. Ibid., p. 4.

George Wellington Waters

(1832 - 1912)

Untitled: Lake George, 1868

Oil on canvas 24 x 40
Checklist no. 343

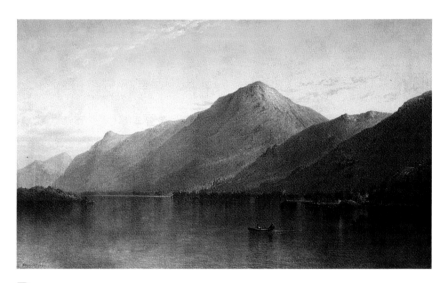

During the period that Waters painted Lake George, he was living in Elmira, New York.[1] The way in which he carefully outlines the as-yet-unidentified mountain which looms in the distance, suggests his strong acquaintance with Hudson River School painter, Asher B. Durand. Waters' painting of Lake George greatly resembles Durand's 1855 *Chocorua Peak* in both artists' "scrupulous fidelity" in drawing the contours of the mountain and the careful avoidance of the overly dramatic.[2] The colors of Waters' painting are subdued, flat and uniform in tone so as not to distract from the mountain's linear profile. If Waters were unfamiliar with *Chocorua Peak*, he surely had read Durand's influential "Letters on Landscape Painting" published in *The Crayon*, 1855, which was to become a manifesto for American landscape painters in the mid-1800s.

1. Allen C. Smith, Curator of the Collection, Arnot Gallery, Elmira, New York to William K. Verner, February 28, 1979, AMA files.
2. Patricia C.F. Mandel, *Selection VII: American Paintings from the Museum's Collection, c. 1800-1930* (Providence: Museum of Art, Rhode Island School of Design, 1977), cat. no. 5, ill. Quotation is from Durand's "Letters on Landscape Painting," *The Crayon* (1855) reprinted in John McCoubrey, *American Art 1700-1960 Sources and Documents* (Englewood Cliffs, N.J.: Prentice-Hall, 1965), p. 110.

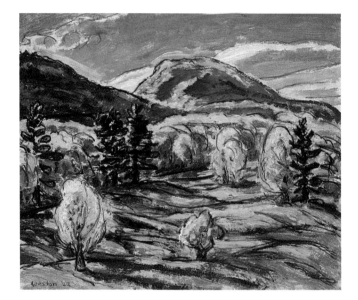

Harold Weston

(1894 - 1972)

Spring Sunlight - St. Huberts, **1922**

Oil on cardboard 8 x 10
Checklist no. 344

Spontaneity of color and paint stroke charges this hastily executed sketch, *Spring Sunlight,* with emotional intensity. Weston's use of cardboard as backing suggests the temporality of his intent to capture a well-known place on the spot. Cardboard is light to carry and deteriorates quickly; it is not for "keeping."

Weston's colors intensify those found in nature; the gold and purple of early spring are made more vibrant by the light of the coming dawn. There is much of the poet and the mystic in this artist's desire to "catch" the transitory moments

of daylight and its colors. For Weston, a realistic representation of the mountains around St. Huberts wasn't necessary. He had absorbed their profiles and topography during his years of living among them in Thoreau-like solitude.[1] Rather, he chose to chart their changes at different hours of the day and did so in a series of color expressions executed between 1920 and 1924. When the first of these sketches was shown in New York City in 1922, the critic Henry McBride noted that Weston "appears to have freshly discovered the world."[3] It is worth observing that for

all his emphasis on expression, Weston has carefully outlined the form of the mountain in pencil beneath the exuberant splashes of oil.

1. Harold Weston, *Freedom in the Wilds, A Saga of the Adirondacks* (St. Huberts, N.Y.: Adirondack Trail Improvement Society, Inc., 1971), chapter 5.
2. Ibid., p. 128.
3. Henry McBride, "Promising Work of Young American Shown," *New York Herald* (November 12, 1922) in Harold Weston Scrapbook, Archives of American Art, Smithsonian Institution, Washington, D.C., reel 515, frame 170.

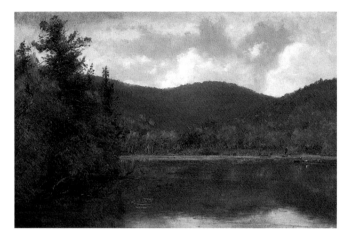

Thomas Worthington Whittredge

(1820 - 1910)

View of the Fourth Lake, Old Forge, ca. 1861-1862

Oil on canvas 11 x 17
Checklist no. 350

After having spent nearly seven years in Dusseldorf, Germany, and three in Rome, Whittredge became homesick and sailed to the United States in the summer of 1859. In 1860, already an associate member of the National Academy of Design, he wrote: "It was the most crucial period of my life. It was impossible for me to shut out from my eyes the works of the great landscape painters which I had so recently seen in Europe, while I knew well enough that if I was to succeed, I must produce something new which might claim to be inspired by home surroundings." He goes on to say that he "hid [himself] in the Catskills" but found "nothing but primitive woods with their solemn silence reigning everywhere."[1]

Whittredge's pictorial treatment of *View of the Fourth Lake* is very close to his 1863 *Twilight on the Shawangunk River*[2] in its sense of quietude; in both, only a single boat ripples the still waters. There is, indeed, a "dreamy level" in his depiction of "the clear, dark, calm lake, the many tinted woods, and the manner in which the pervading light reveals and modifies all

these...."[3] The inspiration for Whittredge's intimate treatment of this Adirondack lake recalls the work of Sanford Gifford with whom he painted in Rome, New York City and the Catskills.[4] There is no documentation about Whittredge's trip to Fourth Lake, but it is known that his wife, Miss Foot, whom he married in 1867, came from Geneva in the western part of the state, and it is possible that Whittredge's visit was related to his courtship.[5] In any case, the visit casts doubt on his statement that he had been "where I could see the Adirondack Mountains and have remained at such places for some time but I never went to see them, not from any suspicion that they were less interesting than the Catskills, but because I did not want to burden myself with studies I could not use."[6]

1. Anthony F. Janson, "Worthington Whittredge: The Development of a Hudson River Painter, 1860-1868," *The American Art Journal*, vol. XI, no. 2 (April 1979), pp. 71-72. Quotation is from Worthington Whittredge, *The Autobiography of Worthington Whittredge*, ed. John I.H. Baur, in *Brooklyn Museum Journal* (1942), p. 42.
2. Ibid., fig. 8 in the collection of the Indianapolis Museum of Art.
3. Ibid., p. 80. Quoted from Henry Tuckerman, *Book of the Artists* (New York, 1867: repr., New York: James F. Carr, 1967), pp. 514-515.
4. Ibid., p. 80.
5. Edward H. Dwight, *Worthington Whittredge (1820-1910), A Retrospective Exhibition of an American Artist* (Utica, N.Y.: Munson-Williams-Proctor Institute, 1969), pp. 19-20.
6. Quoted from Whittredge, *Autobiography*, p. 63 by Warder Cadbury in letter to Mrs. Harold K. Hochschild, August 3, 1966, AMA files.

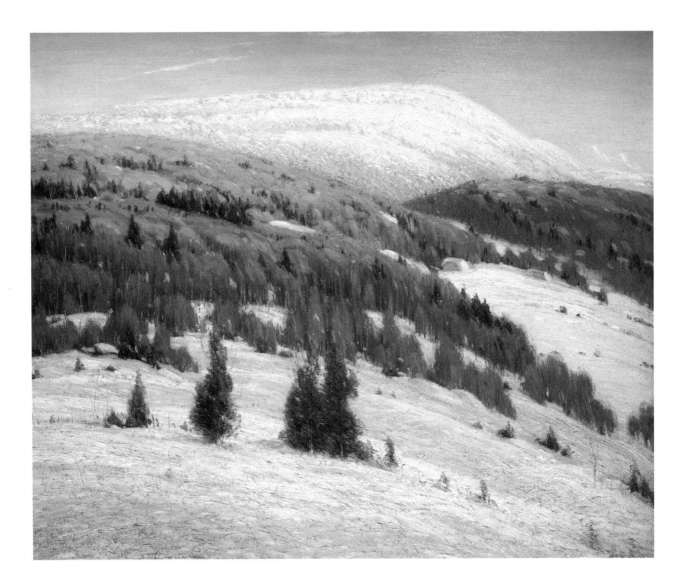

Gustave Adolf Wiegand

(1869 - 1957)

Blue Mountain, ca. 1914

Oil on canvas 41 x 48
Checklist no. 357

An undated brochure advertising Miles Tyler Merwin's Blue Mountain House, on the site of the present-day Adirondack Museum, reads: "MR. GUSTAVE WIEGAND, the noted artist, has established a studio at Blue Mountain House and will give instructions in painting if desired."[1] Wiegand, a native of Bremen, Germany, arrived in America in 1883 and studied at the Brooklyn Art School with the fashionable landscape painter, William Merritt Chase. He later returned to Germany and completed his academic training at the Dresden Royal Academy with Professor Eugene Bracht.

By the time he built his studio at Blue Mountain Lake, Wiegand had been awarded prizes at both the St. Louis World's Fair of 1904 and the National Academy.[2] He was firmly established at Blue Mountain Lake by 1906 where he met and married the concert pianist, Anna Albresch.[3] Wiegand's studio, with a skylight cut into the peak of its roof, was built "just for that" on Mr. Merwin's land, to be used as long as Wiegand wished according to his daughter, the donor of the painting.[4] *Blue Mountain,* executed indoors, was based on an oil sketch (checklist no. 358) made during the winters of 1912 or 1913 when the Wiegands spent almost two full years at Blue Mountain Lake, renting Smith's store part way up the hill going north out of town.[5] Snow covered Blue Mountain looms over delicately drawn trees on its lower ridges. The thick impasto of its surface conveys Wiegand's immersion in the experience of winter in the mountains, its varying shades of white and its transitory light.

1. Blue Mountain House brochure in AML.
2. Gustave Wiegand to George Stevens, Director, Toledo Museum, May 12, 1910, Stevens Collection, in preparation for *Autobiography of Modern Artists,* Archives of American Art, Smithsonian Institution, Washington, D.C., ca. 1910, reel D34, frame 597.
3. Peggy O'Brien, notes on Wiegand, AML, n.d., p. 1.
4. Phyllis W. Tilson, daughter of Gustave Wiegand, to Rhonda Barton, registrar, Adirondack Museum, June 7, 1973. A photograph of Wiegand with his wife and daughter, ca. 1915, posed in front of the studio is in the museum's collection, P23368, gift of Mrs. Tilson. Wiegand holds his palette and brushes and stands next to his easel on which is another painting of Blue Mountain, not in the museum's collection.
5. Ibid.; O'Brien, p.2.

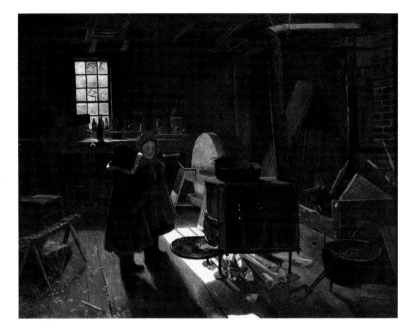

George Bacon Wood, Jr.

(1832 - 1909)

Untitled:
Papa's Shop, 1871

Oil on canvas 14 x 18
Checklist no. 366

Philadelphia-born George Bacon Wood, Jr. studied at the Pennsylvania Academy of Fine Arts where he exhibited this painting in 1877.[1] The "Shop" represented in his picture is his own studio "built, with a north window," above the woodshed at the rear of his home in Germantown. The children depicted may be two of his own seven. The painting is rare in American nineteenth century genre scenes, for it not only represents an interior but a working place. Instead of the artist's accouterments of an easel and palette, all we see relating to his craft are a few picture frames hanging at angles from the back wall. Wood's

emphasis on the "work" of a studio, with the large log at the left and the wood shavings that surround it as well as the millstone in the right background, reflects his Quaker upbringing with its "psychological impediments to a career in art."[2]

The Quakers eschewed the study of the human figure; his daughters' heavy fur coats, hats and boots permit us to view only one child's face.[3] The children have entered the shop for the sole purpose of warming themselves, and the specificity with which Wood depicts the stove with its hot ashes and ample storage of wood beneath make the stove, rather than the shop, the real center of the painting. This focus is further emphasized by the way in which the light from the window highlights the stove's presence.

The precision with which Wood inventories the shop's interior, from its broken windowpanes to the bottles on the worktable in front of it, to the right-angled stovepipe which passes through the brick wall at the right, anticipates his later

accomplishments in the field of photography.[4]

At the time that this painting was executed, Wood spent summers in Elizabethtown.[5] As Peggy O'Brien notes, "Deep in the rock on top of Wood Hill, just north of Elizabethtown, is carved 'WOOD 1866-1874'."[6] His Adirondack landscapes, exhibited at the Pennsylvania Academy, include: *Boquet River, Elizabethtown*; *Pleasant Valley, Adirondacks*; *Old Bridge, Adirondacks*; and *Raven Pass, Adirondack Mountains*, the latter the same year as the museum's painting.[7]

1. Donelson Hoopes, *American Art and Antiques*, vol. 2, no. 5 (Sept.-Oct. 1979), p. 123. Hoopes, Wood's great grandson, explains the delay between Wood's execution of Papa's Shop in 1871 and its exhibition at the Pennsylvania Academy of Fine Arts in 1877. He points out that the Academy was closed during the early 1870s due to its being redesigned by Frank Furness and George W. Hewitt for the Centennial celebration in Philadelphia, 1876.
2. Ibid., 119. Quoted from Elizabeth Coffin, 1916.
3. Ibid., p. 120.
4. Nina Holland, Educational Director, Essex County Historical Society to George Bowditch, Curator, Adirondack Museum, October 13, 1970. Ms. Holland states that Wood received a Gold Medal for "superior composition in Genre Pictures" at the 1887 Chicago meeting of the Photographers Association of America.

A photograph of Wood's darkroom interior appears courtesy of the Library Company of Philadelphia in *Archives of American Art Journal*, vol. 27, no.1 (1987), p. 39, ill.
5. Hoopes, p. 122. Hoopes mentions that Wood remained in Elizabethtown during one winter, that of 1868, prior to the date of the museum's painting.
6. Peggy O'Brien, George B. Wood notes, AML, n.d., pp. 1-2.
7. Cheryl Leibold, Archivist, Pennsylvania Academy of Fine Arts to Patricia C. F. Mandel, February 11, 1988, cites the first three paintings as having been exhibited in 1876 and the last one in 1877.

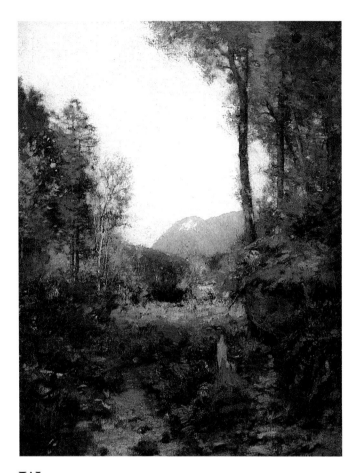

Alexander Helwig Wyant

(1836 - 1892)

Adirondack Vista, ca. 1881

Oil on canvas 25 x 19
Checklist no. 371

Wyant came to Keene Valley in the summer of 1868 on the advice of Roswell Shurtleff and was among the first of the artists to build his own home there.[1] "He selected a location above the Ausable River on the edge of a cliff, known as 'Wyant's Rock' with a broad view of Noonmark and Dial."[2] *Adirondack Vista* depicts Noonmark in the distance and closely resembles Wyant's dated painting, *An Old Clearing,* 1881, in the collection of the Metropolitan Museum of Art.[3] Its delicate use of warm grays and light blues, highlighted with touches of yellow, anticipates the subtle coloration of Wyant's later *Rocky Ledge, Adirondacks,* ca. 1884 which, like *Adirondack Vista,* was once in the collection of George S. Palmer.[4]

1. Pauline Goldmark, "Keene Valley Artists," typescript, 1940, Keene Valley Library, Keene Valley, N.Y., p. 5.
2. Ibid., p. 6.
3. Natalie Spassky, *American Paintings in the Metropolitan Museum of Art* (New York: The Metropolitan Museum of Art, 1985), vol. II, pp. 416-417, ill.
4. Paul D. Schweizer, ed., *Masterworks of American Art from the Munson-Williams-Proctor Institute* (New York: Harry N. Abrams, Inc., 1989), cat. no. 39, ill.

Don Wynn

(1942 -)

Campfire, 1975

Oil on canvas 90 x 72
Checklist no. 373

Wynn's enormous painting depicts an exhausted hiker seated by a campfire. It is a night scene which makes use of the dramatic effect produced by penetrating light. The firelight radiates from below the seated figure and highlights the artist's careful portrait of a female camper. The model for the camper was Wendy Gsell who was at the time of the studio sittings a student at Skidmore College. Wynn's method of carefully analyzing a subject during several studio visits and then creating a life-size, lifelike woman is in the finest tradition of realism. These figure studies were executed in his Blue Mountain Lake studio during September 1975.

Both in his handling of human form and his exaggerated use of light, Wynn identifies himself as an artist imbued with academic tradition and aware of the accomplishments of earlier artists who sculpted form with light. The bravura portraits of the seventeenth century Italian artist, Caravaggio, and the hallucinatory scientific experiments recorded by the late eighteenth century English artist, Joseph Wright of Derby, come to mind when the viewer's attention is arrested by *Campfire.* Despite its dependence on established artistic tradition, the museum's painting is fresh and immediate in the way it captures the specific details which document the camper's previous physical exertion and present fatigue. Well-worn socks and a single glove dry on an extemporaneous clothesline. A melange of an open can of evaporated milk, enamel cooking pot, assorted knives, griddle and axe describe the camper's nighttime world in a carefully assembled still life. Despite the realistic details, Wynn's involvement in the scene, as his title suggests, is not in its portraiture of a specific person or site but rather in the study of light and its ability to carve the harsh lines of reality.

8

Checklist

Key to abbreviations:

AMC Adirondack Museum
 Collections
AML Adirondack Museum
 Library
NAD National Academy
 of Design

All dimensions are in inches.

The Checklist is arranged alphabetically by artist. Each listing includes the title of the work and the date, followed by medium, dimensions, signature, provenance, and exhibit history, when known. The number at the end of each listing is the Adirondack Museum's accession number; the number in parenthesis is the painting number assigned by the museum. P plus number is the assigned photograph number.

Drawings and etchings that appear in the Checklist have no Checklist number.

Paintings, drawings, and etchings illustrated in the Entry section of this catalogue are indicated by a box next to the title.

Walter Monteith Aikman
(1857 - ?)

1 *Boat on Shore,* 1894
 Watercolor 11 x 15
 Signed l.l. W.M. Aikman
 Purchase.
 Logbooks, Cranford Camp,
 1889 - 1891, Osgood Lake,
 MF5.2, AML.
 71.021.01 (253)

2 *Cabin at Camp,* 1917
 Oil on canvas 6 x 9
 Signed l.l. W.M. Aikman
 Gift of Miss Margaret
 Cranford.
 See 71.021.01.
 71.044.02 (261)

Grosvenor Atterbury
(? - ?)

3 *Durant Desk Design,* June 1893
 Watercolor 8 x 12
 Signed u.r. Grosvenor
 Atterbury
 Gift of Mrs. Bromley Seeley.
 66.060.01 (132)

William Bliss Baker
(1859 - 1886)

4 *A Pleasant Day at Lake George,*
 ca. 1883
 Oil on canvas 20 x 36
 Signed l.r. Wm. Bliss Baker
 Purchase.
 NAD, 1883, No. 141.
 66.114.02 (139)

Daniel Folger Bigelow
(1823 - 1910)

5 *Whiteface from Wilmington*
 Valley, 1895
 Oil on canvas 16 x 24
 Signed l.r. D.F. Bigelow
 Gift of Harold K.
 Hochschild.
 1) D.F. Bigelow scrapbook
 compiled by daughter,
 Florence. 2) Bigelow
 sketchbook, 70.163, AMC.
 61.002.01 (28)

Allen Blagden
(1938 -)

6 *September Snow - Loon,*
ca. 1986
Watercolor 25 x 40
Signed l.r. Allen Blagden
Purchase.
88.017.01 (498)

Ralph Albert Blakelock
(1847 - 1919)

7 Untitled: The Log Cabin,
ca. 1890
Oil on board 12 x 10
Signed l.l. Blakelock
Gift of Harold K.
Hochschild; David D.
Blakelock, artist's grandson.
1) *Ralph Albert Blakelock
(1847-1919)*, New York,
M. Knoedler and Co.,
March 3 - 31, 1973, fig. 5.
2) University of Nebraska,
Blakelock Inventory,
cat. 8650.
73.125.01 (353)

DeWitt Clinton Boutelle
(1820 - 1884)

8 *The Sacandaga River at
Hadley, New York,* 1867
Oil on canvas 20 x 30
Signed l.l. Boutelle
Purchase.
90.002.01 (509)

Nelson S. Bowdish
(1831 - 1916)

9 *Lake With Steamboats,* n.d.
Watercolor 9 x 17
Not signed
Purchase.

Nancy Douglas Bowditch
(1890 - 1979)

10 *Fall Mountains, Adirondacks
Near Putnam Camp,* 1941
Watercolor 12 x 18
Signed l.r. N.D. Bowditch
Gift of the artist.
Elizabeth Putnam McIver,
"Early Days at Putnam
Camp," reprint of paper
read at annual meeting of
Keene Valley Historical
Society, September 1941,
n.d., 29 pgs., ill.
67.114.01 (161)

11 *Morning Mist Rising from
the Woods, Keene Valley,
Adirondacks, N.Y.,* 1941
Watercolor 22 x 14
Signed l.r. Nancy D.
Bowditch
Gift of the artist.
67.114.02 (162)

12 *View from Putnam Camp,
Adirondacks, N.Y.,* 1941
Watercolor 12 x 16
Signed l.r. N.D. Bowditch
Gift of the artist.
See 67.114.01.
67.114.03 (163)

13 *Noonmark Mountain from
Putnam Camp, Adirondack
Mountains,* 1941
Watercolor 17 x 12
Signed l.r. N.D. Bowditch
Gift of the artist.
See 67.114.01.
67.114.04 (164)

14 *Putnam Camp, Keene Valley,
Adirondacks,* n.d.
Watercolor 12 x 18
Signed l.r. Nancy D.
Bowditch
Gift of the artist.
See 67.114.01.
67.114.05 (165)

Courtenay Brandreth
(1891 - 1947)

15 *Old Rube, Portrait of Reuben
Cary (1845 - 1933),*
ca. 1945-46
Oil on canvas 20 x 26
Not signed
Gift of Mrs. Courtenay
Brandreth.
1) Paulina Brandreth, "Old
Leviathan of Burnt Moun-
tain Lake," *Forest & Stream,*
Jan. 4, 1913. 2) W.W.
Durant, "The Brandreth
Preserve," *Forest & Stream,*
Sept. 18, 1897. 3) Related to
photograph of Reuben Cary,
ca. 1945, P10904, AMC.
65.033.01 (109)

Paul Bransom
(1885 - 1979)

16 Untitled: Landscape with
Cabin, n.d.
Oil on canvas 15 x 24
Signed l.r. Paul Bransom
Gift of Paul Bransom Collec-
tion (a.k.a. Althea Bond).
87.001.03 (477)

17 Untitled: Landscape with
Trees and Boulder, n.d.
Watercolor 20 x 15
Signed l.l. Paul Bransom
Gift of Paul Bransom Collec-
tion (a.k.a. Althea Bond).
87.001.05 (479)

18 Untitled: Lake Scene, n.d.
Watercolor 5 x 8
Signed l.l. Paul Bransom
Gift of Paul Bransom Collec-
tion (a.k.a. Althea Bond).
87.001.06 (480)

19 Untitled: Lake Scene, n.d.
Watercolor 5 x 8
Signed l.l. P.B.
Gift of Paul Bransom Collec-
tion (a.k.a. Althea Bond).
87.001.07 (481)

20 Untitled: Lake Scene, n.d.
Watercolor 5 x 8
Signed l.l. Paul Bransom
Gift of Paul Bransom Collec-
tion (a.k.a. Althea Bond).
87.001.08 (482)

21 Untitled: Lake Scene with
Pine Trees, n.d.
Watercolor 5 x 8
Signed l.l. P.B.
Gift of Paul Bransom Collec-
tion (a.k.a. Althea Bond).
87.001.09 (483)

22 Untitled: Meadow
with Trees, n.d.
Watercolor and
gouache 11 x 12
Signed l.l. Paul Bransom
Gift of Paul Bransom Collec-
tion (a.k.a. Althea Bond).
87.001.10 (484)

23 Untitled: Trees in Snow, n.d.
Watercolor 8 x 10
Signed l.r. P.B.
Gift of Paul Bransom Collec-
tion (a.k.a. Althea Bond).
87.001.11 (485)

24 Untitled: Landscape with
Hunter, Dog and Geese, n.d.
Watercolor 6 x 5
Signed l.r. Paul Bransom
Gift of Paul Bransom Collec-
tion (a.k.a. Althea Bond).
87.001.12 (486)

25 Untitled: Landscape with
Hunter, Dog and Geese, n.d.
Watercolor 6 x 5
Signed l.r. Paul Bransom
Gift of Paul Bransom Collec-
tion (a.k.a. Althea Bond).
87.001.13 (487)

26 Untitled: Tree Trunks, n.d.
Watercolor 9 x 6
Not signed
Gift of Paul Bransom Collec-
tion (a.k.a. Althea Bond).
87.001.14 (488)

27 *Arieta Looking North to the
Adirondacks,* n.d.
Watercolor 14 x 20
Signed l.r. Paul Bransom
Gift of Paul Bransom Collec-
tion (a.k.a. Althea Bond).
87.001.15 (489)

28 Untitled: Lake Through
Trees, n.d.
Watercolor 5 x 8
Signed l.l. P.B.
Gift of Paul Bransom Collec-
tion (a.k.a. Althea Bond).
87.001.16 (490)

29 Untitled: Trees, 1970
Watercolor 15 x 11
Signed l.r. Paul Bransom
Gift of Paul Bransom Collec-
tion (a.k.a. Althea Bond).
87.001.17 (491)

30 Untitled: Tree Branches,
1971
Watercolor 15 x 20
Signed l.r. Paul Bransom
Gift of Paul Bransom Collec-
tion (a.k.a. Althea Bond).
87.001.18 (492)

31 Untitled: Trees, n.d.
Watercolor 20 x 15
Signed l.l. P.B.
Gift of Paul Bransom Collec-
tion (a.k.a. Althea Bond).
87.001.19 (493)

32 Untitled: Lake Scene
at Dawn, n.d.
Watercolor 7 x 9
Signed l.l. Paul Bransom
Gift of Paul Bransom Collec-
tion (a.k.a. Althea Bond).
87.001.20 (494)

33 Untitled: Lake Scene
at Dusk, n.d.
Watercolor 6 x 9
Signed l.r. P.B.
Gift of Paul Bransom Collec-
tion (a.k.a. Althea Bond).
87.001.21 (495)

34 Untitled: Trees, n.d.
Watercolor 15 x 20
Not signed
Gift of Paul Bransom Collec-
tion (a.k.a. Althea Bond).
87.001.22 (496)

42

35 Untitled: Elk in Woods, n.d.
Watercolor and gouache
10 x 7
Signed l.r. Paul Bransom
Gift of Paul Bransom Collection (a.k.a. Althea Bond).
87.001.23 (497)

Alfred Thompson Bricher
(1837 - 1908)

36 Untitled: Boating Party on
Lake George, ca. 1867
Oil on canvas 26 x 48
Signed l.r. A.T. Bricher
Purchase.
Preston, "Alfred Thompson
Bricher, 1837 - 1908," *Art
Quarterly*, Summer 1962,
p. 154.
82.004.01 (443)

John Bunyan Bristol
(1826 - 1909)

37 *Near Wilmington Pass,
Adirondacks*, ca. 1881
Oil on canvas 24 x 44
Signed l.l. J.B. Bristol
Purchase.
NAD, 1881, No. 394,
Near Willmington [sic]
Pass, Adirondacks.
69.022.01 (206)

James E. Buttersworth
(1818 - 1894)

38 *Fort William Henry Hotel,*
ca. 1870
Oil on board 7 x 9
Signed l.r. J.E. Buttersworth
Purchase.
1) *Kennedy Quarterly*, New
York, Kennedy Galleries,
November 1967, cat. no. 189,
p. 156, ill. 2) Schaefer, *J.E.
Buttersworth, 19th Century
Marine Painter*, Mystic, Conn.,
Mystic Seaport Museum,
1975, no. 134, p. 158, ill.
67.220.01 (180)

Joseph (?) Caldwell
(fl. 1869)

39 *Rattlesnake Cobble,
Caldwell/Lake George*, 1869
Watercolor 7 x 10
Signed l.c. Caldwell
Purchase.
77.042.01 (413)

James Cameron
(1817 - 1882)

40 *Long Lake*, ca. 1855
Oil on canvas 26 x 42
Signed l.c. J. Cameron
Gift of Farrand Northrup
Benedict, Jr.; F.N.
Benedict, Sr.
69.091.01 (213)

John William Casilear
(1811 - 1893)

41 Untitled: Keene Valley,
Adirondacks, New York,
1881
Oil on canvas 14 x 20
Signed l.r. JWC
Purchase.
80.058.01 (431)

C.H. Chapin
(fl. 1871 - 1904)

42 Untitled: Autumn in the
Adirondacks, 1871
Oil on canvas 30 x 50
Signed l.r. C.H. Chapin
Gift of Mr. and Mrs.
Frederick Darling.
80.090.01 (433)

46

George L. Clough
(1824-1901)

43 Untitled: Adirondack
Camping Scene, n.d.
Oil on canvas 24 x 36
Signed l.l. G.L. Clough
Purchase.
Study for this painting, the
Seward House, Auburn, N.Y.
73.019.01 (313)

E.C. Coates
(fl. 1839 - 1864)

44 *Pioneer's Home*, 1851
Oil on canvas 22 x 27
Signed l.r. E.C. Coates
Gift of Frederick B. Hard.
81.079.01 (442)

Thomas Cole
(1801 - 1848)

45 *Schroon Lake*, ca. 1846
Oil on canvas 33 x 32
Signed l.c. TC
Purchase; Edith Cole Hill
Silberstein; estate of
Florence H. Cole Vincent;
the artist.

Possibly the *Schroon Lake*
listed in the inventory of
Cole's estate, March 3, 1848.
65.003.02 (101)

Samuel Colman
(1832 - 1920)

46 Untitled: Colvin and
Sawtooth from Beede's, n.d.
Watercolor 7 x 10
Not signed
Purchase.
70.199.02 (235)

47 Untitled: View from Scott's
Clearing, Adirondacks, #4,
ca. 1890
Watercolor 7 x 18
Not signed
Purchase.
70.199.03 (236)

48 Untitled: AuSable River,
ca. 1869
Oil on canvas 30 x 40
Signed l.r. Sam.l Colman
Gift of Harold K.
Hochschild.
72.160.03 (311)

Edith M. Cook
(? - ?)

49 Untitled: Ledge Overlooking
Mountains, 1867
Oil on wood 7 x 14
Signed l.r. Edith M. Cook
Purchase.
70.199.01 (234)

Ralph Noyes Cranford
(1866 - 1936?)

50 Untitled: The Slash, n.d.
Oil on cardboard 7 x 10
Signed back of frame u.r.
R.N.C.
Gift of Mr. and Mrs. Walter
V. Cranford and Miss
Margaret Cranford.
Logbooks, Cranford Camp,
1889 - 1891, Osgood Lake,
MF5.2, AML.
71.044.01 (260)

51 Untitled: Deer at Pond, n.d.
Oil on canvas 20 x 28
Not signed
Gift of Mr. and Mrs. Walter
V. Cranford and Miss
Margaret Cranford.
See 71.044.01.
75.038.01 (381)

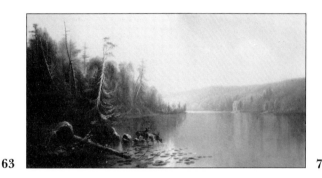

63

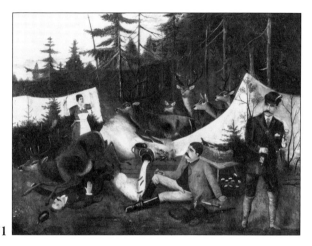

71

52 Untitled: Landscape, 1944
Oil on canvas 9 x 12
Signed l.r. R.N.C.
Gift of Mr. and Mrs. Walter
V. Cranford and Miss
Margaret Cranford.
See 71.044.01.
75.038.02 (382)

53 Untitled: Landscape, 1915
Oil on panel 6 x 9
Signed l.r. R.N.C.
Gift of Mr. and Mrs. Walter
V. Cranford and Miss
Margaret Cranford.
See 71.044.01.
75.038.03 (383)

54 Untitled: Deer at Pond, 1933
Oil on academy board 6 x 9
Signed l.r. R.N.C.
Gift of Mr. and Mrs. Walter
V. Cranford and Miss
Margaret Cranford.
See 71.044.01.
75.038.04 (384)

Lillian Haines Crittenden
(1858 - 1919)

55 *Partley* [sic] *Cloudy,*
ca. 1908 - 1917
Pastel on academy board
8 x 16

Not signed
Gift of Mrs. Lawrence B.
Dunham.
83.068.01 (451)

Jasper Francis Cropsey
(1823 - 1900)

56 Untitled: Adirondack
Landscape, n.d.
Oil on canvas 6 x 11
Signed l.l. J. Cropsey
Purchase.
64.221.01 (98)

C.G. Dana
(1843 - 1924)

57 *Lower AuSable Lake,* 1862
Oil on canvas 16 x 26
Signed l.r. C.G. Dana
Gift of Mr. and Mrs. Harold
K. Hochschild.
61.018.02 (34)

Will Davis
(1812 - 1873)

58 *Self Portrait,* 1845
Oil on canvas 13 x 12
Not signed
Gift of Arthur F. Tait, II.
68.128.01 (200)

Charles De Feo
(? - ?)

59 Untitled: Forest Scene, 1960s
Watercolor 10 x 14
Signed l.l. Charles De Feo
Gift of Paul Bransom Collec-
tion (a.k.a. Althea Bond).
86.038.01 (470)

60 Untitled: Landscape, 1960s
Watercolor 9 x 8
Signed l.c. Charles De Feo
Gift of Paul Bransom Collec-
tion (a.k.a. Althea Bond).
86.038.02 (471)

61 Untitled: Landscape, 1960s
Watercolor 18 x 12
Signed l.r. Charles De Feo
Gift of Paul Bransom Collec-
tion (a.k.a. Althea Bond).
87.001.01 (475)

62 Untitled: Landscape, 1960s
Watercolor 15 x 11
Signed l.l. Charles De Feo
Gift of Paul Bransom Collec-
tion (a.k.a. Althea Bond).
87.001.02 (476)

73

Robert M. Decker
(1847 - 1921)

63 *Raquette Lake*, 1871
Oil on canvas 14 x 26
Signed l.l. R.M.D.
Gift of Mrs. Irving E. Wood,
artist's daughter.
58.303.01 (15)

64 *Hague*, n.d.
Oil on canvas 8 x 14
Signed l.l. R.M. Decker
Purchase.
62.012.01 (61)

65 *Hague*, n.d.
Oil on canvas 12 x 18
Signed l.r. R.M. Decker
Purchase.
62.012.02 (62)

66 *Hague*, n.d.
Oil on canvas 8 x 14
Signed l.r. R.M. Decker
Purchase.
62.012.03 (63)

67 *From the Rising House, Looking
South at Hague, Lake George,*
n.d.
Oil on canvas 10 x 40

Signed l.l. R.M. Decker
Purchase.
64.222.01 (99)

Foster Disinger
(fl. 1948 - 1959)

68 *Lumber Headquarters*, 1948
Oil on canvas 18 x 24
Not signed
Gift of the artist.
59.036.01 (21)

John Henry Dolph
(1835 - 1903)

69 *The Adirondack Mountains,
Near Elizabethtown, Essex Co.,
N.Y.*, 1866
Oil on canvas 27 x 48
Signed l.l. J.H. Dolph
Purchase.
66.024.01 (117)

Alice Donaldson
(? - ?)

70 *Little Red - Saranac #2*, n.d.
Watercolor 22 x 30
Not signed
Gift of Dr. Bela O. Duboczy
and Dr. Ben Frulinger.
75.138.01 (398)

? Dubson
(fl. 1902)

71 Untitled: Adirondack
Primitive Scene, 1902
Oil on canvas 30 x 40
Not signed
Gift of The Shelburne
Museum, Shelburne, Vt.
65.015.02 (105)

Asher Brown Durand
(attributed)
(1796 - 1886)

72 Untitled: Boulder and Trees,
ca. 1858
Oil on canvas 25 x 20
Not signed
Gift of Mrs. Douglas
Delanoy; Professor Allan
Marquand, donor's father.
72.036.01 (281)

Don R. Eckleberry
(fl. 1960)

73 *Inside the Adirondack Forest*,
1960
Oil on canvas 48 x 120
Not signed
Purchase.
60.059.01 (23)

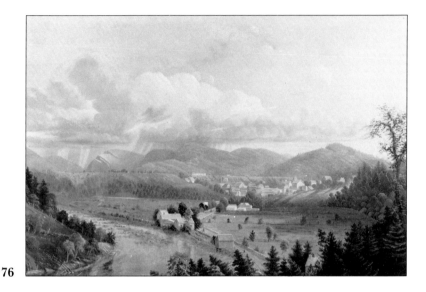

76

74 *Outside the Adirondack Forest,*
ca. 1959-1960
Oil on canvas 48 x 120
Not signed
Purchase.
60.059.02 (24)

John Whetten Ehninger
(1827 - 1889)

75 *Mission of the Good Shepherd,*
St. Hubert's Island, Raquette
Lake, 1881
Oil on canvas 25 x 44
Signed l.r. Jno. W. Ehninger,
N.A.
Purchase.
1) *Kennedy Quarterly,* New
York, Kennedy Galleries,
November 1967, cat. no. 195,
p. 162, ill. 2) Gilborn,
Durant: The Fortunes and
Woodland Camps of a Family in
the Adirondacks, Blue
Mountain Lake, N.Y., The
Adirondack Museum, 1981,
fig. 27, ill.
72.010.01 (280)

Charles H. Ellenwood
(fl. 1825 - 1876)

76 *Keeseville,* n.d.
Oil on canvas 24 x 36
Signed l.r. C.H. Ellenwood
Gift of Adam Hochschild;
Mr. and Mrs. Harold K.
Hochschild.
81.011.01 (430)

James Fairman
(1826 - 1904)

77 *People by the River Bank,* n.d.
Oil on canvas 7 x 14
Signed l.c. J. Fairman
Gift of Warren W. Kay.
83.077.20 (455)

Henry A. Ferguson
(1842 - 1917)

78 *Sunset Blue Mountain Lake,*
Adirondacks, ca. 1893
Oil on canvas 16 x 26
Not signed
Purchase.
NAD, 1894, No. 75,
Shore of Blue Mountain Lake.
67.135.01 (168)

79 *Blue Mountain Lake,*
Adirondacks, n.d.
Oil on canvas 11 x 13
Signed l.l. Henry A.
Ferguson
Gift of Adam Hochschild;
Mr. and Mrs. Harold K.
Hochschild.
81.046.04 (441)

Hugh Antoine Fisher
(1867 - 1916)

80 *Rapids of the Au Sable,*
n.d.
Watercolor and gouache
40 x 30
Signed l.l. H. Fisher
Purchase.
85.061.01 (469)

John Lee Fitch
(1836 - 1895)

81 *Eagle Lake,* 1881
Oil on canvas 15 x 36
Signed on original backing
J. Fitch
Purchase.
1) Exhibition, Century
Club, January 14, 1882.
2) Register, Prospect House,

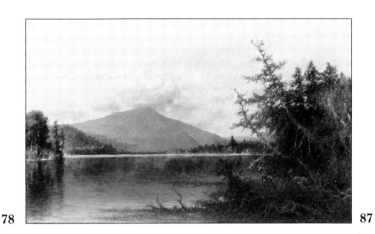

78

87

Blue Mountain Lake,
August 1881, AML.
72.045.01 (299)

John (?) Forgy
(fl. 1886)

82 *Lake Scene,* 1886
Oil on canvas 18 x 27
Signed l.r. Forgy
Purchase.
69.192.01 (221)

Arthur Burdett Frost
(1851 - 1928)

83 *Breaking Up Camp/The*
Racquette [sic] *River at the*
End of Sweeny Carry, 1881
Gouache 8 x 14
Signed l.r. A.B.F.
Gift of Warren W. Kay.
1) "Adirondack Days,"
Harper's New Monthly
Magazine, Oct. 1881, ill. as
A Carry - The End, p. 685.
2) See wood engraving
69.179.11, AMC.
83.077.17 (452)

Hermann Fuechsel
(attributed)
(1832 - 1915)

84 *Brook Crossing,* n.d.
Oil on canvas 13 x 23
Not signed
Purchase.
Kennedy Quarterly, New York,
Kennedy Galleries,
November 1967, cat. no. 233,
p. 202, ill.
67.220.12 (190)

Sanford Robinson
Gifford
(1823 - 1880)

85 *A Twilight in the Adirondacks,*
1864
Oil on canvas 24 x 26
Signed l.r. S.R. Gifford
Purchase; C.H. Ludington.
1) NAD, 1864, No. 250.
2) Sheldon, *American Paint-*
ers, New York, D. Appleton &
Co., 1881, p. 19, ill.
3) *A Memorial Catalogue of*
Paintings by Sanford Robinson
Gifford, N.A., New York,
Metropolitan Museum of
Art, 1881, no. 345.
4) Cikovsky, *Sanford Robinson*
Gifford (1823-1880), Austin,

University of Texas Art
Museum, 1970, cat. no. 29,
ill. 5) Weiss, *Sanford Robinson*
Gifford, (1823-1880), New
York, London, Garland Pub.,
1977, fig. VII, E 4, ill.
63.124.02 (90)

86 *Camping for the Night on*
Mansfield Mountain, ca. 1868
Oil on canvas 10 x 17
Not signed
Purchase; E. Pinchot, 1868.
See 63.124.02, #3) no. 469,
#4) cat. no. 41, ill., #5)
fig. VII, E 7, ill.
65.003.01 (100)

87 Untitled: Echo Lake,
Franconia Notch, White
Mountains, ca. 1866
Oil on canvas 12 x 10
Signed l.r. S.R. Gifford
Purchase.
1) See 63.124.02, #4) cat. no.
38, ill., and #5) fig. III, G 1,
ill. as *Echo Lake, Franconia*
Notch, White Mountains.
2) *Kennedy Quarterly,* New
York, Kennedy Galleries,
November 1967, cat. no. 227,
p. 194, ill., as *Lake in the*
Adirondacks.
67.220.11 (189)

88 *Adirondack Lake*, 1869
Pastel on paper 6 x 10
Signed l.l. S.R. Gifford
Purchase.
72.078.01 (304)

Regis Francois Gignoux
(1816 - 1882)

89 *Log Road in Hamilton County,*
1844
Oil on canvas 27 x 34
Signed l.r. R. Gignoux
Gift of Mrs. Boris Sergievsky;
George W. Austen, 1844.
NAD, 1844, No. 270, lent by
George W. Austen.
64.005.01 (92)

William B. Gillette
(1864 - 1937)

90 *Small-Mouth Black Bass,*
ca. 1907
Watercolor 18 x 27
Signed l.r. W.B. Gillette
Purchase.
74.141.01 (358)

Philip R. Goodwin
(1881 - 1935)

91 *The Little Shack by the Lake,*
Adirondacks. Cranford Camp,
n.d.
Oil on canvas 12 x 16
Signed l.r. Philip R. Goodwin
Gift of Mr. and Mrs. Walter
V. Cranford and Miss
Margaret Cranford.
Logbooks, Cranford Camp,
1889 - 1891, Osgood Lake,
MF5.2, AML.
75.038.05 (385)

92 *Osgood River, n.d.*
Oil on canvas 10 x 14
Signed l.r. Philip R. Goodwin
Gift of Mr. and Mrs. Walter
V. Cranford and Miss
Margaret Cranford.
See 75.038.05.
75.038.06 (386)

93 Untitled: Camp in Fir Trees,
n.d.
Oil on cardboard 10 x 14
Signed l.r. Philip R. Goodwin
Gift of Mr. and Mrs. Walter
V. Cranford and Miss
Margaret Cranford.
See 75.038.05.
75.038.07 (387)

94 Untitled: Landscape
with Tree, n.d.
Oil on cardboard 10 x 14
Signed l.r. Philip R. Goodwin
Gift of Mr. and Mrs. Walter
V. Cranford and Miss
Margaret Cranford.
See 75.038.05.
75.038.08 (388)

95 Untitled: Mountain
and Lake, ca. 1930
Oil on canvas 8 x 10
Signed l.r. Philip R. Goodwin
Gift of Mr. and Mrs. Walter
V. Cranford and Miss
Margaret Cranford.
See 75.038.05.
75.038.09 (389)

96 Untitled: Camp, Trees,
ca. 1929
Oil on canvas 6 x 9
Signed l.r. Philip R. Goodwin
Gift of Mr. and Mrs. Walter
V. Cranford and Miss
Margaret Cranford.
See 75.038.05.
75.038.10 (390)

97 Untitled: Tree, ca. 1927
Oil on panel 4 x 5
Signed l.r. Philip R. Goodwin
Gift of Mr. and Mrs. Walter
V. Cranford and Miss
Margaret Cranford.
See 75.038.05.
75.038.11 (391)

98 Untitled: Tree, 1934
Oil on panel 8 x 6
Signed l.r. Philip R. Goodwin
Gift of Mr. and Mrs. Walter
V. Cranford and Miss
Margaret Cranford.
See 75.038.05.
75.038.12 (392)

99 Untitled: Birches, n.d.
Oil on board 6 x 8
Signed l.r. Philip R. Goodwin
Gift of Mr. and Mrs. Walter
V. Cranford and Miss
Margaret Cranford.
See 75.038.05.
75.038.13 (393)

100 *Boathouse, Camp,* n.d.
Oil on board 6 x 10
Signed l.r. Philip R. Goodwin
Gift of Mr. and Mrs. Walter
V. Cranford and Miss
Margaret Cranford.
See 75.038.05.
75.038.14 (394)

Samuel W. Griggs
(1827 - 1898)

101 *Scroon* [sic] *Lake, N.Y.,*
ca. 1871
Oil on canvas 14 x 24
Signed on stretcher
S.W. Griggs
Gift of Stephen C. Clark;
Gunn Collection.
59.001.01 (20)

104

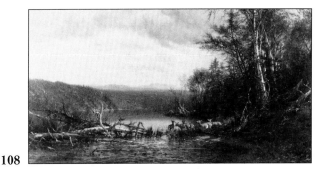

108

102 *On the Bouquet River,*
Elizabethtown, N.Y., n.d.
Oil on canvas 18 x 30
Signed l.l. S.W. Griggs
Purchase.
67.116.01 (166)

103 *Blue Mountain Lake, From*
Merwin's Blue Mountain
House, ca. 1887
Oil on canvas 18 x 30
Signed l.r. S.W. Griggs
Gift of William Wessels,
proprietor of Blue Mountain
House.
Blue Mountain House
Register, July 13, 1887,
documents Griggs' visit to
the area, AML.
75.116.02 (396)

104 *Fort Ticonderoga,* ca. 1870s
Oil on canvas 22 x 30
Signed l.l. Griggs; back of
stretcher S.W. Griggs
Purchase.
82.030.01 (445)

105 *Prentice Falls,* 1887
Oil on canvas 30 x 18
Signed l.r. S.W. Griggs
Gift of Barbara and George
R. Wells, grandchildren of
Miles Tyler Merwin, founder
and proprietor of Blue
Mountain House.
88.018.01 (499)

D.C. Grose
(fl. 1869)

106 *Bolten's* [sic] *Landing,* 1869
Oil on canvas 8 x 12
Signed l.c. D.C. Grose
Purchase.
Kennedy Quarterly, New York,
Kennedy Galleries, November 1967, cat. no. 191,
p. 158, ill.
67.220.02 (181)

George Grosz
(1893 - 1959)

107 Untitled: North End,
Saranac, ca. 1959
Watercolor 6 x 9
Signed l.l. Grosz; l.r. George
Purchase; Mr. and Mrs.
Philip N. Lehr.
63.070.01 (78)

James McDougal Hart
(1828 - 1901)

108 Untitled: A Bit of
Lake Placid, 1860
Oil on canvas 18 x 34
Signed l.r. J.M. Hart
Purchase.
Kennedy Quarterly, New York,
Kennedy Galleries, November 1967, cat. no. 199,
p. 166, ill.
67.220.04 (182)

109 Untitled: View on
Loon Lake, 1862
Oil on canvas 19 x 32
Signed l.r. James M. Hart
Purchase; C. M. Vanderlip.
1) NAD, 1862, No. 160.
2) See 67.220.04, cat. no.
211, p. 178, ill., as
An Adirondack Deer Herd.
67.220.06 (184)

110 Untitled: Tall Timber, 1888
Oil on canvas 31 x 11
Signed l.l. Jas. M. Hart
Purchase.
73.066.01 (319)

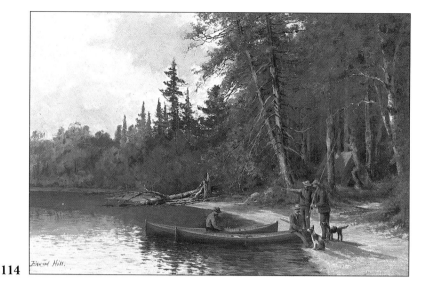

114

William M. Hart
(1823 - 1894)

111 Untitled: Night Scene,
Keene Valley, 1861
Oil on canvas 8 x 16
Signed l.r. Wm. Hart
Purchase.
70.198.01 (233)

John Held, Jr.
(1889 - 1958)

112 Untitled: Blue Mountain
Lake, 1919
Watercolor 9 x 12
Not signed
Gift of Harold K.
Hochschild.
70.096.01 (224)

Henry W. Herrick
(1824 - 1906)

113 *Round Lake, Adirondacks,*
1886
Watercolor 12 x 27
Signed l.l. Herrick
Purchase.
65.078.01 (111)

Edward Hill
(1852 - ?)

114 *Camping on Loon* [?] *Lake,*
n.d.
Oil on canvas 16 x 24
Signed l.l. Edward Hill
Purchase.
66.013.01 (114)

John Henry Hill
(1839 - 1922)

115 Untitled: Campsite, 1867
Watercolor 10 x 14
Signed l.r. J. Henry Hill
Purchase; Charles M. Hill,
artist's step-nephew.
57.132.01 (2)

116 *The Island Pines, Lake George,*
1871
Watercolor 7 x 10
Not signed
Purchase; Charles M. Hill,
artist's step-nephew.
1) Study for etching of same
title by J.H. Hill, 1871, Avery
Collection, New York Public
Library, no. 11. 2) Reverse
of etching (with half moon
in upper right), center left in
The Narrows, Lake George,
surveyed by G.W. Hill, 1871,

drawn and etched by J.Henry
Hill, Avery Collection, New
York Public Library, no. 9.
3) John Henry Hill, Diary at
"Artist's Retreat," December
25, 1870 - March 25, 1874,
October 21, 27, 1871, AML.
57.132.04 (5)

117 *Long Lake,* 1867
Watercolor 5 x 10
Signed l.l. J.H. Hill
Purchase.
58.304.02 (17)

118 Untitled: Landscape, 1909
Watercolor 13 x 19
Signed l.l. J. Henry Hill
Gift of Lynn Boillot, Patricia
LaBalme, Ann Poole.
85.035.01 (468)

John Henry Hill
(attributed)
(1839 - 1922)

119 *Tuppers* [sic] *Lake,* ca. 1867
Watercolor 4 x 6
Not signed
Purchase; Charles M. Hill,
artist's step-nephew.
58.304.01 (16)

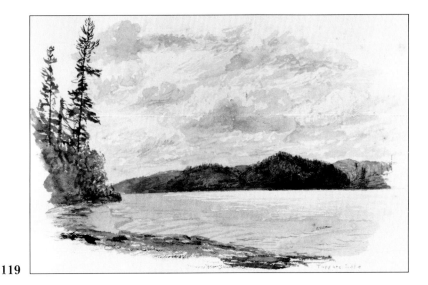

119

John William Hill
(1812 - 1879)

120 *Lake George*, 1871
Watercolor 13 x 18
Signed l.r. J.W. Hill
Purchase; Charles M. Hill.
57.132.02 (3)

121 Untitled: Waterfall, 1874
Watercolor 10 x 13
Signed l.l. J.W. Hill
Purchase; Charles M. Hill.
57.132.03 (4)

122 Untitled: The Raccoon,
ca. 1842
Watercolor 4 x 7
Signed l.r. J.W. Hill
Purchase.
DeKay, *Natural History of
New York*, Part I. "Zoology";
New York, D. Appleton &
Co., 1842, pp. 26-27,
pl. VI, fig. 2 as *The Raccoon,
Procyon Lotor.*
75.251.01 (402)

Winslow Homer
(1836 - 1910)

123 *Casting, "A Rise"*, 1889
Watercolor 9 x 20
Signed l.l. Homer
Purchase; Mr. and Mrs.
Sidney Simon; Samuel A.
Lewisohn, Mrs. Simon's
father; Knoedler & Co.;
William T. Evans; Gustave
Reichard.
Goodrich, *Winslow Homer in
the Adirondacks, An Exhibition
of Paintings*, Blue Mountain
Lake, N.Y., The Adirondack
Museum, 1959, p. 23.
67.058.01 (156)

Charles Dow Hunt
(1840 - 1914)

124 Untitled: Landscape, 1886
Oil on canvas 30 x 22
Signed l.l. C.D. Hunt
Purchase; New Jersey
Historical Society; Mrs. J.C.
Alling; J.A. Alling.
63.160.385 (91)

125 *On the Asauble* [sic], 1873
Oil on canvas 15 x 24
Signed l.r. C.D. Hunt
Purchase.
1) Exhibition, Brooklyn
Academy of Art, Brooklyn,
N.Y., December 1873, no. 59,
AuSable River, Adirondacks.
2) Exhibition, Brooklyn
Academy of Art, Brooklyn,
N.Y., November 1874, no. 43,
AuSable River, Adirondacks.
3) *Kennedy Quarterly*, New
York, Kennedy Galleries,
November 1967, cat. no. 204,
p. 172, ill.
67.220.05 (183)

K.F. Huyssoun
(fl. 1884)

126 *Noon-Mark from Keene Valley*,
1884
Oil on canvas 14 x 22
Signed l.r. K.F. Huyssoun
Purchase.
74.333.01 (380)

Charles Cromwell Ingham
(1796 - 1863)

127 *The Great Adirondack Pass,*
Painted on the Spot, 1837
Oil on canvas 48 x 40
Not signed
Gift of Mr. and Mrs. Harold
Grout (McIntyre descendant); Mrs. Archibald
McIntyre, gift of the artist,
1840.
1) NAD, 1839, No. 20.
2) Emmons, New York State
Assembly, *Document 200,*
1838, relative to the Geological Survey of the State,
Albany, 1838, pl. 2. Lithograph by Bufford, titled
View of the Indian Pass (after
C.C. Ingham, signed l.l. C.C.
Ingham) 3) Letter to
Thomas Cole, July 10, 1837,
MS Room, New York State
Library, Albany, N.Y.
66.114.01 (138)

Charles Cromwell Ingham
(attributed)
(1796 - 1863)

128 Untitled: Portrait of Peter
McMartin (? - 1830), ca. 1827
Oil on canvas 6 x 7
Not signed
Gift of Arthur M. Crocker
(McIntyre descendant); Mrs.
Arthur H. Masten (Christine
McMartin Masten), donor's
grandmother.
McMartin Correspondence,
MS 61-62, Box 2, Duncan
E. McMartin, Jr. to wife
Margaret, Albany, February
20, 1827, p. 2, AML.
67.196.02 (171)

129 Untitled: Portrait of
Archibald McIntyre
(1772 - 1857), n.d.
Oil on wood panel 10 x 8
Not signed
Gift of Arthur M. Crocker
(McIntyre descendant); Mrs.
Arthur H. Masten (Christine
McMartin Masten), donor's
grandmother.
Stylistically related to
miniature watercolor
portraits of McIntyre's
daughter Annie and her
husband, David Henderson,
Museum of the City of New
York, gift of Margaret H.
Elliot, David Henderson's
granddaughter, 1949,
accession numbers 49.170.15
and 49.170.14, respectively.
Portrait of Annie is not
signed or dated. Portrait of
David is signed "Chas. C.
Ingham, New York, 1834."
67.196.03 (172)

Henry Inman
(attributed)
(1801 - 1846)

130 Untitled: Portrait of Henry
Eckford (1775 - 1832), n.d.
Oil on wood 9 x 9
Not signed
Gift of Adam Hochschild;
Mr. and Mrs. Harold K.
Hochschild.
81.046.03 (440)

David Johnson
(1827 - 1908)

131 *Lake George, Looking North,*
from Tongue Mountain Shore,
1874
Oil on canvas 14 x 22
Signed l.l. D.J.
Purchase.
Owens, *Nature Transcribed:*
The Landscapes and Still Lifes
of David Johnson (1827 -
1908), Ithaca, N.Y., Herbert
F. Johnson Museum of Art,
1988, cat. no. 32, ill.
63.025.01 (75)

132 *Sketch, Storm King on*
the Hudson, 1860
Oil on wood 10 x 9
Signed l.c. D.J.; on back
David Johnson
Gift of Collier W. Baird;
M.E. Sloane.
74.203.02 (366)

Amy Wisher Jones
(1899 -)

133 *St. Regis Reservation,* 1937
Oil on masonite 28 x 53
Signed l.c. Amy Jones
Purchase.
86.065.01 (474)

J. Karlen
(fl. 1926)

134 Untitled: Portrait of Mitchell
Sabattis, 1926
Oil on canvas 30 x 25
Signed l.r. J. Karlen
Gift of Franklin H. Farrell.
57.135.01 (6)

Herbert S. Kates
(1894 - 1947)

135 *Old Steamboat,* 1934
Watercolor 11 x 15
Not signed
Gift of Jerome Kates, artist's
brother.
1) Carson, *Peaks and People of
the Adirondacks,* Garden City,
N.Y., Doubleday & Co., 1927,
ill. 2) Logbook of Jerome
Kates, Scrapbook of Jerome
Kates, 1923-1941, MF4.65,
AML.
68.168.12 (201)

136 Untitled: Noonmark from
Keene Valley, n.d.
Watercolor 19 x 26
Signed l.r. Herbert S. Kates
Gift of Jerome Kates, artist's
brother.
See 68.168.12
73.084.01 (325)

137 Untitled: Tree with Sign, n.d.
Watercolor 7 x 6
Not signed
Gift of Jerome Kates, artist's
brother.
See 68.168.12
73.084.02 (326)

138 Untitled: Tree with Falls,
n.d.
Watercolor 7 x 5
Not signed
Gift of Jerome Kates, artist's
brother.
See 68.168.12
73.084.03 (327)

139 Untitled: River, n.d.
Watercolor 5 x 7
Not signed
Gift of Jerome Kates, artist's
brother.
See 68.168.12
73.084.04 (328)

140 *Lake Arnold/Adirondacks,* n.d.
Watercolor 8 x 12
Signed l.l. Herbert S. Kates
Gift of Jerome Kates, artist's
brother.
See 68.168.12
73.084.05 (329)

141 *Hunter's Cabin, Roaring Brook,
Adirondack Mountains,* n.d.
Watercolor 14 x 19
Signed l.l. Herbert S. Kates
Gift of Jerome Kates, artist's
brother.
See 68.168.12
73.084.06 (330)

142 Untitled: Bob Glassbrock's,
Raquette Lake, n.d.
Watercolor 8 x 12
Signed l.l. Herbert S. Kates
Gift of Jerome Kates, artist's
brother.
See 68.168.12
73.084.07 (331)

143 *Avalanche Pass,* 1924
Watercolor 4 x 7
Signed l.r. Herbert S. Kates
Gift of Jerome Kates, artist's
brother.
See 68.168.12
75.249.01 (332)

144 *Avalanche Pass Trail,* 1926
Watercolor 7 x 4
Signed l.l. Herbert S. Kates
Gift of Jerome Kates, artist's
brother.
See 68.168.12
75.249.02 (333)

145 Untitled: Boat House,
Raquette Lake, n.d.
Watercolor 10 x 14
Signed l.r. Herbert S. Kates
Gift of Jerome Kates, artist's
brother.
See 68.168.12
75.249.03 (334)

146 Untitled: Raquette River,
Adirondacks, n.d.
Watercolor 6 x 10
Signed l.l. Herbert S. Kates
Gift of Jerome Kates, artist's
brother.
See 68.168.12
75.249.04 (335)

147 *Brandreth Outlet, Forked Lake,*
n.d.
Watercolor 15 x 19
Signed l.l. Herbert S. Kates
Gift of Jerome Kates, artist's
brother.
See 68.168.12
75.249.05 (336)

148 Untitled: River Camp, n.d.
Watercolor 11 x 13
Not signed
Gift of Jerome Kates, artist's
brother.
See 68.168.12
75.249.06 (337)

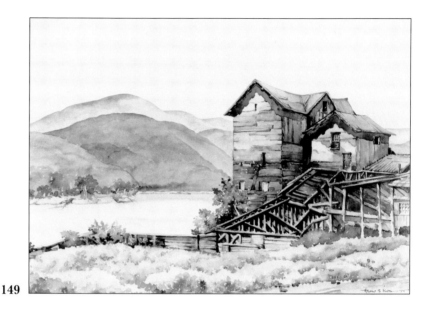

149

149 *McIntyre Iron Works,* 1935
Watercolor 14 x 20
Signed l.r. Herbert S. Kates
Gift of Jerome Kates, artist's
brother.
See 68.168.12
75.249.07 (338)

150 *Sunrise from Scott Pond Trail,*
1932
Watercolor 5 x 7
Signed l.l. Herbert S. Kates
Gift of Jerome Kates, artist's
brother.
See 68.168.12
75.249.08 (339)

151 Untitled: Storm Clouds Over
McIntyre Range, 1932
Watercolor 5 x 7
Signed l.r. H.S. Kates
Gift of Jerome Kates, artist's
brother.
See 68.168.12
75.249.09 (340)

152 *Sunrise from Scott Pond Camp,*
1932
Watercolor 6 x 8
Not signed
Gift of Jerome Kates, artist's
brother.
See 68.168.12
75.249.10 (341)

153 Untitled: Adirondack
Sawmill, n.d.
Watercolor 14 x 17
Signed l.l. Herbert S. Kates
Gift of Jerome Kates, artist's
brother.
See 68.168.12
75.249.11 (342)

154 Untitled: North Creek, n.d.
Watercolor 13 x 17
Signed l.l. Herbert S. Kates
Gift of Jerome Kates, artist's
brother.
See 68.168.12
76.001.01 (343)

155 Untitled: Autumn, n.d.
Watercolor 3 x 8
Not signed
Gift of Jerome Kates, artist's
brother.
See 68.168.12
76.001.02 (344)

156 *Seher's Poultry Farm/*
Westfield Mass., 1930
Watercolor 6 x 4
Signed l.l. H.S. Kates
Gift of Jerome Kates, artist's
brother.
See 68.168.12
76.001.03 (345)

157 Untitled: Beaver Dam, Scott
Pond, Adirondacks, 1932
Watercolor 5 x 7
Not signed
Gift of Jerome Kates, artist's
brother.
See 68.168.12
76.001.04 (346)

158 *Summit of Seymour Mountain/*
Adirondacks, n.d.
Watercolor 10 x 7
Signed l.r. Herbert S. Kates
Gift of Jerome Kates, artist's
brother.
See 68.168.12
76.001.05 (347)

159 Untitled: New Rochelle/
Reservoir/Autumn, 1932
Watercolor 7 x 5
Signed l.l. Herbert S. Kates
Gift of Jerome Kates, artist's
brother.
See 68.168.12
76.001.06 (348)

160 Untitled: Giant Mountain
from Nubble Mountain,
1932
Watercolor 5 x 7
Not signed
Gift of Jerome Kates, artist's
brother.
See 68.168.12
76.001.07 (349)

161 Untitled: Marcy Dam, n.d.
Watercolor 5 x 5
Not signed
Gift of Jerome Kates, artist's
brother.
See 68.168.12
76.001.08 (350)

162 *Cabin,* 1941
Watercolor 13 x 18
Signed l.l. Herbert S. Kates
Gift of Jerome Kates, artist's
brother.
See 68.168.12
76.001.09 (351)

Alexander George Kennedy
(1864 - 1931)

163 Untitled: Adirondacks, n.d.
Watercolor 11 x 16
Signed l.r. A.G. Kennedy
Gift of Dr. and Mrs. Fred E.
Luborsky.
82.036.01 (446)

John Frederick Kensett
(1816 - 1872)

164 Untitled: Lake George, n.d.
Oil on canvas 9 x 8 Oval
Signed l.c. JFK
Gift of Collier W. Baird;
M.E. Sloane.
64.108.01 (94)

165 *Lake George,* 1856
Oil on canvas 26 x 42
Signed l.r. JFK
Purchase.
1) NAD, 1856, No. 187, *Lake
Scene* [?], owner J.W. Field.
2) *Kensett,* New York,
Florence Lewison Gallery,
Oct.- Nov. 1965,
cat. no. 6, ill.
65.079.01 (112)

166 Untitled: Lake Scene, n.d.
Oil on canvas 15 x 23
Not signed
Gift of Collier W. Baird;
M.E. Sloane.
69.096.01 (218)

Rockwell Kent
(1882 - 1971)

167 Untitled: AuSable Farm,
1961
Oil on canvas 28 x 42
Signed l.r. Rockwell Kent
Purchase.
61.056.01 (44)

168 *Mountain Road,* ca. 1960
Oil on canvas 28 x 44
Signed l.r. Rockwell Kent
Purchase; Mrs. Rockwell
Kent.
1) NAD, 1969, submitted as a
non-member. 2) *Rockwell
Kent, Adirondack Series, 1940 -
1966,* New York, Larcada
Gallery, December 1973.
74.068.01 (356)

S.A. Kilbourne
(fl. 1872)

169 Untitled: Brook Trout, 1872
Oil on canvas 11 x 18
Signed l.r. S.A. Kilbourne
Purchase.
76.143.01 (410)

"Peddler" Lane
(fl. ca. 1885)

170 *Botheration Pond Lumber
Camp,* ca. 1885
Oil on academy board
13 x 19
Not signed
Gift of Warder H. Cadbury.
88.024.01 (500)

Charles Lanman
(1819 - 1895)

171 Untitled: Temporary Camp,
n.d.
Oil on canvas 18 x 24
Signed l.r. Lanman
Purchase.
75.126.01 (397)

N.T. Leganger
(fl. 1877 - 1891)

172 *Keene Flats, Adirondax* [sic]
N.Y., 1877
Oil on canvas 17 x 25
Signed l.l. N.T. Leganger
Purchase.
77.112.01 (416)

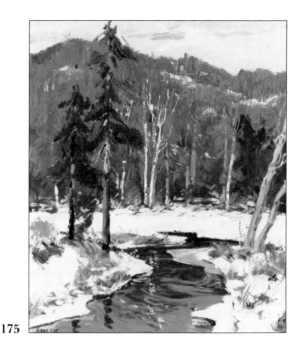

175

Emanuel Gottlieb Leutze
(1816 - 1868)

173 *Indians and American Captive,*
ca. 1862
Oil on canvas 17 x 25
Signed l.l. E. Leutze
Purchase; Wilhelm Mugs,
Dusseldorf.
Replica of *Indians Hauling
Rowboat with Bound Captive,*
The Thomas Gilcrease
Museum, Tulsa, Oklahoma,
illustrated in Groseclose,
*Emanuel Leutze, 1816 - 1868:
Freedom is the Only King,*
Washington, D.C., National
Collection of Fine Art,
Smithsonian Institution,
1975, no. 102, p. 97.
65.028.01 (106)

Edmund Darch Lewis
(1835 - 1910)

174 Untitled: Landscape, 1873
Oil on canvas 17 x 15
Signed l.l. E.D. Lewis
Purchase.
65.013.02 (103)

Jonas Lie
(1880 - 1940)

175 *Home Pond,* 1930
Oil on canvas 30 x 25
Signed l.l. Jonas Lie
Gift of Mrs. Francis P.
Garvan.
Garvan, *Adirondack Winter -
1930: Paintings by Jonas Lie,*
Blue Mountain Lake, N.Y.,
The Adirondack Museum,
1971, p.7, ill.
76.217.02 (411)

176 *Men's Camp and Stables,* 1930
Oil on canvas 30 x 45
Signed l.l. Jonas Lie
Gift of Mrs. Francis P.
Garvan.
See 76.217.02, p. 11, ill.
76.217.03 (412)

**David Cunningham
Lithgow**
(1868 - 1920?)

177 Untitled: Portrait of John
Anderson (1858 - 1920), n.d.
Oil on canvas 27 x 20
Signed l.l. D.C. Lithgow
Gift of Mrs. Mildred
Anderson.
74.213.01 (368)

John Marin
(1870 - 1953)

178 *Adarondack* [sic] *Lake,* 1911
Watercolor 14 x 16
Signed l.l. Marin
Purchase.
*Landscapes of the Berkshires
and Adirondacks,* New York,
"291" Gallery, April-July
1913.
69.142.01 (219)

Homer Dodge Martin
(1836 - 1897)

179 Untitled: Autumn
Landscape, n.d.
Oil on canvas 15 x 23
Signed l.r. H.D. Martin
Gift of Mr. and Mrs. Harold
K. Hochschild.
66.023.01 (115)

180 Untitled: Adirondack
Woodland, n.d.
Oil on canvas 16 x 24
Signed l.r. H.D. Martin
Source unknown; acquired
by the museum ca. 1965.
67.095.01 (160)

182

181 Untitled: Two Anglers, n.d.
Oil on academy board 8 x 6
Not signed
Purchase.
Kennedy Quarterly, New York,
Kennedy Galleries, November
1967, cat. no. 222,
p. 190, ill.
67.220.10 (188)

182 *Lake Champlain,* n.d.
Oil on canvas 40 x 60
Not signed
Gift of Mr. and Mrs. C.V.
Whitney; William C. Brownell.
Mather, *Homer Martin,
Poet in Landscape,* New York,
privately printed, 1912, facing
p. 32, ill.
69.146.01 (220)

183 *Mountain View on the Saranac,*
1868
Oil on canvas 30 x 56
Signed l.l. H.D. Martin
Purchase; Eagle Hotel, Dillon,
Nevada.
Source for Stewart's wood
engraving after Martin,
Mountain View on the Saranac,
"In the Adirondacks," *Every
Saturday,* September 3, 1887,
p. 568.
71.046.01 (262)

184 Untitled: Autumn Lake, n.d.
Oil on canvas 10 x 21
Signed l.l. H.D. Martin
Purchase.
72.070.01 (303)

Osborne A. Mayer
(1883 - 1959)

185 *Hunting Season Opens
Tomorrow,* n.d.
Oil on upson board 21 x 16
Signed l.r. A. Osborne Mayer
Gift of the artist.
57.140.01 (7)

Jervis McEntee
(1828 - 1891)

Wood's Cabin on Rackett [sic]
Lake, 1851
Pencil drawing 11 x 13
Not signed
Gift of Mrs. Jacqueline
Schonbrun and sons in
memory of Stanley I.
Schonbrun; Lockwood
de Forest, owner of McEntee
sketchbook.
1) Engraving after this by
Loomis-Annin, "The Lakes
of the Wilderness," *The Great*

*Republic Monthly, A National
Magazine,* April 1859, p. 341,
ill. as *Our Shanty.* 2) See *A
Selection of Drawings by Jervis
McEntee from the Lockwood
de Forest Collection,* New York,
Hirschl and Adler Galleries,
1976, no. 2. 3) Jervis
McEntee Diary, July 6, 1851,
Archives of American Art,
Smithsonian Institution,
reel D9, frames 589, 594.
76.077.01

Andrew W. Melrose
(1836 - 1901)

186 *Lake George,* n.d.
Oil on canvas 22 x 36
Signed l.l. Andrew Melrose
Gift of Mr. and Mrs. Walter
Fletcher.
Choromolithograph after
this painting, signed in plate
l.l. "Andrew Melrose,"
inscribed in plate l.c. "This
Design is the Property of
Andrew Melrose the Artist
and Copyrighted at Washing-
ton." Borders have been
trimmed to edge of plate,
78.128.1, AMC.
62.119.01 (74)

Nelson Augustus Moore
(1824 - 1902)

187 Untitled: Lake George, 1872
Oil on canvas 14 x 24
Signed l.l. N.A. Moore
Gift of Mr. and Mrs. Harold
K. Hochschild.
62.005.01 (58)

188 *Islands in Shadow,*
Lake George, 1871
Oil on canvas 14 x 24
Signed l.l. N.A. Moore
Gift of Mr. and Mrs. Harold
K. Hochschild.
NAD, 1871, No. 89.
62.005.02 (59)

189 *Adirondacks, Blue Mountain*
Lake, n.d.
Oil on canvas 8 x 12
Signed l.r. N.A. Moore
Gift of Harold K.
Hochschild.
66.011.01 (113)

190 *N.A. Moore's Camp on the*
Lower Saranac, 1891
Oil on canvas 14 x 14
Signed l.l. N.A. Moore
Purchase.
67.124.01 (167)

191 Untitled: Upper Saranac
Lake, ca. 1891-1893
Oil on canvas 15 x 26
Signed l.r. N.A. Moore
Gift of Collier W. Baird.
74.203.01 (365)

192 *Schroon Lake,* 1884
Oil on canvas 11 x 16
Signed l.r. N.A. Moore
Purchase.
78.127.02 (421)

Jonathan Bradley Morse
(1834 - ?)

193 Untitled: Lawrence Camp,
4th Lake, Fulton Chain, 1882
Oil on canvas 18 x 30
Signed l.l. J.B. Morse
Gift of Mr. and Mrs. Horace
Norton Holbrook in memory
of Elizabeth Norton
Lawrence, owner of the
camp until the year of her
death in 1915.
1) Grady, "The Story of a
Wilderness," *The Adirondacks:*
Fulton Chain - Big Moose
Region, Little Falls, N.Y.,
Journal and Courier Co., ca.
1933, pp. 185-188.
2) 17 photographs of
Lawrence Camp in 1913,
P49278–P49294, AMC.
84.039.01 (460)

Seth Moulton
(fl. 1954)

194 *Lumbering 1908,* 1954
Oil on paper 12 x 20
Signed l.r. Seth Moulton
Purchase.
86.039.01 (472)

John Francis Murphy
(1853 - 1921)

195 *Adirondacks,* 1874
Oil on canvas 10 x 9
Signed l.l. J.F. Murphy

Purchase; Dr. Emerson C.
Kelly.
1) Pencil sketches by
Murphy, Adirondacks 1874,
79.19.2-44. 2) Notebook and
sketchbook, Keene Valley,
1874, 79.20.2-3. 3) Photo-
graph of Murphy in studio,
P42782. 4) Photograph of
Murphy with R.M. Shurtleff,
W. Homer, C.R. Smith, K.
Van Elten, 1874, P47500,
all AMC.
79.019.01 (423)

Kate W. Newhall
(fl. 1875 - 1893)

196 *Whiteface Mountain from*
Mirror Lake, 1893
Oil on canvas 12 x 20
Signed l.l. K.W. Newhall
Purchase; John Leal and
Elizabeth D. Way, wedding
gift from the artist.
71.155.01 (263)

Grace Oesher
(fl. 1958)

197 *Eleventh Mountain,* 1958
Watercolor 22 x 15
Signed l.r. Grace Oesher
Gift of the artist.
58.347.01 (18)

William Ongley
(1836 - 1890)

198 Untitled: Hunters in Canoe,
ca. 1886
Oil on canvas 18 x 30
Signed l.l. W. Ongley
Gift of Dr. and Mrs. Charles
E. Sheppard; Dr. Millard
Moon Slocum.
70.094.01 (223)

201

John Adams Parker, Jr.
(1829 - 1900)

199 *The Gothics, Adirondacks,*
ca. 1885
Oil on board 12 x 9
Signed l.l. J.A.P.
Purchase.
NAD, 1885, No. 358.
71.029.01 (257)

200 *Sawtooth Mountain,* n.d.
Oil on board 12 x 9
Signed l.r. J.A.P.
Purchase; Florence Howard,
artist's daughter.
71.029.02 (258)

201 *The Close of a November
Day - AuSable Pond,* ca. 1886
Oil on canvas 10 x 19
Signed l.l. J.A.P.
Purchase; Florence Howard,
artist's daughter.
NAD, 1886, No. 241 [?].
71.029.03 (259)

Stephen Parrish
(1846 - 1938)

202 *Flooded Lands, Adirondacks,*
1880
Oil on cardboard 4 x 9
Not signed
Gift of Mr. and Mrs. Richard
J. Fay.
1) Related to etching, NAD,
1880, No. 648, *Flooded Lands,
Adirondacks.* 2) *Catalogue of
Mr. Stephen Parrish's Complete
Etched Work on Exhibition at
the Gallery of H. Wunderlich &
Co.,* New York, Nov. 1886,
cat. no. 9, lent by Joseph M.
Rogers, Esq.
82.131.01 (450)

Flooded Lands, Adirondacks,
ca. 1880-1881
Etching 4 x 7
Signed in plate l.r. S. Parrish;
verso, u.r. No. 9
Gift of Mr. and Mrs. Richard
J. Fay.
Parrish, *A Catalogue of*

*Etchings by Stephen Parrish,
1879 - 1883,* Philadelphia,
n.d., cat. no. 9.
82.131.02

Arthur Parton
(1842 - 1914)

203 Untitled: Camping Party,
1871
Oil on board 8 x 12
Signed l.r. A. Parton
Purchase.
Kennedy Quarterly, New York,
Kennedy Galleries, Novem-
ber 1967, cat. no. 217, p.
184, ill.
67.220.08 (186)

204 *In the Adirondacks,* ca. 1866
Oil on canvas 21 x 29
Signed l.l. Arthur Parton
Gift of Harold K.
Hochschild.
NAD, 1866, No. 458,
Study in the Adirondacks,
lent by the artist.
68.169.01 (202)

210

William Paskell
(? - ?)

205 Untitled: Pool, Ausable
 River, n.d.
 Watercolor 21 x 14
 Signed l.l. Wm. Paskell
 Gift of Robert S. Sleicher.
 66.124.01 (140)

G.W. Pflanz
(? - ?)

206 Untitled: Portrait of Atwell
 Martin (fl. 1870s - 1890), n.d.
 Oil on canvas 32 x 20
 Signed l.r. G.W. Pflanz
 Gift of Mr. and Mrs.
 Otto Koening; Charles
 Brown, reservoir tender,
 Herkimer, N.Y.
 74.268.01 (374)

Robert Plumb
(1933 - 1985)

207 *Sun Rays*, n.d.
 Watercolor 13 x 20
 Signed l.r. R. Plumb
 Gift of Harold K.
 Hochschild.
 65.029.01 (107)

208 Untitled: Green Pond, 1968
 Watercolor 14 x 19
 Signed l.l. R. Plumb
 Gift of Harold K.
 Hochschild.
 68.181.01 (203)

209 Untitled: Stillwater, 1968
 Watercolor 18 x 24
 Signed right of center
 R. Plumb
 Gift of Harold K.
 Hochschild.
 68.181.02 (204)

Levi Wells Prentice
(1851 - 1935)

210 *Smith's Lake, Adirondacks,
 N.Y.*, 1883
 Oil on canvas 26 x 48
 Signed l.r. L.W. Prentice
 Gift of Mr. and Mrs. Harold
 K. Hochschild.
 66.023.02 (116)

211 *White Birches of the
 Racquette* [sic], ca. 1878
 Oil on canvas 30 x 25
 Signed l.r. L.W. Prentice
 Gift of Mrs. Franklin Kent
 Prentice, Jr. in memory of
 Franklin Kent Prentice, Jr.,

artist's nephew.
Syracuse Journal,
February 5, 1878.
69.090.01 (212)

212 Untitled: Ruffed Grouse,
 1883
 Oil on academy board
 13 x 11
 Signed l.r. L.W. Prentice
 Purchase.
 71.020.01 (252)

213 Untitled: View in the
 Adirondacks, 1873
 Oil on canvas 27 x 44
 Signed l.r. L.W. Prentice
 Purchase.
 76.142.01 (409)

214 Untitled: Still Life, n.d.
 Oil on canvas 7 x 12
 Signed l.r. L.W. Prentice
 Gift of Elizabeth Prentice
 Cassidy, artist's great-niece.
 79.052.01 (427)

215 Untitled: Raquette Lake, n.d.
 Oil on canvas 11 x 19
 Signed l.r. L.W. Prentice
 Gift of Huntington
 Memorial Camp (Camp
 Pine Knot).
 83.084.01 (457)

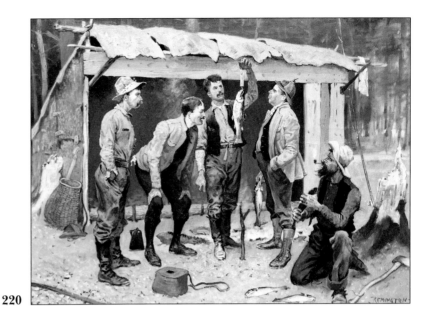

220

216 Untitled: Camping by
the Shore, n.d.
Oil on canvas 12 x 18
Signed l.r. L.W. Prentice
Purchase.
85.027.01 (467)

**Levi Wells Prentice
(attributed)**
(1851 - 1935)

217 Untitled: Gold and Silver
Beach, Raquette Lake,
ca. 1880
Oil on canvas 18 x 35
Not signed
Purchase.
61.029.01 (35)

218 Untitled: Night Scene,
Smith's Lake, n.d.
Oil on canvas 12 x 23
Not signed
Gift of Harold K.
Hochschild.
73.038.01 (315)

**Frederic Sackrider
Remington**
(1861 - 1909)

219 Untitled: Ab [Albert]
Thompson's Cabin on
Silver Lake, ca. 1890

Oil on panel 18 x 28
Signed l.r. Frederic
Remington
Purchase; Robert Purcell;
Timothy L. Woodruff, Kamp
Kill Kare, gift of the artist.
1) Crowley, ed., *The North
Country Art of Frederic
Remington Artist in Residence*,
Blue Mountain Lake, N.Y.,
The Adirondack Museum,
1985, Remington checklist
no. 2, ill. as *Hunter's Cabin,
Silver Lake*. 2) Photograph of
the cabin, P11782, AMC.
67.057.01 (155)

220 *Spring Trout Fishing in the
Adirondacks - An Odious
Comparison of Weights*, 1890
Monochrome oil on canvas
22 x 30
Signed l.r. Remington
Purchase; Henry Sleeper
Harper, publisher of *Harper's
Weekly*.
1) Wells, "Weighing Trout in
the Woods," *Harper's Weekly*,
May 24, 1890, p. 403, ill.
2) See 67.057.01, Remington
checklist no. 6, ill.
70.196.01 (231)

**Frederic Sackrider
Remington
(attributed)**
(1861 - 1909)

221 Untitled: Lean-to, 1888
Watercolor on paper
mounted on bristol board
10 x 14
Not signed
Purchase.
88.113.01 (503)

222 Untitled: Fisherman's
Shelter, n.d.
Watercolor on paper
mounted on bristol board
10 x 14
Not signed
Purchase.
88.113.02 (504)

223 Untitled: Rapids, n.d.
Watercolor on paper
mounted on bristol board
10 x 14
Not signed
Purchase.
88.113.03 (505)

William Trost Richards
(1833 - 1905)

224 *In the Adirondacks*, 1857
Oil on canvas 29 x 44
Signed l.l. Wm. T. Richards
Purchase; LeRoy Ireland,
Philadelphia; Mrs. Anna M.
Vincent, Philadelphia.
1) *"Morning in the Adirondac*
[sic], exhibited at the
Washington Art Association,
Washington, D.C.," *The
Cosmopolitan Art Journal*,
March-June 1858, p. 140.
2) Ferber, *William Trost
Richards, American Landscape
and Marine Painter, 1833 -
1905*, Brooklyn, N.Y., The
Brooklyn Museum, 1973,
no. 20, ill.
69.053.01 (211)

**Horace Wolcott
Robbins, Jr.**
(1842 - 1904)

225 Untitled: Morning in the
Alleghanies, 1860
Oil on canvas 14 x 22
Signed l.l. H.W. Robbins
Purchase.
NAD, 1862, No. 351.
73.138.01 (354)

226 Untitled: Wolf Jaw
Mountain, 1863
Oil on canvas 13 x 22
Signed l.l. Robbins
Purchase.
74.292.01 (376)

Augustus Rockwell
(1822 - 1882)

227 *Lake Placid, Essex Co., N.Y.*,
n.d.
Oil on canvas 17 x 14
Signed on back of canvas
A. Rockwell, Pt.
Purchase.
68.125.01 (197)

228 *Lake George, Warren Co., N.Y.*,
n.d.
Oil on canvas 17 x 14
Signed on back of canvas
A. Rockwell, Pt.
Purchase.
68.125.02 (198)

229 *Whiteface Mountain from
Lake Placid, Essex Co.*, 1873
Oil on canvas 20 x 34
Signed on back of canvas
Rockwell, Pt.
Purchase.
70.197.01 (232)

230 *Mount McIntyre from
Brewster's Pond*, 1869
Oil on canvas 17 x 14
Signed l.r. Rockwell, Pt.
Gift of Mr. and Mrs. Walter
Hochschild.
71.022.01 (254)

231 *Reminiscence of Eighth Lake,
Brownstrack* [sic], 1869
Oil on canvas 17 x 14
Signed on back of canvas
Rockwell, Pt.
Gift of Mr. and Mrs. Walter
Hochschild.
71.022.02 (255)

232 *4th Lake Camp, John Brown
Tract, Herkimer Co.*, 1874
Oil on canvas 10 x 17

Signed on back of canvas
A. Rockwell, N.Y., Pt.
Purchase.
72.066.01 (302)

233 *On Schroon Lake, Essex Co.,
N.Y.*, 1865
Oil on canvas 18 x 30
Signed on back of canvas
A. Rockwell, Pt., Buffalo
Gift of Warren W. Kay.
83.077.19 (454)

Frederic Rondel
(1826 - 1892)

234 *A Hunting Party in the Woods./
In the Adirondac* [sic],
N.Y. State, 1856
Oil on canvas 22 x 30
Signed l.r. F. Rondel
Gift of The Shelburne
Museum, Shelburne, Vt.,
through the generosity of
J. Watson Webb; Maxim
Karolik Collection, Museum
of Fine Arts, Boston.
NAD, 1857, No. 525.
65.015.01 (104)

James N. Rosenberg
(1874 - 1970)

235 Untitled: Adirondack
Landscape Near
Elizabethtown, Essex Co.,
1961
Pastel 18 x 24
Signed l.l. JR
Gift of the artist.
61.043.01 (43)

L.L.S.
(fl. 1876)

236 *Adirondacks/Memory Sketch*,
1876
Watercolor 7 x 9

Not signed
Purchase.
72.044.01 (282)

237 *Adirondacks/Memory/Sketches/*
Depiction of Camp, 1876
Watercolor 7 x 9
Not signed
Purchase.
72.044.02 (283)

238 *Adirondacks/Memory Sketch*,
1876
Watercolor 7 x 9
Not signed
Purchase.
72.044.03 (284)

239 *Adirondacks/Memory Sketch*,
1876
Watercolor 7 x 9
Not signed
Purchase.
72.044.04 (285)

240 *Memory Sketch*, 1876
Watercolor 5 x 7
Not signed
Purchase.
72.044.05 (286)

241 *Memory Sketch*, 1876
Watercolor 5 x 7
Not signed
Purchase.
72.044.06 (287)

242 *Round Lake/Adirondacks/From*
Camp/Ampersand, 1876
Watercolor 10 x 7
Signed at bottom L.L.S. & M.
Purchase.
72.044.07 (288)

243 *View from our Camping Ground*
Round Lake Looking Towards
Whiteface, 1876
Watercolor 7 x 10

Not signed
Purchase.
72.044.08 (289)

244 *View from our Camping Ground*
Round Lake Looking Towards
Whiteface, 1876
Watercolor 7 x 10
Not signed
Purchase.
72.044.09 (290)

245 *Upper Saranac Lake from*
Indian Carry, 1875
Watercolor 2 x 4
Signed l.c. L.L.S.
Purchase.
72.044.10 (291)

246 *Indian Carry from*
Corry's [sic] *Piazza*, 1876
Watercolor 4 x 10
Signed l.l. L.L.S.
Purchase.
72.044.11 (292)

247 *Memory Sketch/Upper*
Saranac Lake, 1876
Watercolor 5 x 7
Signed l.c. L.W. from L.L.S.
Purchase.
72.044.12 (293)

248 *Memory Sketch*, 1876
Watercolor 7 x 5
Not signed
Purchase.
72.044.13 (294)

249 *Memory Sketch*, 1876
Watercolor 7 x 3
Not signed
Purchase.
72.044.14 (295)

250 *Road from Corries* [sic]
to Spectacle Pond, 1876
Watercolor 7 x 10
Not signed
Purchase.
72.044.15 (296)

251 *Stony Creek Lake/Adirondacks*,
1876
Watercolor 7 x 10
Not signed
Purchase.
72.044.16 (297)

252 *Evening View from Side of*
Corry's [sic] *House/Upper*
Saranac, N.Y. State, 1876
Watercolor 4 x 10
Not signed
Purchase.
72.044.17 (298)

Charles Nicolas Sarka
(1879 - 1960)

253 Untitled: Camp Cooking,
ca. 1910
Watercolor 15 x 22
Signed l.r. Sarka
Purchase; Mrs. Charles N.
Sarka.
63.076.01 (79)

254 Untitled: Camper, ca. 1910
Watercolor 15 x 18
Signed l.l. Sarka
Purchase; Mrs. Charles N.
Sarka.
63.076.02 (80)

255 Untitled: Lumber Camp,
ca. 1910
Watercolor 16 x 22
Signed l.l. Sarka
Purchase; Mrs. Charles N.
Sarka.
63.076.03 (81)

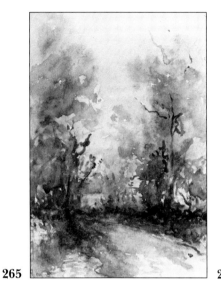

265

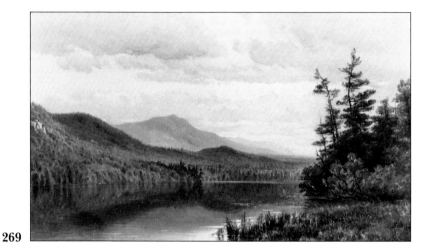

269

256 Untitled: Winter Landscape,
1910
Watercolor 15 x 20
Signed l.r. Sarka
Purchase; Mrs. Charles N.
Sarka.
63.076.04 (82)

257 *Garbage Dump,* ca. 1910
Watercolor 16 x 21
Signed l.r. Sarka
Purchase; Mrs. Charles N.
Sarka.
63.076.05 (83)

R.A. Savage
(? - ?)

258 Untitled: Allegory of the
Adirondack Region, 1893
Oil on canvas 18 x 30
Signed l.c.l. R.A. Savage
Purchase.
Possibly an adaptation of
Currier & Ives, *The Lakes of
Killarney.* See Peters, *Currier
& Ives,* New York, Double-
day, Doran & Co., 1931,
vol. II, no. 4282a, p. 193, ill.
71.019.01 (251)

Roswell Morse Shurtleff
(1838 - 1915)

259 Untitled: Wood Scene, n.d.
Oil on canvas 12 x 16
Signed l.l. R.M. Shurtleff,
N.A.
Purchase.
63.124.01 (89)

260 Untitled: Woods, n.d.
Oil on canvas 20 x 26
Signed l.r. R.M. Shurtleff,
N.A.
Gift of Mrs. Malcolm E.
Shroyer, artist's cousin.
71.018.01 (249)

261 Untitled: Mountainside, n.d.
Oil on canvas 20 x 25
Signed l.l. R.M. Shurtleff
Gift of Mrs. Malcolm E.
Shroyer, artist's cousin.
71.018.02 (250)

262 *The Road to the AuSable,*
ca. 1893
Oil on canvas 40 x 30
Signed l.l. R.M. Shurtleff,
N.A.
Gift of Henrietta Gibson
Ledden in loving memory of
her sister, Mary Gibson; Mary

Gibson; Charles Gibson,
father of Henrietta and Mary
Gibson, 1915; Mrs. Roswell
M. Shurtleff.
73.091.01 (352)

263 Untitled: Sunset, n.d.
Watercolor 5 x 7
Signed l.l. R.M. Shurtleff
Gift of Mrs. Malcolm E.
Shroyer, artist's cousin.
74.202.01 (362)

264 Untitled: Lake, n.d.
Watercolor 5 x 6
Signed l.l. R.M. Shurtleff
Gift of Mrs. Malcolm E.
Shroyer, artist's cousin.
74.202.02 (363)

265 Untitled: Road, n.d.
Watercolor 7 x 5
Signed l.l. RMS
Gift of Mrs. Malcolm E.
Shroyer, artist's cousin.
74.202.03 (364)

266 Untitled: AuSable Lake,
Adirondacks, n.d.
Oil on canvas 10 x 16
Signed l.l. R.M. Shurtleff
Purchase.
74.210.01 (367)

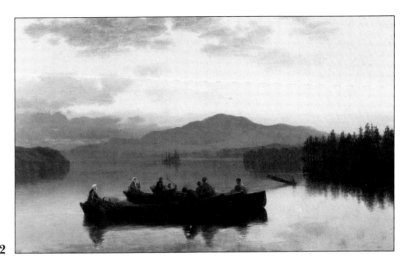

272

William Thomas Smedley
(1858 - 1920)

267 *At Bluff Point, Lake Champlain,* 1890
Watercolor and gouache on paper 17 x 13
Signed l.l. W.T. Smedley
Purchase.
Janvier, "The Uncle of an Angel," *Harper's New Monthly Magazine,* August 16, 1890, pp. 404-426.
70.164.01 (229)

George Henry Smillie
(1840 - 1921)

268 Untitled: A Lake in the Woods, 1872
Oil on canvas 36 x 60
Not signed
Purchase.
NAD, 1872, No. 281.
72.160.02 (310)

269 *AuSable Lake, Adirondack Mts.,* 1868
Oil on canvas 11 x 18
Signed l.r. Geo. H. Smillie
Purchase.
74.292.02 (377)

270 *AuSable River,* 1870
Oil on canvas 14 x 21
Signed l.l. Geo. H. Smillie
Purchase.
"Adirondack Scenery," *Appleton's Journal of Popular Literature, Science and Art,* Sept. 24, 1870, pp. 362-366.
86.043.01 (473)

James David Smillie
(1833 - 1909)

271 *Top of Giant's Leap, Adirondacks,* 1869
Watercolor 20 x 13
Not signed
Gift of Mrs. Harold K. Hochschild.
1) James D. Smillie Diaries, Oct. 1, 1869, Archives of American Art, Smithsonian Institution, reel 2849, frame 858. 2) Witthoft, "Listing," unpublished manuscript, 1989, no. WC-48.
62.009.01 (60)

272 *Evening on Lake Raquette, Adirondacks,* 1874
Oil on canvas 18 x 30
Signed l.l. J.D. Smillie

Gift of Mr. and Mrs. Harold K. Hochschild; Anna C. Cook, 1874 (who commissioned the painting and in 1881 became artist's wife).
1) NAD, 1874, No. 144, lent by Anna C. Cook. 2) See 62.009.01, #1) Jan. 7, 1873, Feb. 7, 1873, March 16-17, 1874, March 20-21, 1874, reel 2850, frames 120, 135, 344-347. 3) Witthoft, "The Diary of James D. Smillie," *Adirondac,* May 1986, p. 23, ill. 4) See 62.009.01, #2) no. P74.1. 5) Source for J.D. Smillie, mezzotint of same title, 1896.
66.098.03 (136)

273 *AuSable River,* 1869
Watercolor 7 x 10
Not signed
Purchase.
1) See 62.009.01, #1) August 18, 1869, reel 2849, frame 836. 2) See 62.009.01, #2) no. WC-5.
78.127.01 (420)

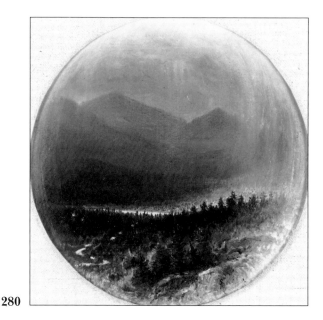

280

274 *Dome Island, Lake George,*
ca. 1878-1879
Watercolor 10 x 14
Signed l.r. J.D. Smillie
Purchase.
1) "Lake George," *Harper's*
New Monthly Magazine,
August 1879, p. 327, ill.
2) See 62.009.01, #2) no.
WC-35.
80.062.01 (434)

Thomas Lochlan Smith
(1835 - 1884)

275 Untitled: Night in the
North Woods, n.d.
Oil on canvas 27 x 48
Signed l.l. T.L. Smith
Gift of George W. Van
Santvoord; Seymour Van
Santvoord, Troy, N.Y.,
donor's father; 1892,
Mrs. L.M. Morton.
67.184.01 (169)

H. Snyder, Jr.
(attributed)
(fl. 1880s)

276 *Cold Spring Camp,*
Fourth Lake, 1881
Watercolor 6 x 7

Signed on backing H.S., Jr.
Gift of Mrs. Emmett Brazie;
Lewis L. Grant.
Grady, "Early Camps," *The*
Adirondacks - Fulton Chain -
Big Moose Region: The Story of
a Wilderness, Little Falls, N.Y.,
Journal and Courier Co.,ca.
1933, p. 157, photograph
facing p. 157.
61.009.01 (32)

William Louis
Sonntag, Sr.
(1822 - 1910)

277 *View Near Cascade Bridge -*
Valley of the Susquehanna,
1863
Oil on canvas 33 x 55
Signed l.r. W.L. Sonntag
Gift of Harold K.
Hochschild.
NAD, 1863, No. 237.
68.201.01 (205)

278 Untitled: Morning in
the Adirondacks, n.d.
Oil on canvas 20 x 30
Signed l.l. W.L. Sonntag
Gift of Mr. and Mrs. Richard
J. Fay.
84.031.01 (459)

Seneca Ray Stoddard
(1843 - 1917)

279 *View of the Hudson Near*
Newcomb, ca. 1870s
Oil on academy board 7 x 10
Not signed
Gift of Mr. and Mrs. Harold
K. Hochschild.
Crowley, *Seneca Ray Stoddard:*
Adirondack Illustrator, Blue
Mountain Lake, N.Y., The
Adirondack Museum, 1982,
no. 105.
66.098.02 (135)

280 *Mt. Marcy Across Wolf Pond,*
ca. 1870s
Monochrome oil on
academy board 6 x 6 circle
Signed right of center SRS
Purchase.
See 66.098.02, no. 97.
71.157.01 (264)

281 *In the Drowned Lands of the*
Raquette River, ca. 1888
Monochrome oil on
academy board 6 x 8
Signed l.r. SRS
Purchase.
See 66.098.02, no. 96.
71.157.02 (265)

292

282 *Along the Upper Hudson,*
ca. 1870s
Monochrome oil on
academy board 2 x 7
Signed l.r. SRS
Purchase.
1) See 66.098.02, no. 98.
2) Illustration for Stoddard's
unpublished manuscript,
"The Hudson from the
Mountains to the Sea," 1892,
MS 75-2, AML.
71.157.03 (266)

283 *Mountain Trail in the
Adirondacks,* ca. 1870s
Monochrome oil on
academy board 10 x 3
Signed l.r. SRS
Purchase.
1) See 68.098.02, no. 99.
2) See 71.157.03, #2).
71.157.04 (267)

284 *Summit Rock, Indian Pass,* n.d.
Oil on canvas 6 x 8
Not signed
Purchase; artist's niece.
See 66.098.02, no. 101, ill.
74.233.38 (370)

285 *Keene Valley from Baxter
Mountain,* ca. 1870s
Oil on canvas 6 x 8
Not signed
Purchase; artist's niece.
See 66.098.02, no. 102.
74.233.39 (371)

286 *Lake George,* n.d.
Oil on academy board 7 x 10
Not signed
Purchase; artist's niece.
74.233.40 (372)

287 *The Narrows, Lake George,* n.d.
Oil on academy board 9 x 14
Not signed
Gift of the Carl E. Plumley
Memorial Fund.
See 66.098.02, no. 104, ill.
81.008.01 (436)

288 *Schroon River,* 1870
Oil on canvas 8 x 10
Not signed
Gift of Adam Hochschild;
Mr. and Mrs. Harold K.
Hochschild.
81.046.01 (438)

289 Untitled: Possibly
Schroon River, n.d.
Oil on canvas 8 x 13
Not signed
Gift of Adam Hochschild;
Mr. and Mrs. Harold K.
Hochschild.
81.046.02 (439)

Stephen Story
(1915 - 1988)

290 *The Log Skidder Near Charlie
Pond, Adirondacks, N.Y.,* 1981
Oil on masonite 28 x 33
Signed l.l. Steve Story
Gift of Jennifer Blumenfeld
and Roberta Walton, artist's
daughters.
88.030.01 (501)

291 *The Loader Near Charlie Pond,
Adirondacks, N.Y.,* 1982
Oil on masonite 24 x 36
Signed l.r. Steve Story
Gift of Jennifer Blumenfeld
and Roberta Walton, artist's
daughters.
88.030.02 (502)

294

T. Strebel
(fl. 1870 - 1907)

292 *Jacob's Hunting*, 1907
Oil on canvas 30 x 40
Signed left of center
T. Strebel
Gift of Mrs. Frederick Vetter.
70.027.31 (222)

Henry Suydam
(fl. 1859 - 1878)

293 *Mount Haystack from Upper AuSable Inlet*, ca. 1878
Oil on canvas 12 x 22
Posthumous signature left of center Henry Suydam
Gift of Harold K. Hochschild.
1) See Stoddard, 66.098.02, no. 107, no. 45, ill. 2 After Stoddard photograph which appeared as basis for lithograph in Colvin, *Annual Report on the Progress of the Topographical Survey of the Adirondack Region of New York for the Year 1880*, Albany, N.Y., Weed, Parsons & Co., 1881, plate 18.
69.052.01 (210)

Arthur Fitzwilliam Tait
(1819 - 1905)

294 *An Anxious Moment*, 1880
Oil on canvas 20 x 30
Signed l.r. A.F. Tait
Gift of Mr. and Mrs. Walter Hochschild; Charles R. Flint, 1880.
1) NAD, 1881, No. 369, *An Anxious Time, A Study from Nature, Long Lake Adirondacks*, lent by C.R. Flint.
2) *A.F. Tait - Artist in the Adirondacks*, Intro. Gilborn, essays Cadbury and Mandel, Blue Mountain Lake, N.Y., The Adirondack Museum, 1974, cat. no. 37, ill.
3) Cadbury and Marsh, *Arthur Fitzwilliam Tait: Artist in the Adirondacks*, Newark, Del., The American Art Journal/University of Delaware Press, 1986, Tait checklist no. 80.21, ill.
57.206.01 (11)

295 *Snowed In*, 1877
Oil on canvas 36 x 28
Signed l.l. A.F. Tait
Gift of Mr. and Mrs. Walter

Hochschild; Judge Henry Hilton; A.T. Stewart.
1) Strahan [Shinn], ed., *The Art Treasures of America, Being the Choicest Works of Art in the Public and Private Collections of North America*, Philadelphia, G. Barrie, 1880, vol. 1, p. 48, ill.
2) See 57.206.01, #2) cat. no. 33, ill. and #3) Tait checklist no. 77.13, ill.
3) Mandel, "The Animal Kingdom of Arthur Fitzwilliam Tait," *The Magazine Antiques*, October 1975 p. 753, ill.
60.077.01 (27)

296 *A Good Time Coming*, 1862
Oil on canvas 20 x 30
Signed l.c. A.F. Tait
Gift of Harold K. Hochschild; James Stillman, Schaus Gallery, New York.
1) NAD, 1863, No. 217, *Taking it Easy - Camping Out, Adirondacks, 1862*, For Sale.
2) NAD, 1876, No. 388, *There's a Good Time Coming.*
3) See 57.206.01, #2)

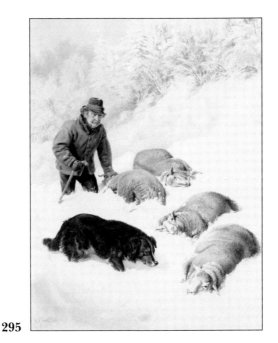

295

no. 23, ill. and #3) Tait
checklist no. 62.16, ill.
63.037.1 (76)

297 *Autumn Morning,
Racquette* [sic] *Lake*, 1872
Oil on canvas 36 x 72
Signed l.r. A.F. Tait
Gift of Harold K.
Hochschild; James Stillman,
Schaus Gallery, New York.
1) NAD, 1872, No. 262, For
Sale. 2) See 57.206.01, #2)
cat. no. 30, ill. and #3) Tait
checklist no. 72.16, ill.
3) See 60.077.01, #3)
p. 748, ill.
63.037.02 (77)

298 Untitled: The Escape,
ca. 1873
Oil painted over
chromolithograph 18 x 24
Not signed
Gift of Henry F. Marsh.
1) See 57.206.01, #3) Tait
checklist no. 73.11, ill.
2) Chromolithograph
published for Laflin and
Rand Powder Co., New York,
Peletreau, Raynor and Co.,
F. Jones, chromolitho-
grapher.
63.077.01 (84)

299 *Morning on the Loon Lake*,
1873
Oil on canvas 16 x 20
Signed l.r. A.F. Tait
Gift of Claude J. Ranney,
grandson of William Ranney,
the artist, many of whose
paintings Tait finished after
Ranney's death.
1) Schenks Auction Gallery,
New York, February 14, 1873.
2) See 57.206.01, #3) Tait
checklist no. 73.3, ill.
63.081.01 (85)

300 *Racquette* [sic] *Lake*, 1879
Oil on canvas 23 x 27
Signed l.r. A.F. Tait
Purchase; Southside
Sportsmen's Club, Long
Island; Otto Von Kienbusch;
Mrs. Talcott, who commis-
sioned the painting in 1879.
1) See 57.206.01, #2) cat.
no. 35, ill. and #3) Tait
checklist no. 79.40, ill.
2) See 60.077.01, #3)
p. 749, ill.
64.126.01 (95)

301 *Still Hunting on the First Snow:
A Second Shot*, 1855
Oil on canvas 54 x 76
Signed l.r. A.F. Tait
Gift of Mr. and Mrs. Walter
Hochschild; Carroll Tyson,
1932; Leeds Sale, December
18, 1863.
1) NAD, 1855, No. 147,
*A Second Shot: Still Hunting
on the First Snow in the
Chateaugay Forest.* 2) See
57.206.01, #2) cat. no. 9, ill.
and #3) Tait checklist no.
55.1, ill. 3) See 60.077.01,
#3) p. 752, ill.
65.036.01 (110)

302 Untitled: Dorking Chickens,
1861
Oil on board 9 x 10
Signed l.r. A.F. Tait
Gift of Mr. and Mrs. Harold
K. Hochschild.
See 57.206.01, #2) cat. no.
18, ill. and #3) Tait checklist
no. 61.1, ill.
66.098.01 (134)

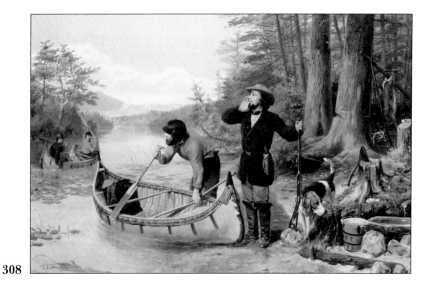

308

303 Untitled: American Black
Bear, ca. 1868
Oil on canvas 15 x 26
Not signed
Gift of John K. Lovell; Arthur
J.B. Tait.
1) See 57.206.01, #2) cat. no.
14, ill. and #3) Tait checklist
no. 68.22, ill. 2) See
60.077.01, #3) p. 751, ill.
66.169.01 (153)

304 Untitled: Study at Raquette
Lake, ca. 1860
Oil on canvas 17 x 24
Not signed
Gift of John K. Lovell; Arthur
J.B. Tait.
1) See 57.206.01, #2) cat. no.
17, ill. and #3) Tait checklist
no. 60.52, ill. 2) See
60.077.01, #3) p. 745, ill.
66.169.02 (154)

305 Untitled: Jacking Deer, n.d.
Ink wash on paper 7 x 9
Signed l.l. A.F. Tait
Purchase.
1) *Kennedy Quarterly*, New
York, Kennedy Galleries,
November 1967, cat. no. 212,

p. 180, ill. 2) See 57.206.01,
#2) p. 72 and #3) Tait
checklist no. ND.2, ill.
67.220.07 (185)

306 Untitled: Dog's Head, 1879
Watercolor 9 x 7
Signed l.r. A.F. Tait
Gift of Mrs. George H.
Morris.
See 57.206.01, #2) p. 72
and #3) Tait checklist no.
79.46, ill.
70.115.01 (225)

307 *The Gap in the Fence*, 1893
Oil on canvas 14 x 22
Signed l.l. A.F. Tait
Gift of Mr. and Mrs. Herman
A. Young; James Gill, Spring-
field, Massachusetts.
See 57.206.01, #2) cat. no.
43, ill. and #3) Tait checklist
no. 93.2, ill.
71.028.01 (256)

308 *Going Out: Deer Hunting
in the Adirondacks*, 1862
Oil on canvas 20 x 30
Signed l.l. A.F. Tait
Gift of Harold K.
Hochschild; Leeds Sale,
December 18, 1863;

Currier and Ives.
1) Currier and Ives, *American
Hunting Scenes, "An Early
Start,"* 1863. 2) See
57.206.01, #2) cat. no. 24, ill.
and #3) Tait checklist no.
62.17, ill. 3) See 60.077.01,
#3) p. 745, ill.
73.036.01 (314)

309 *Good Hunting Ground*, 1881
Oil on canvas 20 x 26
Signed l.r. A.F. Tait
Gift of Mr. and Mrs. Walter
Hochschild; Williams and
Everett, Boston.
1) NAD, 1882, No. 491.
2) See 57.206.01, #2) cat. no.
40, ill. and #3) Tait checklist
no. 81.27, ill.
74.293.01 (355)

310 *A Natural Fisherman*, 1875
Oil on canvas 14 x 22
Signed l.r. A.F. Tait
Gift of Harold K.
Hochschild.
See 57.206.01, #2) cat. no.
32, ill. and #3) Tait checklist
no. 75.9, ill.
74.101.01 (357)

316

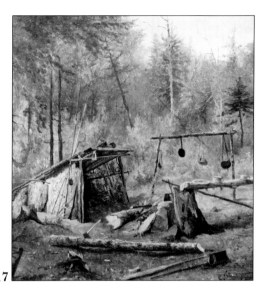

317

311 Untitled: Nine Views
of the Adirondacks, 1861
Oil on academy board
23 x 29
Two signed A.F. Tait,
one signed A.F.T.
Gift of Mr. and Mrs.
Frederick B. Hard; Tahawus
Club. See 57.206.01, #3)
Tait checklist numbers
61.42 - 61.50.
74.314.01 (379)

312 *Play Fellows*, 1894
Oil on canvas 14 x 22
Signed l.r. A.F. Tait
Gift of Emilie Buchmann;
Mrs. George Taylor Lang-
horne, Chicago; Mrs. Waller,
Chicago; Mr. Waller,
Chicago, 1894.
See 57.206.01, #3) Tait
checklist no. 94.9, ill.
79.051.01 (426)

313 *Dog and Two Ruffed Grouse*,
1881
Oil on canvas 12 x 16
Signed l.r. A.F. Tait
Gift of Mr. and Mrs. Horace
Norton Holbrook in memory
of Elizabeth Norton Law-
rence; Gustave Reichard,

New York, 1881.
See 57.206.01, #3) Tait
checklist no. 81.10.
84.039.02 (461)

**Arthur Fitzwilliam Tait
(attributed)
(1819 - 1905)**

314 Untitled: The Hunter's
Dilemma, ca. 1851
Oil on canvas 35 x 45
Not signed
Gift of Warren W. Kay;
Donald D. Donohue,
Falls Church, Va.
See 57.206.01, #3) Tait
checklist numbers 51.5 and
51.13, ill.
83.077.21 (456)

**Edna West Teall
(1881 - 1968)**

315 *Schoolroom*, ca. 1950
Oil on masonite 9 x 12
Signed l.r E.A.W. Teall
Purchase.
Teall, *Adirondack Tales -
A Girl Grows Up in the Adiron-
dacks in the 1880s*, Willsboro,
N.Y., 1970, p. 104, ill.
84.071.01 (465)

**Eliphalet Terry
(1826 - 1896)**

316 *Log Cabin in the Adirondacks
Near North Woods Club,*
ca. 1857
Oil on canvas 9 x 14
Not signed
Gift of Harold K.
Hochschild.
1) Diary of Juliet Baker
Kellogg, MS 61-83.
2) Fisher, "Eliphalet Terry,"
unpublished manuscript,
MS 75-7, both AML.
69.051.01 (209)

**C. Themanen
(fl. 1865)**

317 *Constable Point, Raquette Lake,*
1865
Oil on canvas 11 x 11
Signed l.r. C. Themanen
Purchase.
74.143.01 (359)

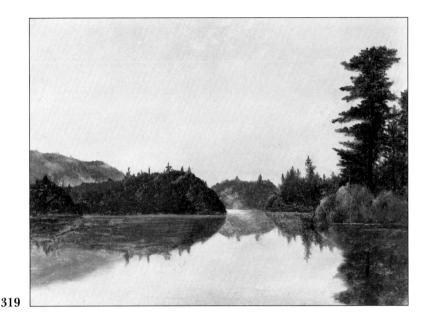

319

Roland Tiemann
(fl. 1952 - 1964)

318 *Adirondack Trail,* 1952
Watercolor 22 x 30
Signed l.l. Roland Tiemann
Gift of the artist.
64.079.01 (93)

Joseph Tubby
(1821 - 1896)

319 *Star Lake,* ca. 1894-1895
Oil on canvas 11 x 15
Scratched on back of upper
frame Joseph Tubby
Gift of Mr. and Mrs. William
Gerdts; Miss Gertude Tubby,
artist's daughter.
71.017.01 (248)

Mrs. O.C. Tuttle
(fl. 1919)

320 *Tuttle Bug and Black Bass,*
ca. 1919
Oil on canvas 24 x 18
Signed l.l. Mrs. O.C. Tuttle
Gift of Edith Tuttle Morcy,
artist's daughter and daugh-
ter of O.C. Tuttle, inventor
of Devil Bugs (deer hair
fishing lures).
77.212.01 (418)

Cora M. Twining
(1880 - ?)

321 *Camp on Moose River/
Moose Lake,* ca. 1890-1900
Oil on canvas 17 x 27
Not signed
Gift of John Millard, artist's
son.
Subjects of painting include:
Fred Walker, Principal,
Copenhagen School; John
S. Twining, artist's father,
farmer and lumberman;
Charles Merrill, storekeeper,
Copenhagen; Dr. James
Jamblin, MD, Copenhagen.
74.232.01 (369)

William Richardson Tyler
(1825 - 1896)

322 *West Mountain, Raquette Lake,*
ca. 1875
Oil on canvas 12 x 20
Signed l.r. W.R. Tyler
Gift of Mrs. Harold K.
Hochschild.
61.002.04 (30)

Unknown

323 Untitled: Columbia
Crowning Bust of George
Washington, ca. 1832
Oil on wood 28 x 30
Not signed
Gift of W. Lewis Armstrong.
Fire pumper on which this
painting appears as decora-
tion was built by James
Smith, New York City, 1832,
and used there by the
Martha Washington
Company.
58.279.01 (13)

Unknown

324 Untitled: Indians and
Captive [John Smith],
ca. 1832
Oil on wood 7 x 14
Not signed
Gift of W. Lewis Armstrong.
See 58.279.01.
58.279.02 (14)

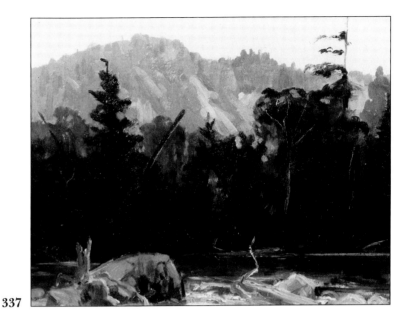

337

Unknown

325 Untitled: Hunters in Camp,
n.d.
Oil on canvas 18 x 26
Not signed
Gift of Mr. and Mrs. Harold
K. Hochschild.
Related to Currier and Ives
after Louis Maurer, *Camping
Out - Some of the Right Sort*,
1856.
61.030.01 (36)

Unknown

326 Untitled: Portrait of Duncan
McMartin, Jr. (1772 - 1837),
ca. 1820s
Oil on canvas 30 x 25
Not signed
Gift of Christine McMartin
Masten; Arthur M. Crocker,
Mrs. Masten's grandfather.
Masten, *The Story of Adiron-
dac*, New York, 1923; repr.
The Adirondack Museum/
Syracuse University Press,
Syracuse, N.Y., 1968, facing
p. 16.
67.196.01 (170)

Unknown

327 Untitled: Hunters at Rest,
n.d.
Oil on canvas 14 x 20
Not signed
Purchase.
68.062.03 (194)

Unknown

328 Untitled: Portrait of Noah
John Rondeau (1883 - 1967),
n.d.
Oil on pillow ticking 26 x 20
Not signed
Gift of the Adirondack
Mountain Club.
69.031.01 (207)

Unknown

329 Untitled: Wadhams, N.Y.,
n.d.
Watercolor 10 x 14
Not signed
Purchase.
70.117.01 (226)

Unknown

330 Untitled: Fish and Tackle,
n.d.
Oil on canvas 16 x 21
Not signed
Purchase.
70.200.01 (237)

Unknown

331 Untitled: Camping Out -
Some of the Right Sort,
after 1856
Oil on canvas 20 x 28
Not signed
Purchase.
After Currier and Ives,
*Camping Out - Some of
the Right Sort*, 64.152.09,
AMC.
72.061.01 (301)

Unknown

332 Untitled: Portrait of Martin
M. Moody (1833 - 1910),
ca. 1876
Oil on academy board 10 x 8
Not signed
Purchase; Moody family.
1) "A Half-way House," *Forest

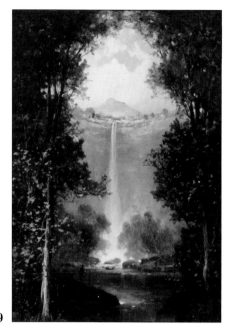
339

and Stream, August 24, 1882.
2) Goldthwaite, "'Uncle
Mart' Moody," *The New York
Times,* May 10, 1903.
75.230.06 (400)

Unknown

333 Untitled: Portrait of Minerva
Reid Moody, ca. 1876
Oil on academy board 10 x 8
Not signed
Purchase; Moody family.
See 75.230.06.
75.230.07 (401)

Unknown

334 Untitled: Lake Scene
with Boat, n.d.
Oil on canvas 26 x 44
Not signed
Gift of Mrs. William A.
Rockefeller in memory of
William A. Rockefeller.
75.263.01 (403)

Unknown

335 Untitled: Port Henry, n.d.
Oil on canvas 22 x 34
Not signed
Gift of Mrs. Sheldon

Howard; estate of John
Howard, Port Henry.
76.031.01 (408)

Utley Brothers
(fl. 1906)

336 *Accident at Pullman's Mill*
[Forestport, N.Y.],
June 14th 1906, 1906-1910
Oil on canvas 35 x 51
Signed l.r. Utley Bros.
Gift of Mary L. Wilburn and
Florence Sargent, daughters
of George Lanz (subject of
the painting).
1) *The American Journal of
Clinical Medicine,* Chicago,
The Clinic Publishing Co.,
June 1910, p. 694 ff, ill.
2) Photograph from which
painting was done, P49623,
AMC.
85.020.01 (466)

Robert Ward
Van Boskerck
(1855 - 1932)

337 Untitled: Chapel Pond, n.d.
Oil on board 18 x 24
Not signed
Purchase; Maitland

DeSormo; Mrs. Jacques,
Keene Valley (in lieu of
grocery bill).
74.233.41 (373)

338 *In the Adirondacks,
Keen* [sic] *Valley,* n.d.
Oil on canvas 26 x 36
Signed l.l. R.W.
Van Boskerck
Gift of Harold K.
Hochschild; Hamilton Club,
Brooklyn, New York.
75.171.01 (399)

Hendrik-Dirk Kruseman
Van Elten
(1829 - 1904)

339 *Russell Falls, Adirondacks,*
1878
Oil on canvas 26 x 19
Signed l.l. Kruseman
Van Elten
Gift of Mr. and Mrs. Harold
K. Hochschild.
61.018.01 (33)

Fred T. Vance
(ca. 1840 - 1892)

340 Untitled: Upper AuSable,
1880
Oil on canvas 14 x 20

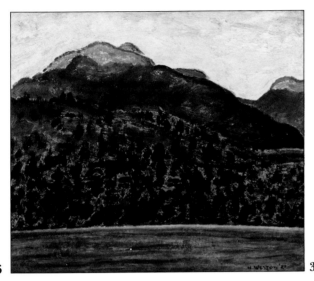
346

348

Signed l.r. F.T. Vance
Gift of Mrs. Harold K.
Hochschild.
67.083.01 (157)

D.L. Walker
(fl. 1883 - 1890)

341 Untitled: Women Fishing,
1890
Oil on canvas 22 x 36
Signed l.r. D.L. Walker
Source unknown.
67.207.01 (178)

William J. Wallace
(? - ?)

342 Untitled: Weathered
Batteau, n.d.
Watercolor 11 x 19
Signed l.l. William J. Wallace
Source unknown.
73.083.01 (324)

George Wellington Waters
(1832 - 1912)

343 Untitled: Lake George, 1868
Oil on canvas 24 x 40
Signed l.l. G. Wellington
Waters

Purchase.
Kennedy Quarterly, New York,
Kennedy Galleries, Novem-
ber 1967, cat. no. 219,
p. 186, ill., as *An Angler
on Lake George (?).*
67.220.09 (187)

Harold Weston
(1894 - 1972)

344 *Spring Sunlight - St. Huberts,*
1922
Oil on cardboard 8 x 10
Signed l.l. Weston
Gift of Mrs. Harold K.
Hochschild.
1) *Exhibition of Paintings,
Adirondack Mountains and
Persia,* New York, Montross
Gallery, Nov. 8-28, 1922, no.
162. 2) McBride, "Art News
and Art Reviews - Promising
Work of Young American
Shown," *New York Herald,*
Nov. 12, 1922 in Harold
Weston Scrapbook, Archives
of American Art, Smith-
sonian Institution, reel 515,
frame 170. 3) Weston,
*Freedom in the Wilds, A Saga of
the Adirondacks,* St. Hubert's,

N.Y., Adirondack Trail
Improvement Society, 1971,
pp. 128-133, 140, 146.
67.199.01 (173)

345 *Giant Early Spring/
Windy Brow #1,* 1922
Oil on cardboard 8 x 10
Signed l.r. Weston
Gift of Mrs. Harold K.
Hochschild.
See 67.199.01, #1).
67.199.02 (174)

346 *Last Glow,* 1921
Oil on cardboard 8 x 9
Signed l.r. H. Weston
Gift of Mrs. Harold K.
Hochschild.
See 67.199.01, #1).
67.199.03 (175)

347 *Sugar Maples - September,* 1923
Watercolor 7 x 10
Signed l.l. H.F. Weston
Gift of Mr. and Mrs. J.
Richardson Dilworth.
See 67.199.01, #3).
82.085.01 (447)

351

348 *Noonday Sun,* 1922
Oil on canvas 16 x 22
Not signed
Gift of Faith B. Weston,
artist's widow.
See 67.199.01, #1).
89.075.01 (506)

349 *Nubble Near Alders,* 1922
Oil on board 6 x 10
Signed l.r. Weston
Gift of Barbara Weston
Foster, artist's daughter.
See 67.199.01, #1).
89.076.01 (507)

Thomas Worthington Whittredge
(1820 - 1910)

350 *View of the Fourth Lake,*
Old Forge, ca. 1861-1862
Oil on canvas 11 x 17
Signed l.l. Whittredge
Purchase.
66.087.01 (133)

Gustave Adolf Wiegand
(1869 - 1957)

351 *Indian Summer, Blue*
Mountain Lake, N.Y., ca. 1915
Oil on canvas 40 x 48

Signed l.r. Gustave Wiegand
Gift of Mrs. Paul R. Tilson,
artist's daughter.
57.141.01 (8)

352 *Blue Mountain Lake,*
ca. 1910 - 1918
Oil on canvas 7 x 10
Signed l.l. Gustave Wiegand
Gift of Mrs. W.L. Webb.
57.201.01 (9)

353 *Hoar Frost,* 1913
Oil on paper 10 x 8
Signed l.r. Gustave Wiegand
Gift of Mrs. Boris Sergievsky.
57.205.01 (10)

354 *The Giant of the Valley,*
ca.1910-1912
Oil on canvas 30 x 36
Signed l.l. Gustave Wiegand
Gift of Mrs. Paul R. Tilson,
artist's daughter.
59.037.01 (22)

355 *The Summer Sun, Blue*
Mountain Lake, N.Y., 1917
Oil on academy board
12 x 10
Signed l.l. Gustave Wiegand
Purchase.
68.124.01 (196)

356 *First Snow,* ca. 1918
Oil on academy board 8 x 10
Signed l.l. Gustave Wiegand
Gift of C. Edward Wells,
artist's friend.
Exhibited Syracuse Museum
of Fine Arts, March 1918.
72.051.01 (300)

357 *Blue Mountain,* ca. 1914
Oil on canvas 41 x 48
Not signed
Gift of Mrs. Paul R. Tilson,
artist's daughter.
73.043.79 (316)

358 *Sketch from Blue Mountain,*
ca. 1912 - 1913
Oil on canvas 12 x 16
Not signed
Gift of Mrs. Paul R. Tilson,
artist's daughter.
73.043.80 (317)

359 *Silvery Summer, Blue Mountain*
Lake, N.Y., ca. 1900-1918
Oil on academy board 8 x 10
Signed l.l. Gustave Wiegand
Purchase.
77.062.01 (414)

358

360 *Golden Autumn,*
ca. 1918 -1922
Oil on board 8 x 10
Signed l.l. Gustave Wiegand
Gift of Miss Grace L.
Thompson.
79.071.01 (429)

361 *High Noon, Blue Mountain
Lake,* 1915
Oil on academy board 8 x 10
Not signed
Gift of estate of Helen M.
Fuller in memory of F.
Howard Trewin; commis-
sioned by F. Howard Trewin
in memory of his parents
Frank W. and Amy F. Trewin.
84.070.01 (462)

362 *Wings of the Morning, Blue
Mountain Lake, New York,*
1914
Oil on wood 8 x 10
Signed l.r. Gustave Wiegand
Gift of estate of Helen M.
Fuller in memory of F.
Howard Trewin.
84.070.02 (463)

363 *Passing Storms, Blue
Mountain Lake,* 1916
Oil on masonite 8 x 10
Signed l.r. Gustave Wiegand
Gift of estate of Helen M.
Fuller in memory of F.
Howard Trewin; F. Howard
Trewin.
84.070.03 (464)

George Bacon Wood, Jr.
(1832 - 1909)

364 *Interior of an Adirondack
Shanty,* ca. 1880
Oil on canvas 14 x 20
Signed l.l. Geo. B. Wood
Gift of Mr. and Mrs. Harold
K. Hochschild.
1) *51st Annual Exhibition,*
Philadelphia, Pennsylvania
Academy of Fine Arts, April
5 - May 30, 1880, no. 86, ill.
2) Coffin, *A Girl's Life in
Germantown,* Boston,
privately printed, 1916.
3) Hoopes, "George B.
Wood, Jr.–A Student of
Nature," *American Art and
Antiques,* Sept.-Oct., 1979,
pp. 118-125, ill.
68.123.01 (195)

365 Untitled: Cows/Haystacks,
n.d.
Oil on canvas 11 x 16
Signed l.l. Geo. B. Wood
Purchase.
1) *50th Annual Exhibition,*
Philadelphia, Pennsylvania
Academy of Fine Arts, 1879,
as *Study of Cows Grazing.*
2) Photograph of George B.
Wood as "Cattle Painter,"
P20927, AMC, copy of
original at Adirondack
Center Museum, Elizabeth-
town, N.Y.
75.059.01 (395)

366 Untitled: Papa's Shop, 1871
Oil on canvas 14 x 18
Signed l.l. Geo. B. Wood, Jr.
Gift of Mr. and Mrs. Harold
K. Hochschild.
1) *48th Annual Exhibition,*
Philadelphia, Pennsylvania
Academy of Fine Arts, 1877,
no. 325. 2) See 68.123.01,
#2) and #3).
75.264.01 (404)

369

May S. Wood
(? - ?)

367 Untitled: Portrait of Mitchell Sabattis (? - 1906), 1900
Oil on canvas 20 x 16
Signed l.r. May S. Wood
Gift of William L. Wessels.
55.008.01 (1)

John Kellogg Woodruff
(1879 - 1956)

368 *Road to Chapel Pond/ Adirondacks,* 1922
Watercolor 15 x 20
Signed l.l. John K. Woodruff
Purchase.
A Special Exhibition of Watercolors by John Kellogg Woodruff, Glen Cove, N.Y., The North Gallery, November 28 - January 15, 1976, no. 16.
77.083.01 (415)

Ferdinand Alexander Wust
(1837 - 1876)

369 *Early Morning in the Adirondacks: The Successful Hunter,* 1873
Oil on canvas 74 x 48
Signed l.r. Alexander Wust
Purchase.
1) Exhibition, Brooklyn Art Academy, Brooklyn, N.Y., November 1875, *In The Adirondacks.* 2) *Kennedy Quarterly,* New York, Kennedy Galleries, November 1967, cat. no. 228, p. 196, ill.
81.045.01 (437)

Alexander Helwig Wyant
(1836 - 1892)

370 Untitled: Adirondack Landscape, n.d.
Oil on canvas 9 x 14
Signed l.l. A.H. Wyant
Purchase.
67.094.01 (159)

371 *Adirondack Vista,* ca. 1881
Oil on canvas 25 x 19
Signed l.r. A.H. Wyant
Gift of Walter Hochschild; Edward and Tullah Hanley, Bradford, Pa.; George S. Palmer.
Clark, *Sixty Paintings by Alexander H. Wyant,* New York, privately printed, 1920, no. 42, ill.
74.294.01 (378)

Don Wynn
(1942 -)

372 *Casey Mountain,* 1973
Watercolor 17 x 24
Not signed
Purchase.
78.097.01 (419)

373 *Campfire,* 1975
Oil on canvas 90 x 72
Signed l.l. W.
Gift of Mr. and Mrs. J. Richardson Dilworth.
82.085.02 (448)

Selected Bibliography

Adirondack Bibliography. Gabriels, N.Y.: Adirondack Mountain Club, 1958.

American Paradise: The World of the Hudson River School. Exhibition catalogue. Introduction by John K. Howat. Texts by Kevin J. Avery, Oswaldo Rodriguez Rogue, John K. Howat, Doreen Bolger Burke, Catherine Hoover Voorsanger. New York: The Metropolitan Museum of Art, 1987.

Artists' File, Adirondack Museum, Blue Mountain Lake, New York.

Cadbury, Warder H. and Marsh, Henry F. *Arthur Fitzwilliam Tait: Artist in the Adirondacks.* Newark, Del.: The American Art Journal/University of Delaware Press, 1986.

Callow, James T. *Kindred Spirits: Knickerbocker Writers and American Artists, 1807-1855.* Chapel Hill, N.C.: The University of North Carolina Press, 1967.

Ferber, Linda S. and Gerdts, William H. *The New Path: Ruskin and The American Pre-Raphaelites.* Exhibition catalogue. Preface by Robert T. Buck. Essays by Linda S. Ferber, William H. Gerdts, Kathleen A. Foster, Susan P. Casteras. Brooklyn: The Brooklyn Museum, 1985.

Goldmark, Pauline. "Keene Valley Artists." Typescript. Keene Valley, N.Y.: Keene Valley Library, 1940.

Graham, Frank, Jr. *The Adirondack Park: A Political History.* New York: Alfred A. Knopf, 1978.

McCoubrey, John W., ed. *American Art 1700-1960 Sources and Documents.* Englewood Cliffs, N.J.: Prentice-Hall, 1965.

Masten, Arthur H. *The Story of Adirondac,* 1923. Reprint, with introduction and notes by William K. Verner. Blue Mtn. Lake, N.Y.: The Adirondack Museum and Syracuse University Press, Syracuse, 1968.

National Academy of Design Exhibition Record, 1828-1860. 2 vols. New York: New-York Historical Society, 1943.

Naylor, Maria, ed. *The National Academy of Design Exhibition Record, 1861-1900.* 2 vols. New York: Kennedy Galleries, Inc., 1973.

Noble, Louis Legrand. *The Life and Works of Thomas Cole. The Course of Empire, Voyage of Life and Other Pictures of Thomas Cole, N.A.,* 1853. Reprint, edited by Elliot S. Vesell. Cambridge: Harvard University Press, Belknap Press, 1964.

Novak, Barbara. *Nature and Culture: American Landscape and Painting 1825-1875.* New York: Oxford University Press, 1980.

O'Brien, Peggy. *Adirondack Paintings.* Exhibition catalogue. Plattsburgh, N.Y.: The Myers Fine Art Gallery of the State University College of Plattsburgh, 1972.

_____. "Artists of the Adirondacks." Unpublished manuscript. Adirondack Museum Library, Blue Mountain Lake, New York, n.d.

Spassky, Natalie. *American Paintings in the Metropolitan Museum of Art.* 3 vols. With Linda Bantel, Doreen Bolger Burke, Meg Perlman, Amy L. Walsh. New York: The Metropolitan Museum of Art, 1985, vol. II.

Staley, Allen. *The Pre-Raphaelite Landscape.* London: Oxford University Press, 1973.

Stein, Roger B. *John Ruskin and Aesthetic Thought in America, 1840-1900.* Cambridge: Harvard University Press, 1967.

The White Mountains: Place and Perceptions. Exhibition catalogue. Exhibition curator, Donald D. Keyes. Essays by Catherine H. Campbell, Donald D. Keyes, Robert L. McGrath, R. Stuart Wallace. Hanover, N.H.: University Press of New England for University Art Galleries, University of New Hampshire, Durham, 1980.

Index

Pages on which illustrations appear are in *italics*.

Patricia C.F. Mandel is a native of Albany, New York, where her family has lived for five generations. A graduate of Wellesley College and the Institute of Fine Arts, New York University, she earned her doctoral degree for her dissertation on Homer Dodge Martin, noted for his paintings of the Adirondacks. Dr. Mandel has been associated with the Whitney Museum of American Art, the Rhode Island School of Design, and the Parrish Art Museum; she has taught at Hunter College, Brown University and Vassar College, has co-authored two catalogues, and contributed essays on American artists and etchers to numerous catalogues and periodicals. She lives in New York City and Hillsdale, New York, where she is a member of the Town Planning Board and the Hurricane Chapter of the Adirondack Mountain Club.